Portraits of Nature

Portraits of Nature

Paintings by
ROBERT BATEMAN

Stanwyn G. Shetler

SMITHSONIAN INSTITUTION PRESS
Washington, D.C. London

Published on the occasion of the exhibition "Portraits of Nature: Paintings by Robert Bateman," National Museum of Natural History, Smithsonian Institution, January 17–May 17, 1987.

This book was edited by Caroline Newman and designed by Carol Beehler.

Photographs of all artworks courtesy of Mill Pond Press except the following courtesy of Madison Press Books: *Cheetah Siesta; Pride of Lions, Samburu; Whistling Swan, Lake Erie;* and *Wildebeests at Sunset.* Illustrations on pages 6, 12, 16, 38, 116, 136, 150, and 156 from Robert Bateman's sketchbooks. All photographs of Robert Bateman by Norman Lightfoot, courtesy of Mill Pond Press.

∞ The paper used in this publication meets the minimum requirements of the American National Standard for Permanence of Paper for Printed Library Materials Z39.48–1984.

Front Cover: *Evening Light—White Gyrfalcon*
Back Cover: *Along the Ridge—Grizzly Bears*

Cataloging-in-Publication data is given on the last page.

To naturalists and artists of all ages,
without whom nature would be a blank and imageless page.

Contents

Foreword

Fads and fashions often dominate human endeavors, and the fields of science and art are no exception. Indeed, it could be argued that artistic tastes are unusually volatile: a once-popular style or school may suffer a long period of neglect, if not outright hostility, only to be rediscovered by critics and art historians and rehabilitated in the public eye. The art world's rediscovery, about the middle of this century, of nature—natural landscapes and objects—is a case in point. American landscape artists of the nineteenth century, such as Church, Heade, Inness, and others, have recently recaptured public attention as a result of widely acclaimed exhibitions and scholarly reevaluations. Their works now command rapidly escalating prices.

Despite the renaissance of interest in realism and landscape art, little critical attention has been paid to the special class of nature painting that realistically depicts wildlife species. As a class, this tradition is characterized by its focus on the bird, mammal, or other organism as primary subject, with the landscape (habitat) occupying a secondary, though frequently important, place in the composition. The style is well established in North America; one thinks immediately of John James Audubon and his sons or, more recently, of Louis Agassiz Fuertes and Carl Rungius. Today there are many practitioners of this genre and despite the lack of critical attention, wildlife art enjoys popularity with a large portion of the public. The source of this popularity seems to be a basic human fascination with the natural world in general, and animals in particular.

Many wildlife artists have come to their craft through landscape painting or through natural history illustration. One artist stands out in this group—Robert Bateman. His emotional commitment is rooted in his intimate familiarity with the natural surroundings of semirural Ontario, near Toronto, where he was raised. Like many natural scientists, he responded earlier and more directly than the average person to the fundamental appeal of wild nature and its

inhabitants. Unlike most scientists, however, he had an equally natural aptitude for drawing and painting and took art lessons throughout his high school and university years. Significantly, Bateman took his degree in geography, the science of landscapes and the natural world. Already by this time he considered himself primarily an artist, but since wildlife art was not deemed worthy of attention, he experimented with the stylistic trends of the 1940s and 1950s that culminated in abstract expressionism. This training in abstract painting is possibly unique among animal artists, and it had a significant influence on Bateman's subsequent return to realism. A self-described turning point came in 1962, when he first encountered the work of Andrew Wyeth. It is tempting to suggest that this event gave him the courage to return to the realism of his first style and to revitalize his emotional commitment to nature. In any event, within a few years Bateman was again painting natural subjects in a realistic style—but with a distinctive difference. The apprenticeship from impressionism to abstraction now supported a strong formal structure, and animal portraits gave way to complex compositions in which animals *and* their habitats became coequal elements. Bateman's mature paintings embody rich fragments of the ecosystem, and the viewer finds a double reward in aesthetic composition and acute observation of the natural world.

This book and the exhibition that served as its inspiration provide an opportunity for students of art or nature to appreciate Robert Bateman's vision of our shared planet. The insightful text by Stanwyn Shetler, Curator of Botany at the National Museum of Natural History, offers the reader the means to explore more fully the complex beauty of the ecosystems Bateman depicts. Moreover, as opportunities for wilderness experience diminish, Bateman's artistic skill and sensibility and Shetler's interpretation will become a means for some people to discover the sublimity of our natural heritage, from the mountains to the seashores. We may all be grateful that their talents have come together so well in this magnificent book.

Robert S. Hoffmann
Director, National Museum of Natural History
Smithsonian Institution

Preface

This book is a joyful and hopeful celebration of the natural world as seen through the eyes and brush of the Canadian artist Robert Bateman. It is a vicarious journey over the landscape of the globe through his compelling portraits of nature. In exploring and interpreting the rich meaning of individual images, I weave a larger story of the incredible diversity and ecological fabric of life on earth. My commentary shows how Bateman's paintings bring focus to the wildlife of continents, biomes, and habitats and thereby convey powerful conservation messages.

Art and nature have been Robert Bateman's twin passions since childhood. His restless wanderings afield have taken him around the world, always with sketchbook and paintbrush in hand; several African safaris, in particular, have contributed a wealth of images to his gallery of paintings. Though he paints mainly wildlife subjects, Bateman is more than a wildlife artist; his true subject is nature captured with such meticulous realism that it rivals photographic portrai-ture. As he typically portrays birds and animals in lifelike natural settings, nearly every painting tells an ecological story.

Today Bateman, who now lives on an island off the coast of British Columbia, is a public figure. The recipient of many honors and awards, he is regarded by many as the premier nature artist in the world today. He is a fervent conservationist and frequently lectures on his interests and work to increase public awareness of the dangers to our natural heritage.

This book is an outgrowth of my work as curator of the exhibition at the Smithsonian Institution entitled "Portraits of Nature: Paintings by Robert Bateman." The exhibition—held in the Thomas Evans Gallery of the National Museum of Natural History from January through May 1987—represents the most ambitious retrospective of Bateman's works ever assembled in one place. More than a hundred of his paintings have been drawn together from owners around the world, including His Royal Highness, Prince Charles,

and His Serene Highness, Prince Rainier of Monaco.

The book features fifty-three paintings included in the show but has not been primarily conceived as an exhibition catalog. Although the book offers a Bateman extravaganza of sorts, my focus is less on the man than on nature as seen through his art. For those who wish to read more about the artist himself, I recommend the excellent accounts by Ramsay Derry in *The Art of Robert Bateman* (1981) and *The World of Robert Bateman* (1985), two handsomely produced books devoted to Bateman's artistry.

My aim here has been to draw out—to paint in words, as it were—some of the rich messages in Bateman's images. In the first two chapters, I focus on the ecological landscapes with increasing magnification, moving from the scale of continents to the foreground of local habitats. The remaining chapters are devoted to several other themes underlying our concerns for the wildlife heritage of the earth. Except where I have quoted or otherwise credited the artist or other authors, the interpretations are my own. If at times I have gone beyond the artist's context or intent and this has resulted in distortion of fact or misleading interpretation, I bear the regret as well as the responsibility. Many of Bateman's paintings are nature scenes from his native Canada, and a preponderance of his work portrays the wildlife of North America. Not surprisingly, then, I have placed primary emphasis on the wildlife heritage of this continent. In the experience of most readers, it is perhaps closer to the heart than the heritage of any other part of the world.

I am grateful to many people for their assistance with the exhibition and the book. First and foremost, I am indebted to the artist, Robert Bateman, and his wife, Birgit, whom I am now pleased to count as my personal friends, for their enthusiastic support and unfailing cooperation in organizing the exhibition and also for generous permission to reproduce the paintings included here. I am equally indebted to the many lenders who were willing to share their personal treasures with the public for the duration of our exhibit.

Richard S. Fiske, former Director of the National Museum of Natural History, was responsible for the decision to mount a Bateman retrospective, and his unflagging interest and support often sustained my efforts. This support has been continued by Acting Director James C. Tyler and more recently by Director Robert S. Hoffmann; both encouraged me in the writing of this book and granted me time off from my duties as Assistant Director when deadlines had to be met.

In planning the exhibit, I have had the valuable assistance of W. Duane Hope, Rebecca G. Mead, Sheila M. Mutchler, Marilyn J. Schotte, and especially Marjory G. Stoller, the indispensable "quarterback" responsible for coordinating the work of the exhibition committee throughout. The exhibit designer was Elroy Quenroe, the graphic designer, Allyson Smith, and the script editor, Sue N. Voss, all of whose work was vital to the show. The exhibit was lighted by Phillip F. Anderson, and many other members of the Museum's exhibit staff, under the direction of Laurence P. O'Reilly, contributed to its production, including the entire graphics department. Special thanks for promotional assistance go to Thomas R. Harney and Ann Smith.

For help in preparing the book for publication, I am deeply grateful to Joan B. Miles, but also to Carole Lee Kin and Anne E. Curtis, who tirelessly and good-naturedly typed and retyped the entire manuscript. The book was skillfully edited by Caroline Newman and designed by Carol Beehler, who have my sincere thanks. Marjory Stoller again deserves highest praise for keeping the book on track and attending to the numerous details of coordinating the materials for publication, especially the reproductions. She was assisted by Sheila Mutchler and Carolyn J. Margolis.

Madison Press Books, publishers of Robert Bateman's other books, cooperated fully with us in the preparation of this book, and their crucial contribution is gratefully acknowledged.

Among those at the Smithsonian Institution Press who helped to make this book possible, I wish to thank especially Felix C. Lowe, Director; Maureen R. Jacoby, Assistant

Director and Managing Editor; Kathleen Brown, Production Coordinator; and Edward F. Rivinus, Senior Science Editor.

I cannot overemphasize the value of the assistance rendered by Mill Pond Press, Inc., of Venice, Florida, and my debt to President Robert L. Lewin and Executive Vice President Katherine E. Lewin and to Vice Presidents Richard L. Lewin and Laurie L. Simms, and to the entire staff, especially Mary Nygaard. The Beckett Gallery in Hamilton, Ontario, and Mr. and Mrs. Jack Coles and family of Nature's Scene in Toronto also helped in critical ways. Neither the exhibition nor the book would have been possible without their contributions.

Finally, I reserve for my wife, Elaine, and my children, Stephen and Lara, my deepest thanks for their support and indulgence; they kept the family's vital routines going during the months and many long hours of my preoccupation.

Bald Eagle
at nest
one chick.
at Katchemak
Bay
near Homer
Alaska.

12

Introduction

Nature—the vast diversity and intricate interplay of life and environment on earth—is our indispensable common heritage, sheltering and sustaining all mankind. Through the ages, nature's endless variety and riddles have challenged naturalists and philosophers; her inexhaustible images have inspired artists, poets, and writers. As observers of nature, the artist and the naturalist have always been natural allies. But each has explored the reaches of nature from a unique perspective, portraying nature's reality in different but complementary form.

Naturalists have spent centuries cataloging and explaining the enormous diversity of plants and animals in nature. The great natural history museums of the world, such as the Smithsonian's National Museum of Natural History, are storehouses for the naturalists' immense collections, providing essential documentation of their discoveries. These museums keep the catalog of nature and the knowledge we have acquired about the earth's biological diversity. Naturalists are the keepers of the keys to this catalog and this knowledge.

Today's naturalist is a highly specialized scientist, a systematic biologist or systematist, who studies biological diversity with the latest technology. The basic task is far from finished—discovering, describing, and classifying the millions of species (perhaps thirty million) in the world. But the present-day systematist is far more than an explorer and cataloger; he is also a biologist who tries to explain both the evolutionary and the ecological place of species in nature.

Despite his high-tech tools, the modern naturalist still must rely fundamentally on his powers of observation, description, and inference to perceive and portray nature's reality. In time-honored scientific tradition, he paints his perceptions with words and his canvas is the printed page. But the naturalist's language is often so arcane that his portraits of nature assume little real form save in the minds of kindred scientists.

The artist, by contrast, has always perceived natural

diversity through another eye of the mind and painted his perceptions of nature in the universal language of color. His images, often stylized or idealized, may be meticulously realistic or may symbolize or distill some larger essence of the natural realm. Such distillations can take on abstract or impressionistic form, or the realism of a photographic portrait.

Only realist art can illuminate and authenticate the naturalist's word pictures of the rich diversity in nature. And skillful scientific illustration, a specialized form of art realism, has long been the indispensable servant of scientific description. With the rise of modern photography, however, the painter's brush has frequently taken second place to the photographer's lens in the portrayal of the natural world. This is lamentable in many instances because the eye of the artist often sees nature's reality quite differently from the eye of the camera.

The camera, for instance, freezes but a moment in time and space. Its image is slavishly faithful to its subject, with focus fixed by the inflexible laws of optics, often giving us shallow foreground without background or background without foreground. The artist, however, can telescope time and space with the conceptualizing lens of the mind; he can synthesize, synchronize, and idealize nature's images. The artist can compose the essence of reality into synthetic visual wholes, creating a differential or complete depth of focus that deliberately sharpens the essential, relevant, and pleasing elements while obscuring or eliminating harsh and irrelevant distractions.

Paintings of nature can also be far more effective than the photographer's pictures in depicting the often subtle features that distinguish one species of animal or plant from another, or in portraying a species in its habitat or larger ecological setting. Perhaps most important of all, the gifted nature artist can transform a panoramic landscape or doorstep vignette into a true portrait of nature with power and feeling, a grand ecological synthesis that is at once an authoritative statement of relationship and unity and an evocative message of priceless

heritage and higher human values. In this sense, the portrait becomes a call to conservation, compelling concern for the environmental welfare of continents and oceans and spurring action to preserve wilderness near and far.

Robert Bateman is at once naturalist, artist, teacher, and conservationist. His camera-defying brush captures the reality of nature with uncanny authenticity. He is a realist painter because he knows through his own personal odyssey the limitations of abstract and impressionist art for the artist who wishes to portray what Bateman calls the "particularity of nature." Nature's diversity rarely assumes specific identity merely through impressions or abstractions; this diversity resolves itself into recognizable species and habitats only through the proper comprehension and use of detail. When Bateman paints a species of bird or mammal, it must be sufficiently detailed to be identifiable, without being so feather- or fur-perfect that it stands apart from its setting as a field-guide cameo. In his often elaborate settings, he uses just enough detail to impart a sense both of scientific authenticity and photographic fidelity. The background may remain deliberately generic, sketched in only so far as it authenticates the main focus of the painting.

Nature is a matter of focus and scale. On the grandest scale is the planet Earth—a global landscape. When, as through some cosmic zoom lens, the naturalist or the artist focuses on the earth's natural realm with increasing powers of magnification, the global landscape assumes ecological fabric and texture in ever greater detail, resolving itself into naturescapes and habitats at all levels from oceans and continents to life-zones, biomes, communities, and, ultimately, to the fine structure of nature—individual species and local environments. On every scale—structure and pattern. On every level—scientific intrigue and artistic beauty.

Nature is also a matter of perspective and perception. From one vantage point, the naturalist or the artist may survey the ecological landscape and see individual species, habitats, or interactions, while from another viewpoint nature appears only as integrated communities or ecosystems of

closely interrelated organisms and environments. Still another may be fascinated by process, by the rhythms and cycles of nature. Some dwell on the continuities and revel in the familiar or the commonplace. Others are absorbed in the rich diversity of life and are magnetically drawn to wilderness and to exotic biotas. Some become so sensitized to the rare and the unusual within the vast matrix of habitats and living forms that they deliberately look beyond nature's hoi polloi to focus only on the vanishing jewels. These precious remnants, all too rapidly slipping over the brink into extinction, are perceived as the epitome of the natural realm, the very essence of what is worth saving.

At one time or another, Robert Bateman has assumed each of these viewpoints and his paintings reflect the full gamut of perspectives and perceptions. As artist he is able to convey a vivid comprehension of diversity because, as naturalist, he has mastered the particularity of nature.

I

Grand Panoramas and Portraits of Nature: The Wildlife Heritage of Continents

We begin our journey over the ecological landscape of the globe, as seen through the art of Robert Bateman, with the focus of our cosmic lens fixed briefly at the scale of continents. The natural heritage of the earth encompasses a highly evolved panoply of life consisting of millions of species of plants and animals. But this vast biotic inventory is neither generally nor evenly distributed over the globe. Historical process and climatic zonation, among other forces, have conspired over geological time to endow the landmasses with their own distinctive subsets of the earth's biota. Thus, each continent is a natural realm unto itself with a wildlife heritage that includes unique (endemic) species as well as species shared with one or more other continents. Among the shared species, migratory birds are particularly prominent. On every landmass there are species and settings—often large or heroic in character—that instantly suggest the continent. Such images, when painted by the artist, may have a sweeping import that makes them

symbolic both as portraits of nature on a continental scale and as panoramas of the entire wildlife landscape of a continent.

Robert Bateman often paints in heroic proportions, producing continental images of stunning power and grandeur. Whether the bird or animal fills the canvas in magnificent portrait, revealing the very mood and texture of the creature, or merely adorns the stage of some grand panorama of nature, perhaps in insignificant form dwarfed or distanced by an awesome and boundless backdrop, Bateman's heroic paintings always aggrandize their subjects and make them tell a whole continent's story. Indeed each of his heroic paintings, whatever its focus, is at once a portrait, for the fine structure of nature that it discloses in consummate detail, *and* a panorama, for the continental vision of nature as pattern and heritage that it evokes.

Though the whole world is his domain—and, with sketch pad and brush, he has immortalized the wildlife landscapes

wherever he has traveled on the globe—Robert Bateman belongs to North America. He is truly in his element among the wild and often heroic images of the North Country, especially his native Canada, with its snow-covered mountains, remote bogs and lakes, dark coniferous forests, immense prairies and marshes and unending tundra plains, magnificent waterfowl and birds of prey, monarchs of the animal kingdom, and, always, wintry scapes, big skies, and glowing twilights.

Apart from North America, Bateman's world has included Antarctica, Africa, Asia, and Europe, with particularly strong emphasis on Africa, where he lived for two years. In this chapter, as throughout the book, my special focus is North America, but several heroic panoramas/portraits of Antarctic, African, and Asian wildlife are also briefly considered. Species are not discussed in detail because the point of the chapter is to look at selected paintings not as portraits of particular species, but as symbolic portraits of a continental fauna. Similarly, biomes and habitats are mentioned only in passing; they will be treated more fully in the next chapter.

The Polar Regions

The north and south polar regions of the globe offer fascinating ecological similarities and differences. In the polar regions the environment, losing all the agreeable subtleties of the lower latitudes, is reduced to harsh and unforgiving extremes—naked forces of unrelenting hostility to living things. As one moves poleward, whether to the north or to the south, the rich mantle of life that clothes the earth becomes ever more attenuated, until, at the very poles, all is bleak and barren. Both in the Arctic and the Antarctic, but especially in the Antarctic, life is concentrated mainly in the sea and on the coasts where the sea meets land, moderating the environment and affording ready access to food resources.

Antarctica, a concentric landmass around the South Pole, is the fifth largest continent on the earth, and it is almost totally covered with a continental ice sheet averaging more than a mile thick. The Arctic, by contrast, is a "continent" of fragments—a great archipelago of islands, the largest being continent-sized Greenland, arrayed in the Arctic Ocean like a necklace around the North Pole. The Antarctic continent has no native mammals, only four indigenous birds, and only one or two species of seed plants. Its depauperate biota consists largely of an invertebrate fauna and a nonvascular flora (lichens, mosses, liverworts). In the Arctic, the islands have a small but significant vertebrate fauna and vascular flora. The surrounding seas in both polar regions support a rich treasury of animal life, and the coastal regions enjoy a summer influx of birds and marine mammals, although the Arctic has nothing that quite matches the Antarctic's penguins and great seabird rookeries, dependent on the sea's food chain.

The primal, forbidding but spectacular landscape of the south polar region is arrestingly portrayed by Robert Bateman in *Antarctic Elements*. A lone Dominican or kelp gull and the distant forms of Adelie penguins, overwhelmed by an icy, mountainous coastline, are more than enough of the ecological alphabet to spell Antarctica. The common Adelie is one of the four indigenous birds of the continent. The kelp gull, sometimes called the southern black-backed gull, is a circumpolar species in the southern oceans and Antarctic region.

As for the Arctic, the powerful profile of a polar bear's head—Bateman's *Polar Bear Profile*—is all that it takes to place one in the north polar region. The painting vividly shows the artist's complete mastery of fur: "I have treated the fur as landscape," he writes (1981, 128). This hulking carnivore with webbed front toes, virtually an aquatic bear, feeds primarily on seals. Hitchhiking on ice floes and wearing a thick, snowy coat in all seasons, the polar bear not only is superbly fitted for its environment but reigns supreme as it swims and stalks its way across the Arctic in search of seals. The polar bear and the Alaskan brown ("Kodiak") bear are North America's largest carnivores; a large male of either

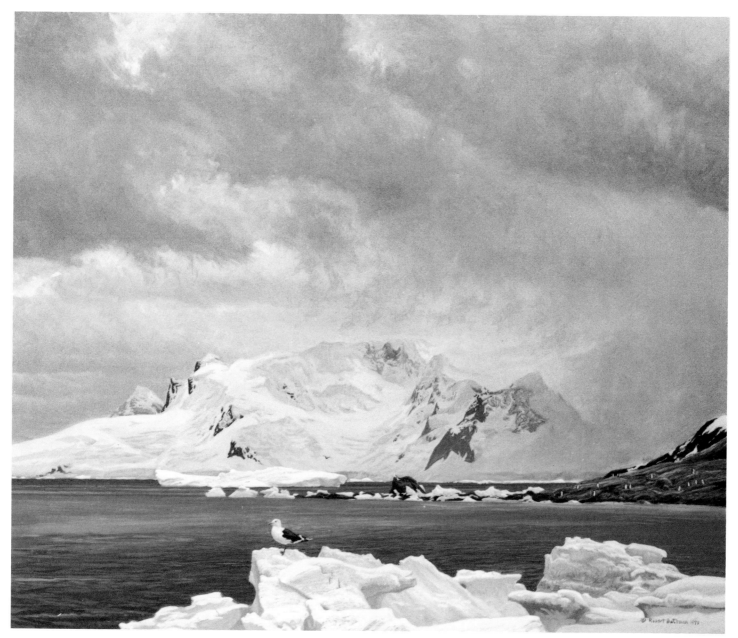

Antarctic Elements

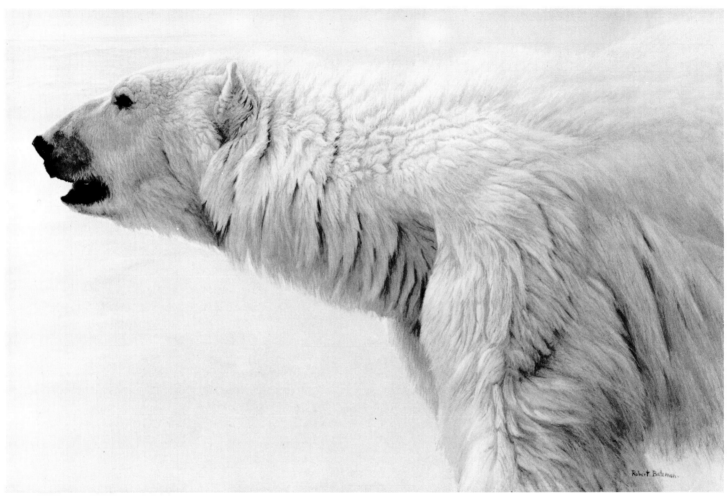

Polar Bear Profile

may weigh nearly a ton and, on hind legs, stand a towering ten feet tall. Native in maritime regions throughout the Arctic, the polar bear is known for its wide roving. Males are active all year, but females give birth to their young (usually two cubs) in winter in ice dens they excavate.

Linking the two great realms of the Arctic and the Antarctic is the arctic tern, and Bateman recently painted an elegant pair of this species. It nests in the Arctic and winters in the Antarctic. Flying from pole to pole each year, this intrepid traveler has perhaps the longest migration journey among birds.

Africa

No continent is so easily characterized by its rich wildlife heritage as Africa. This vast natural zoo can be epitomized by any of a seemingly limitless cast of fabled large mammals and exotic birds. Rhinos, elephants, and big cats are monarchs of the great, grassy savannas and plains of East Africa. They all command wide berth and instant right-of-passage within their ecological domains, but none more obviously symbolize the menacing if majestic dominance of these monarchs than the elephant and the big cats, both of which Bateman has painted on various scales of encounter. The heart of the African savanna is the world-famous Serengeti Plain of East Africa, which often has been likened to the Garden of Eden for its beauty and awe-inspiring herds of animals. As one observer writes, "When the rains finally come to the great Serengeti Plain of East Africa, it is an overwhelming event, almost theatrical in its drama" (*Grasslands and Tundra*, 83).

The lion surely must be the best-known African animal in all the world. Growing up on stories about lions, many children can recognize this roaring cat, the proverbial king of beasts, before they learn to know the animals closer to home. If ever an animal symbolized a continent, it is the lion. Though it once lived in parts of Europe and Asia as well as most of Africa, the lion now occurs only south of the Sahara, except for one small, protected population in India.

In *Pride of Lions, Samburu,* Bateman captures both the majesty and the deceptive innocence of the species. The scene is in the Samburu Game Reserve, located in central Kenya north of Mount Kenya, the country's highest peak. The portrait shows how naturally lions fade into their surroundings, and Bateman notes that "you sometimes get closer to them than you intend" (1981, 146). The scanning lioness, vanguard of her pride, is arousing in late afternoon for the night's hunt from a day's nap among the boulders and scrubby plant life. From the ridge she surveys the bush and grassy openings on the slopes below. Hunting is mainly the work of the lioness; the species, the only cat to live in groups,

sometimes preys on its own kind. The king of beasts is partial to warthogs, but can bring down a wildebeest or zebra especially when working in groups. Here, pretending not to notice any intruders on their set, several others of her pride (count them) are nonchalantly lounging nearby. The lion has mastered the art of looking casual, even while vigilantly "plotting" the kill or taking notice of everything that is going on around it. Today, despite successful populations, as in the Serengeti ecosystem where there may be three thousand animals, the lion's status overall is increasingly endangered.

One could not imagine a more fitting panorama of Africa's wildlife heritage than *Cheetah Siesta* [1],* which puts the cheetah into the midst of the savanna that is so much a trademark of its realm. The fleet and elegant cat is resting ever vigilantly in a grassy sea that stretches to infinity under the immense sky of southern Kenya's incomparable Amboseli plain. Its deadly gaze may be fixed on some unsuspecting gazelle or other prey. Despite its open habitat, the cheetah is well camouflaged, and its lightning sprint enables it to take down even streaking Grant's gazelles—whose droppings are in the foreground, Bateman points out (1981, 152). The cheetah is the fastest of land mammals, reaching speeds of up to 70 miles per hour. Its once common Asian race is now reduced to a few animals in the Near East.

Each of these magnificent carnivores—the lion and the cheetah—is king of a food pyramid and a marvel of the spectacular predator-prey, adaptive evolution in the African fauna. And each of these scenes, whether viewed as panorama or portrait, speaks eloquently of the past evolutionary history and the present biological and ecological diversity that constitute Africa's matchless wildlife heritage.

The giant herbivore of the Serengeti and other African savannas is the African elephant, which is fully as famous and storied as the lion. Bateman, like so many veterans of

* Paintings followed by a number in brackets are also reproduced in the color plates section.

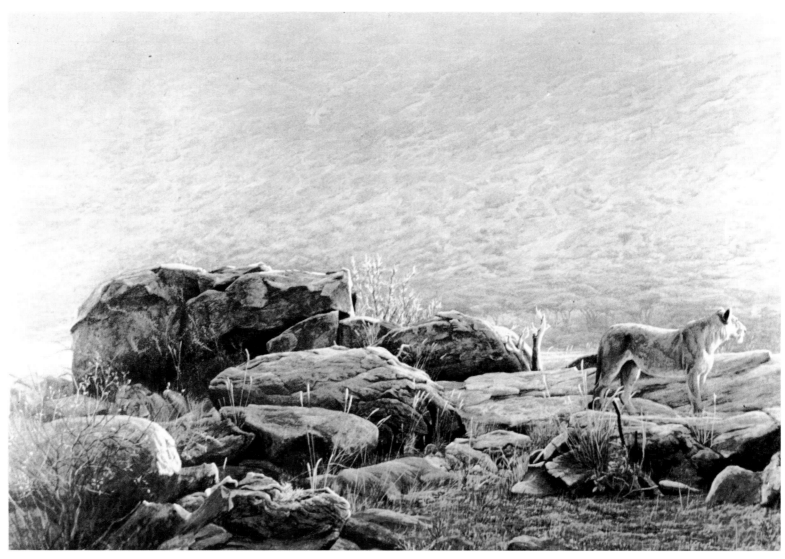

Pride of Lions, Samburu

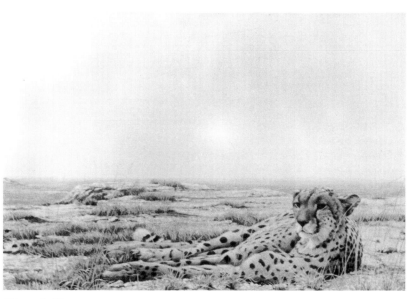

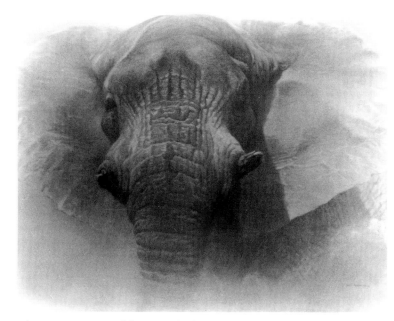

Cheetah Siesta

The Wise One—Old Cow Elephant

zoos and African safaris, finds elephants irresistible and he has painted them frequently. *The Wise One—Old Cow Elephant* [2], first shown publicly at the Smithsonian, is his most recent elephant portrait and also his most imposing. The towering, almost tuskless beast clearly shows the wear and tear of her years. Looking into the monumental face, one almost feels the hot breath of the beast and sees into the troubled soul of a species and a whole heritage. Africa and elephants have always been synonymous, but as we shall see in a later chapter, this is among the most endangered species in a continent of vanishing treasures.

Eurasia

Sweeping over the great wildlife panorama of Europe and Asia, one's eyes easily come to rest on two large, rare cats—the well-known tiger and the little-known snow leopard—that symbolize everything precious and beautiful in the diverse faunal wealth of the Eurasian realm. In *Tiger at Dawn* [3] and *Snow Leopard* [4], Bateman has given us heroic yet sensitive portraits of both of these magnificent animals, and to ponder them is to watch the panorama of Eurasia pass by.

Tiger at Dawn could be the emblem of a continent. In a single portrait it distills more effectively than words could ever do, not only the mesmerizing beauty and power of this legendary animal, but also the living natural heritage of Asia. Nature's largest cat still stalks the tall grasslands, swamps, and forests from Sumatra to Siberia, where it is a fearsome, unchallenged figure of stealth, unpredictable mien, and raw, almost demonic force. Like snowflakes, no two tigers look the same, owing to their limitless individual variations in striping and geographical differences in coloring. The king

Tiger at Dawn

of the big or roaring cats stalks its prey—often deer—alone and then rushes in for the kill. Best-known among the half-dozen races is the Bengal tiger of India, but the largest is the Siberian tiger, which has been brought back from the brink of extinction. The species and its habitats have been destroyed at an alarming rate. In less than a century, the many thousands of tigers that once occupied much of Asia have been reduced to perhaps as few as five thousand animals, of which maybe two thousand still live in the forests of India.

The elusive and mysterious snow leopard or ounce is one of the rarest and most endangered jewels in Asia's crown of animals. Though many do not know it, to those who do the

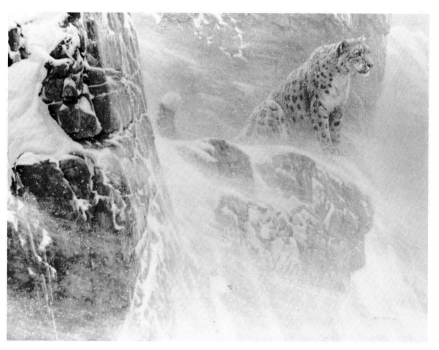

Snow Leopard

far below in spring-set pose. Out of the swirling snow emerges a creature of stunning beauty—a demure and entrancing beauty that belies the cunning, almost electric tenseness in the predatory drama suggested by Bateman's painting. One hopes such scenes will never disappear; as experts Rodney Jackson and Darla Hillard have written, "Without [the snow leopard] the high mountains of Asia would be like the African plains without lions . . . For now, the snow leopard is a living symbol of encouragement" (1986, 808).

North America

North America, including Greenland and Central America, is the earth's third largest continent. Stretching from the Arctic to the tropics, it is a land blessed with great north-south mountain chains and immensely varied landscapes that are clothed with fabled forests, grasslands, and deserts and inhabited by a remarkable wealth of bird and animal life. Much of the continent is well watered and luxuriant. Innumerable lakes, rivers, and seashores and a lavish array of wetlands enhance and endow the land. Bateman has painted a feast of species from North America's temperate and arctic wildlife heritage, doubtless the best known in the world, but his brush has stopped short of the tropical reaches, except for certain migratory birds. We are drawn naturally to some of his grander images depicting true symbols of the American landscape, from the large mammals—monarchs of the land—to the magnificent birds—monarchs of sky and sea.

Mammals

Bateman has a penchant for painting lords of the realm. None are more lordly than Mount McKinley, North America's highest mountain—now often given its Indian name, Denali—and the grizzly bear, one of the continent's largest and most magnificent animals. *Along the Ridge—Grizzly*

snow leopard is the quintessential high mountain spirit and unmistakable symbol of Asia. Few will ever see this large cat with the gorgeous, smoky, spotted coat, which stalks the snowy top of the world in central Asia. Shy and secretive, it passes its life between 6,000 and 18,000 feet in the rugged mountains of the Asian interior. The leopard descends below the treeline only in winter and may range up into regions of perpetual snow in summer, even though its main prey species, the blue sheep, generally lives below the permanent snowline in the alpine zone.

Bateman's almost mystical portrait, *Snow Leopard*, only recently painted and exhibited publicly at the Smithsonian for the first time, shows the leopard, with a tail nearly as long as the body, in its blustery, snowy element, watchfully presiding over its rarified kingdom and scanning the landscape

25

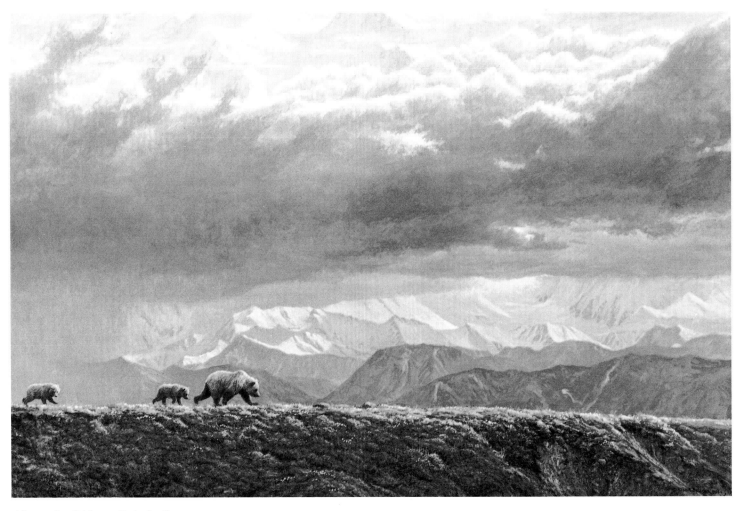

Along the Ridge—Grizzly Bears

Bears [back cover] juxtaposes bear and mountain in an awe-inspiring panorama of rugged power and beauty. Dwarfed by the towering, glacier-clad massif, the grizzly family tramping resolutely across the foreground tundra ridge, as on a stage, manages nevertheless to command the scene and dominate this unbelievable mountain, which in typical fashion is partially shrouded by vast banks of threatening clouds. More than any other, this heroic scene, posed in the heartland of the state and its great backbone, the Alaska Mountain Range, symbolizes and captures the essence of Alaska by uniting the elements of the three kingdoms—plant, animal, mineral—that so characterize her natural realm, namely

Awesome Land—American Elk

spacious tundra, majestic big game, and massive mountain ranges.

The grizzly, a kind of brown bear, once inhabited much of western North America, but human activity has caused a steady retreat. Except for enclaves in Montana and Wyoming, its remaining strongholds are in western Canada and Alaska.

In Denali (McKinley) National Park, a veritable natural zoo, the grizzly bear is a common sight on the lower mountain slopes, especially near Mount McKinley, where it nonchalantly roams the territory in undisputed reign. The luxuriant tundra meadows supply abundant diet of plant and animal food for the omnivorous grizzly in the active summer season.

27

Awesome Land [5], an equally epic portrait of Rocky Mountain wilderness, is a masterly evocation of the wildlife heritage—indeed, the natural heritage—of North America. The regal American elk, the most striking member of the deer family and second only to the moose in size, once was the most widely distributed, large, hoofed animal in North America; it roamed the temperate regions of the continent from the Atlantic to the Pacific and from northern Canada to northern Mexico. Today it survives only in the wilder parts of the West; in some places, particularly Yellowstone National Park, the elk population has outgrown its restricted ecosystem. Often called by its apt Shawnee Indian name *wapiti*, or "white deer," for its bleached winter coat, the elk is a legendary big game animal, important to the subsistence of the American Indians and early European pioneers and still highly prized by modern sportsmen. The elk is truly a wilderness animal, far more sensitive to human disturbance than deer and requiring a much larger foraging range.

In Bateman's midwinter scene, a small herd with five bulls, still crowned with their magnificent spreading antlers and displaying their bleached coats and dark manes, is moving across the snowy landscape before an awesome ecological stage of frozen lake, immense evergreen forest, and raw mountain mass. The restless elk transform an otherwise frozen tableau—a timeless, bleak, and seemingly lifeless winterscape—into a fleeting ecological drama of action and life. In another moment, the elk would have passed off the scene, leaving behind the endless mountain and the limitless forests. Time was, indeed, when this scene could have been painted almost anywhere along the 3,000-mile Rocky Mountain range and other mountains westward to the sea. The incomparable Cordilleran forests of mighty pines, spruces, firs, and other native conifers have been used by man and animal for ages; but these forests, like the wildlife they sustain, are finite, and they have been shrinking steadily through human activity since the white man first settled the West. In a real way, therefore, *Awesome Land* is symbolic; the majestic species moving across its stage is but a moment from passing into history.

Seeing a moose at close range in its native haunts in the north woods—especially a bull with its trademark antlers—can be one of North America's consummate wilderness experiences, provided the encounter is not too close. Eyeball to eyeball, as in Bateman's painting, a bull moose is a terrifying, unpredictable hulk, capable of unleashing reckless power. Moose lore is full of stories of bulls or of cows, defending calves, that chased unwary intruders up trees or into other refuges and kept them there for many hours.

The moose, though not uniquely North American, is esteemed for its singular place in the continent's cast of wildlife. A creature of the boreal forest, the moose, probably more than any other animal, symbolizes the vast northern wilderness of Canada and Alaska; to many, it is a sine qua non of the "north woods." Bateman's *Bull Moose*, having bulldozed its way through the underbrush and crushed headlong into the scene, splintering boughs and bushes in its way, stands glaring defiantly at the intruder. Whether as immovable object or irresistible force, it seems to block all passage, daring any comers to challenge its supremacy. As a counterpoint to the animal's primal force, Bateman has delicately painted, in the lower left and almost underfoot, the telltale leaves of the quaking aspen, another sine qua non of the boreal forest. These leaves, the bull's antlers, and the light snow on the ground are also telltales of the season— late fall or early winter, just after the first snowfall, Bateman informs us (1981, 96). Adding to the authenticity of the ecological setting is the shadowy conifer—spruce or balsam fir—darkly hiding behind the aspen trunks and the alder or other low shrubs on which the animal browses. Fortunately, there are still vast areas of boreal forest or taiga in the Northern Hemisphere where the moose can roam, and in North America alone upwards of a million or more animals are thriving.

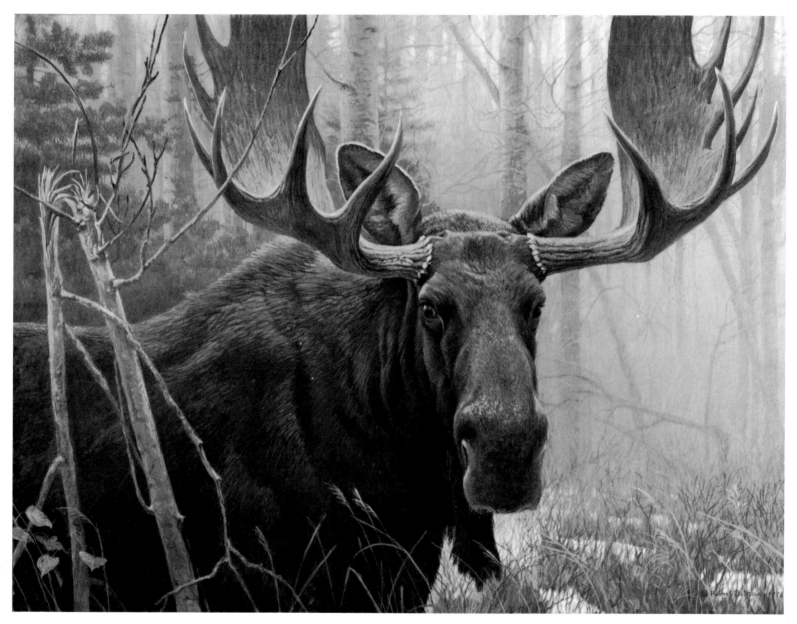

Bull Moose

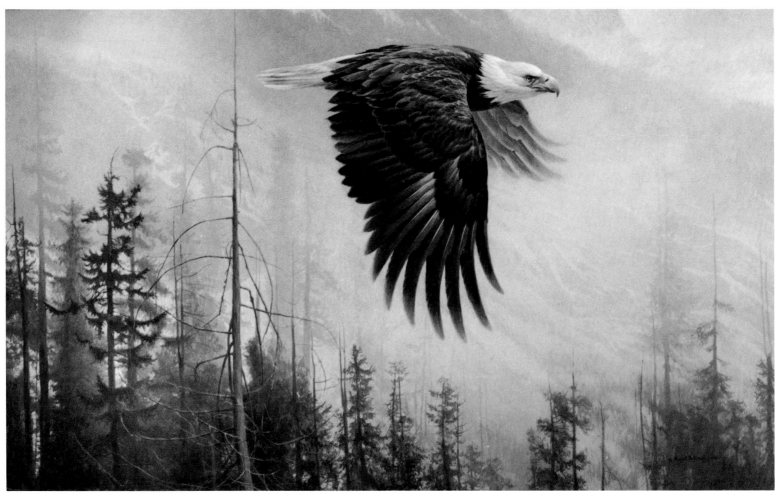

Majesty on the Wing

Birds

"The sky," Bateman writes, "is a great world, obviously greater in size than the earth's surface and far more dynamic in its movements and changes" (1985b, 116). The world of the air and sky is the world of birds. Birds have always captivated the human mind and elevated the human spirit like no other forms of life. Down through the ages, man has pondered the beauties and mysteries of birds, plumbing their scientific depths and penning numberless philosophical and lyrical poems in verse and song. As the outstanding nature writer Charlton Ogburn explains in his joyous book *The*

Adventure of Birds, "Birds account for a disproportionate amount of our perception of nature not only because their flight, song and colors make them noticeable but because they are nearly ubiquitous. . . . Of all the classes of animals, I believe that birds would be most sorely missed if they vanished" (1976, 66). The truth of this conviction was never more evident than in the shocked, worldwide reaction to Rachel Carson's now-classic *Silent Spring*, a vivid and poignant, if hypothetical, forecast of some future spring without the song and beauty of birds. It took an appeal to the feathered kingdom to alert a complacent society to the deadly perils of pesticides in the ecosystem and to spark urgent, almost desperate, efforts to halt the rapid slide toward extinction of many species of animals and birds, especially such magnificent crowns of the food pyramid as eagles, falcons, and ospreys.

Bateman's bird paintings, like his animal paintings, are a study in the mastery of portraying species in an ecological context and often in action. His poses and his settings even though dramatic, are real and believable. His subjects, if not in the midst of some obvious action, always suggest a behavior or ecological relationship. Because of his active and ecological style and his extraordinary skill, Bateman inevitably invites comparisons with John James Audubon, the legendary icon and father of modern wildlife painting. Although Bateman would eschew any comparisons with the unique, sumptuous work of the grand pioneer of bird and animal painting, in fact, Audubon, whose paintings now stand largely as elegant period pieces, comes off second best in a number of ways. Sometimes Audubon's birds are taxonomically more explicit and his backgrounds botanically more precise, but Bateman achieves a three-dimensional depth of field and integration of subject and setting never realized by Audubon. And the natural actions in Bateman's paintings contrast starkly with the stylized and often contrived or exaggerated action poses in Audubon's works. Bateman's birds are so lifelike that the viewer suddenly feels part of the scene and fully expects the bird to move.

Among the lords of the realm in the air that fascinate Bateman are the birds of prey, or raptors, and the waterfowl, especially the larger species, geese and swans. *Majesty on the Wing, Flying High, Winter Mist, Whistling Swan,* and *Across the Sky* are only a few of many fine bird paintings that reveal the biological authenticity, dramatic immediacy, and ecological power of his work.

With singular majesty and power, the bald eagle, North America's largest native eagle, symbolizes both a nation and a continent. Because it is widely recognized as America's flying emblem, this raptor more than any other single species around the world, carries the flag for the wildlife of an entire continent. In *Majesty on the Wing* [6] the eagle, as it reconnoiters, like a flying fortress, along some rugged coastal frontier, is depicted at the moment of maximum thrust in a downstroke of its mighty six-foot wing span that seems to be pushing down the whole earth and subjugating the misty mountain and giant evergreens beneath it. With every primary splayed out, the bird is a study in the anatomy of flight. Down through time many great minds, once including Leonardo da Vinci, have speculated on the marvel of the feather and the miracle of flight, whose evolution still remains largely a mystery. Despite its apparent invincibility, the bald eagle population has declined steadily across the continent, where it once ranged widely. As the work of Rachel Carson showed, the seeming invulnerability of sitting on top of the food chain proved all too sadly to be its very vulnerability.

The sky is the domain of soaring eagles, and *Flying High— Golden Eagle* [7] is a breathtakingly real, yet symbolic, panorama of this lofty realm—a restless and unbounded sea of ever shifting clouds and currents, fearsome, untamed forces, and wandering birds. Like a giant airship cruising over a cloud-cushioned abyss of space, the magnificent golden eagle—one of the grandest monarchs of the skies—navigates

serenely from sky to sky through the eye of a gathering storm. To such denizens of the air as swallows and swifts or falcons and nighthawks, the sky is a vast foraging ground, while to eagles and most other birds it is but a medium of passage or play or a transparent, floating platform from which to search and stoop for prey, sometimes at lightning speed. The golden eagle, unlike the bald eagle, which seldom lives far from coasts or major waterways, is a bird of the open country found nearly throughout the Northern Hemisphere in the inland mountains, canyons, and plains, including tundra and deserts.

Flying High vividly symbolizes migration, the great drama of the spring and autumn skies when countless birds of many species crowd the air lanes, hurrying north to their summer breeding grounds or south to their wintering grounds, often in the tropics. This timeless phenomenon has been a biological and evolutionary riddle of never-ending intrigue to scientists and laymen alike. Along such natural corridors as coastlines and great rivers or mountain ranges many routes coalesce into flyways, the interstate highways of the sky. One of the most famous autumn flyways, known to hawk watchers across America and even around the world, is along the Kittatinny Ridge in eastern Pennsylvania. Thousands of people converge every fall on the rocky, windswept promontories of Hawk Mountain to watch the often spectacular flights of hawks, eagles, and falcons as they sail by in ones and twos or by the hundreds, sometimes at close range, even below eye-level. Nowhere can the drama of migration be more convincingly witnessed.

Bateman's scene, in its every detail—down to the golden neck mantle that gives the eagle its name—might well be glimpsed at Hawk Mountain on any cold and windy day in late November. The artist depicts the menacing energy of the sky with brilliantly sculptured cumulonimbus clouds. So tangible are these thunderheads one can feel and hear the storm coming. As Bateman writes, "A rapidly building cloud looks far from soft and fleecy. It contains enormous energy, and can look as hard and nubbly as a giant cauliflower"

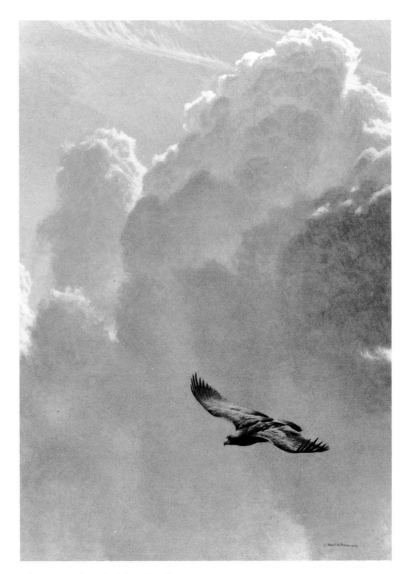

Flying High—Golden Eagle

(1985b, 116). The eagle seems to be fleeing the boiling banks of clouds, and, indeed, birds often migrate in waves before advancing weather fronts.

The great horned owl, sometimes called the "cat owl," ranges throughout the Western Hemisphere from the northern limit of trees in Alaska and Canada to the Straits of Magellan. In North America, it is not only the largest owl with ear tufts and one of the most powerful of all eighteen native species, but may also be the most nearly ubiquitous. Though a bird of many haunts, including deserts and urban parks, and though it often lives close to human habitation, the great horned owl is primarily an inhabitant of the forest, often the deep forest, where it is a deadly lord—a nocturnal terror—of the realm.

Winter Mist is a chillingly powerful portrait of the great horned owl brooding, tigerlike, over its forest domain. Bateman depicts the owl amid the leafless winter woods with such uncanny authenticity and realism that the beholder is mesmerized—almost spooked—by its terrifying authority, instinctively on guard for the lifelike bird to pounce. So commanding is its presence there can be little doubt about the owl's complete dominion over the woodland realm. Bateman not only captures the texture of the winter woods, but gives it further life and particularity by painting the owl's tree with the bark, buds, and curled dry leaves that unmistakably mark a beech in winter.

The glory and wealth of North America's wildlife heritage are richly declared by its waterfowl, as embodied so majestically in Bateman's *Whistling Swan, Lake Erie* and *Across the Sky—Snow Geese.* Of all the natural dramas staged each year across the continent, whether on land or sea or in the air, there is no more compelling spectacle than the cyclic wanderings of the great flocks of ducks, geese, and swans, so diverse in color and kind.

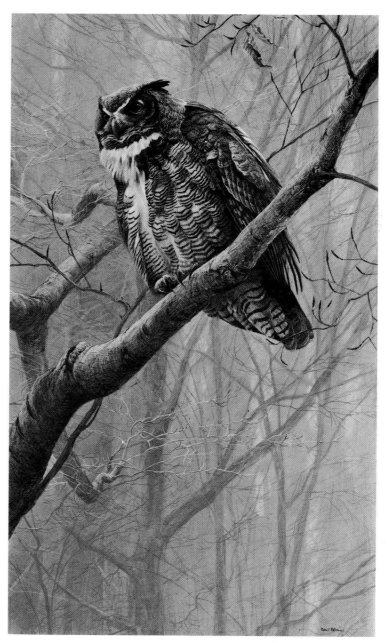

Winter Mist—Great Horned Owl

Most of the fifty-some species of waterfowl regularly migrate, in spring flying to the northern parts of the continent to breed and in fall flying to the southern coastlines, bays, estuaries, and open inland waters to pass the winter. Upwards of a hundred million birds, adults and young, may return from the breeding grounds each year. In winter and in migration, many of the species are gregarious and congregate in wetlands and waterways in mixed flocks by the hundreds, thousands, or tens of thousands. Winter concentrations along the southern coasts and in such famous wintering grounds as the Chesapeake Bay region can be staggering and can keep the naturalist or sportsman transfixed with wonder and excitement. The seething, moody flocks—ever flying to and fro and changing in size, composition, and behavior—can treat the patient observer to a kaleidoscopic, real-life cinema of nature. Full of surprises, it may reveal at any moment, for instance, yet another untallied species, perhaps a very rare one. The mere promise can hold the observer's rapt attention to the shifting scene for hours unending, even in the foulest weather.

In spring and summer, the great winter concentrations of waterfowl disperse northward to nest in relative solitude, fanning out two-by-two through untold wetlands across the entire continent, in the case of some species to the very limit of land or even beyond to Greenland and islands of the High Arctic. Each year the continent is cradle to millions of young, largely in the immense region from the pothole prairies of the north-central states to the tundra of Alaska and Canada. As soon as the birds hatch, the families begin to collect on the myriad bays, rivers, lakes, ponds, and potholes. The species return to more social ways while parents and young prepare for the perilous journey south, past the fall gauntlets of gunners who lay siege to their flyways and ultimate destinations. Fortunately, some safe haven is provided along the way in a strategic network of protected sanctuaries.

Bateman's *Whistling Swan, Lake Erie*, a stark yet grand panoramic portrait of one of North America's most regal and beloved birds, is a study in simple grace and beauty that also tells an ecological story. Swans are the largest of the waterfowl on the continent, and this, the smallest native species, is the most common, with a population believed to number a hundred thousand. Lewis and Clark first discovered it on the Columbia River and named it the "whistling" swan, apparently for a mistaken reason. Its correct common name is now "tundra" swan, which alludes to its nesting on the tundra and barren grounds along the coasts of the Bering Sea and the Arctic Ocean of Alaska and Canada.

The tundra swan winters in large concentrations along both the Atlantic and Pacific seaboards of the United States. On the east coast, it concentrates in the Chesapeake Bay country. When, in early spring, the swans suddenly take leave of their winter home around the bay, they fly northwestward to arctic summer homes in northwest Canada and Alaska on a flight path that takes them over Lake Erie. We learn this from the radio-tracking studies of waterfowl expert William Sladen of Johns Hopkins University, whose research also shows that Lake Erie is the first of several main stopovers for one or more days of resting and feeding during the long, arduous flight to the arctic tundra.

Bateman, perhaps unwittingly, vividly portrays a part of Sladen's story, with the migrating tundra swan on its early spring stopover along the tundralike shores of Lake Erie, still brown and bleak from winter. Like a giant airliner, a comparison that Bateman himself invites by painting a faint jet contrail in the sky, the barely airborne swan, with mighty wing-thrust, labors at maximum power, though artfully, to gain altitude. It is tempting to imagine that this handsome leviathan of the sky, rested and "refueled," has just taken off on the second leg of its journey northward from the Chesapeake Bay. The shrinking windrows of icy snow, signaling winter's retreat, suggest a day in March.

The vapor trail, Bateman tells us, suggests the "faintly disturbing presence of man" (1981, 68). Though nature clearly dominates in this scene, the overflying jet seems sadly

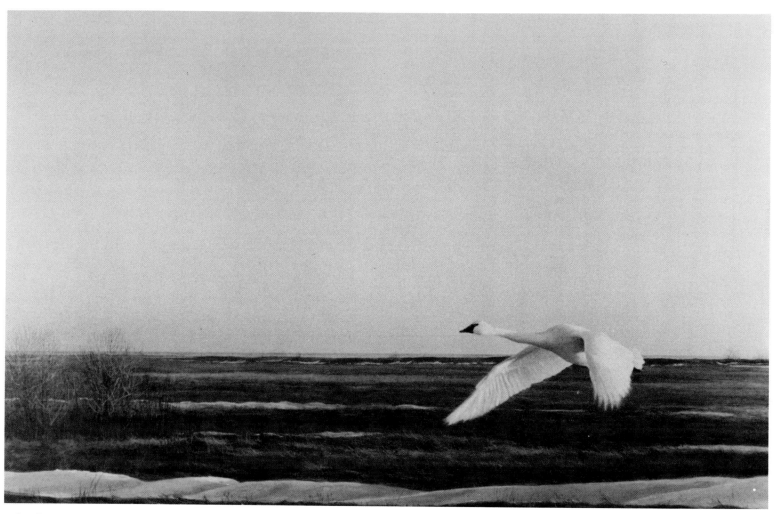

Whistling Swan, Lake Erie

symbolic of man's domination and desecration of nature that one day may spell the end of such magnificent sights as this. Here the imitated, nature, clearly mocks the imitator and the imitation, man and his airplane, but only because the artist has given the swan the upper hand.

Marshes, especially great marshes, can be places of thrilling pandemonium when they come alive with waterfowl in winter or during spring and fall migration. To the fowler in his blind or the naturalist stalking the borders, the scene is one of constant action and excitement. Without warning, as

35

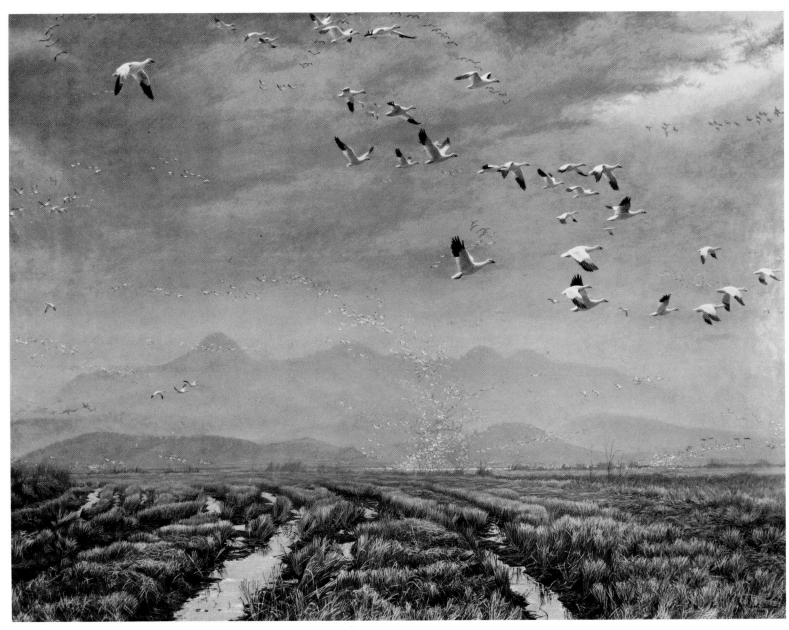

Across the Sky—Snow Geese

though on cosmic cue, whole sloughs may explode with a thunderous whir and blur of wings; in a synchrony of flight that defies imagination, flocks flush from one corner of the marsh only to drop into another. Overhead, stretching upward and to the horizon as far as the eye can see, the sky becomes a sea of commotion, filled with layers and layers of wheeling, churning, crisscrossing flocks, ceaselessly drifting or careening back and forth across the marsh. All the while, singles and small groups randomly trace the sky as they dash hither and yon. One moment the marsh is utterly chaotic, the next, a veritable symphony in the sky. Sometimes hordes of chatty ducks and geese flood the air with a deafening, if joyously exhilarating, cacophony of quacks and honks.

Of all that the marsh can offer, nothing exceeds the thrill of a sky full of snow geese. Between fall and spring, the scene can be witnessed at various places over the marshes on both coasts. In the salt marshes of the central Atlantic Coast, snow geese crowd the sky in unreal numbers—tumultuous, undecided flocks madly swirling like a snowstorm; phantom clouds of shimmering, silvery-white specks winging far up in the blue, illusory as whitecaps on the sea; resolute skeins and formations that seem to fly by forever, all headed in the same direction. Such a vast tangle of strands against a brilliant blue backdrop suggests scribbling on the sky by some mighty hand. Great flocks may touch down in the marshes or on the bays and inlets with choreographed precision or tumble from the skies like falling snowflakes. In bright sunlight, their black and white feathers may blend to make a descending flock look like countless grains of pepper floating down from the sky.

Bateman's *Across the Sky* [8], based on a firsthand encounter on the bird's wintering grounds in northern California, palpably captures the ecological energy and emotion, the sheer excitement of the marshes in snow goose season. In his own evocative language, Bateman compares the scene to "dancers swirling veils in arcs through the air," adding that he "wanted to depict . . . that feeling of a layered, moving atmosphere and the way the endless flocks in the mist created a vast architectural structure out of the air" (1985b, 94). Bateman teases the viewer by suggesting "a good birder" might spot a Ross' goose, white-fronted goose, sandhill crane, or white-tailed kite among his milling snow geese.

Across the Sky is symbolic not only as a panorama of the North American marsh and its waterfowl in season but also as a portrait of the continent's natural wildlife bounty. From prehistoric times, ducks and geese were wild-game staples in the diets of the American Indians and Eskimos. Waterfowl also provided subsistence food for the early European settlers, who stood in awe of the great flocks and the seemingly limitless abundance of game on a continent with limitless frontiers. Waterfowl were part of the native bounty for which the Pilgrims first gave thanks, and since that day they have always epitomized the abundance of wild game in North America. The vast flocks on the wintering grounds and during migration were deceptive, however, because of the seasonal concentrations. Thanks to today's protective laws, scenes like Bateman's *Across the Sky* are still common, although the flocks will never again match those of aboriginal times.

Great Blue Heron

2

Nature's Landscapes:
Wildlife in Its Biomes and
Habitats

Just as wildlife species can symbolize whole continents, so also can they characterize the biomes and habitats that constitute a continent's hierarchy of biotic, ecological, or wildlife landscapes. We have seen how some of Robert Bateman's paintings are panoramas, portraits, or, indeed, panoramic portraits that evoke the wildlife heritage of continents. If, with our cosmic lens, we now zoom in for a closer look at the ecological structure of the earth, narrowing our focus from the continents to their constituent landscapes, we find the earth's surface resolving itself into an architecture of biomes and habitats. Again, Bateman's paintings provide us with portraits of many of these landscapes—landscapes of nature or *naturescapes,* one might call them—a few of which we will examine.

Robert Bateman never paints landscapes as such. However overshadowed by the land the portrayed birds or animals may seem to be, his paintings nearly always shed light on the natural place of the wildlife in the structure and texture of nature. Even when wildlife is not part of the scene, the landscapes have a naturalistic intent. His landscapes, then, are really naturescapes that delineate the biotic and ecological face of the land. His images tell something not only of the lives of the animals and birds depicted but also of the ecological realms they inhabit—the habitats and biomes they occupy and, in part, characterize. Bateman, when he chooses, also has a way of introducing a hint of man and his influence on the ecological order without preaching and without shattering the mood and beauty of the wild.

The animals and plants—fauna and flora—of an area or region constitute the biota. Every plant and animal has a favorite place or type of place to live, and this home is its *habitat.* For plants, which are sedentary, the habitat is a particular growing site or type of site with relatively uniform environment. But for animals, which move around, the habitat is a territory or home range that can be quite large. In the case of migratory species, it can include both summer and

winter or dry season and wet season homes, as well as the routes in between. For animals the notion of "habitat" is much more relative than for plants.

Within major habitats, plants and animals live together in biotic or ecological communities. Though habitat as the place and community as the relationship provide two distinct perspectives on nature, these concepts are often almost interchangeable when used in generalized reference to types of nature. A *biome* is a biotic community on a grand scale—a regional type of nature that defines itself by its most characteristic plant *and* animal life.

In this section, these terms are used rather informally, but the intended nuances and perspectives should be clear from context. Four of the major categories of the section illustrate major biomes or, more accurately stated, types of biomes—Forest, Tundra, Grassland, Desert. They are super biomes of a sort. The three other categories illustrate habitats more than biomes—Wetlands, Coasts, and what I call "Habitat Closeups."

The face of the continents is clothed with a patchwork of forest, grassland, and desert. (Tundra is a special kind of cold-climate grassland.) In round numbers, each occupies about one-third of the earth's land surface. More precisely, forest and grassland each cover somewhat less than a third of the land, and desert, including semidesert, covers somewhat more than a third. In prehistoric times, before man had altered the land so dramatically with his agriculture, the ratio of forest to grassland to desert undoubtedly was different. Climate largely determines the type of vegetation: Desert occupies the most arid regions of the world, forest the least, with grassland falling in between. In general, the warmer the climate, the higher the rainfall must be for forest or, failing this, grassland to form. Thus, a hot tropical climate with high annual rainfall may produce a desert or grassland, while a cold temperate climate with low annual precipitation may produce grassland or forest.

Forest

Robert Bateman has spent most of his life in forested regions, and not surprisingly he is an enthusiastic partisan of the forest biome. Many of his images are drawn from the forest, its edges and clearings, and together these images evoke the ecological drama and diversity of the forest. Indeed, as the variety of Bateman's paintings suggests, this super biome is in fact comprised of several biomes, each with its own story to tell.

Primeval North America was grandly clothed in forest—a seamless virgin forest of many types and textures. The thick, verdant blanket of trees, so rich in form and variety, stretched from sea to sea and from the tundra to the tropics, save for the great prairies of midcontinent. It was a forest of forests that, in the words of nature writer Donald Culross Peattie (1966, ix), "staggered the belief" of the first Europeans who set foot on American shores. They could not have dared to imagine its limits or its wealth—to comprehend its challenges and its lurking dangers or to explain its wild and compelling appeal. Indeed, it was the forest that gave the name to America's Keystone State, "Penn-sylvania" or "Penn's woodlands."

Human existence is impoverished and difficult at best without trees. Trees condition the atmosphere and the soils, shield from the sun, regulate water flow and storage, stabilize land and prevent erosion. Trees clothe, feed, warm, cool, and shelter people by providing food, fiber, fuel, and safe haven. Trees yield timber, medicines, dyes, resins, and paper, and they have enabled man to build houses, publish newspapers, sail ships, drive automobiles, fly airplanes, and, alas, to fight wars. Above all, trees and forests beautify the land and bring peace of mind; their beauty and majesty uplift the human spirit and have inspired art, music, literature, philosophy, and religion. The mysteries of the forest have challenged scientific minds for ages.

Much of North America's rich wildlife heritage is inseparably linked to the forest. The primeval forest encountered by

the first European settlers was teeming with birds and mammals that provided the Indians with bountiful game, furs, and skins for their welfare. The new colonists quickly began to cut down the forests and to exploit this wildlife bounty, especially through fur trading, and thus began the long, sad decline of the North American forest biome that continues inexorably today.

The forest is not a monolithic biome across the continent, but a grand composite of greater and lesser forest types, all with their own personalities. From the pine woods of New Jersey to the redwoods of California, from the taiga of Canada and Alaska to the swamp forests of the South or the incomparable deciduous formation of the Appalachians—the forests all show, to those who make their acquaintance, wonderful individuality in their historical development, climax communities, and roll calls of native fauna and flora. The naturalist or the artist gets to know the forest only by getting to know the many plant and animal inhabitants by first name. Only then do the seeming monotony and the sometimes awesome formidability of the forest dissolve into a colorful variety of species and an intriguing harmony of relationships. The dim halls of the woodland wilderness, once strange and threatening, suddenly become familiar and friendly—joyful studios and laboratories for artist and naturalist. The trees of the forest, in human terms, represent ageless continuity, giving them an enviable intimacy with history.

Boreal Forest

The most northern forest in the world is the taiga. It is a vast coniferous forest that spans the circumboreal land surfaces of the globe in an almost unbroken sweep from Labrador to Alaska and from Siberia to Scandinavia. The taiga, usually called the boreal forest or the northern coniferous forest in North America, is the only forest to form a continuous belt around the globe. (Tundra and taiga are the only continuous global biomes on earth.) Often dominated by spruce, boreal forest develops under cold, moist climates that are only slightly less harsh than in the tundra zone. Two-thirds of the boreal forest are in Eurasia, mostly in the Soviet Union, especially Siberia, where the taiga forms the largest forest in the world and constitutes about a fifth of all of the earth's forests. Everywhere the boreal forest is carpeted with mosses and lichens, sometimes a mere crunchy crust underfoot but often a plush spongy cushion. Everywhere, also, there is water, and much of the boreal forest is wet underfoot. Because of the generally low relief and almost universal glacial topography, the boreal forest region is a land of countless lakes, bogs, muskegs, and slow meandering streams.

Typical resident wildlife of the northern coniferous forest biome in North America are the moose, caribou, black bear, wolf, Canada lynx, beaver, snowshoe hare, marten, spruce grouse, raven, and great gray owl. Each spring and summer, the boreal forest comes alive with millions of songbirds that return here from neotropical regions to nest, including many warblers and other of the hemisphere's most colorful birds. The myriad lakes, streams, and wetlands are famous nesting grounds for many species of the continent's shorebirds and waterfowl.

Robert Bateman, as we have seen, is partial to the boreal forest and its wildlife. He is especially fond of owls and has painted several of them, some more than once. Among his owls—barn, barred, elf, great gray, horned, screech, short-eared, snowy—his great gray owl, *Ghost of the North*, is particularly lifelike and evocative of the boreal forest realm. This species is imbued with a double portion of the mysterious aura of owls.

The great gray owl is a superb emblem of the boreal forest's ecological intrigues and paradoxes and a peerless example of the fitness of its creatures. It is an authentic element of this biome nearly throughout, ranging widely in

the taiga of Eurasia, especially eastern Siberia, and in the boreal forest of North America, particularly northwestward from Hudson Bay to central Alaska. The great gray owl, its large size and habit of hunting by day notwithstanding, is one of the most elusive and secretive dwellers of the boreal forest if not of North American forests generally. So seldom are its coming and goings noticed that it has the reputation of being a phantom or ghost, earning it the apt and picturesque sobriquet, "spectral" owl. It is a tribute to the great gray owl's natural camouflage and highly adaptive structure and behavior in the ecosystem that this aerial predator with a length of up to 30 inches and a wingspan of up to 5 feet can be so transparent or invisible in the boreal forest.

With uncanny insight and fidelity, Bateman has captured the essence of the owl and its typical haunt in *Ghost of the North*. Amid the twiggy, leafless branches of an old and weathered quaking aspen, one of the owl's favorite nesting trees, the spectral form of the great gray owl blends so well with its subdued, almost ethereal surroundings that it seems but an organic extension of the tree itself; standing beneath it one might easily overlook the owl in the tangle of branches. While it might seem intent on keeping track of the human intruder, more likely it is fixing its sight and auditory gaze on its next meal, some unwitting mouse poking about within range, perhaps even under the snow into which the owl can dive, ternlike. The overstuffed size and seemingly awkward proportions of the owl mask its supreme fitness for the boreal forest environment and give it a severe, understated beauty that is symbolic of the beauty and fitness of the forest itself.

Though typically secreted in the dense spruce and tamarack forests, muskegs, and bogs, the great gray owl also frequents sparsely wooded clearings and edges where aspens may dominate, as here in Bateman's winter portrait. Ecologically, the quaking aspen is a successional tree that quickly follows the clearing of the coniferous forests by human activity or by such natural disturbances as fire, but in its ecological place it is as characteristic of the boreal forest biome as the conifers and the owl.

There is no more fitting summary of this enigmatic avian caricature and its place in the forest biome than the eloquent words of Bateman's fellow Canadian, the naturalist Robert Nero, writing in his lyrical book *The Great Gray Owl— Phantom of the Northern Forest*: "A bird of mystery, the great gray owl bears in its aloofness some of the remoteness of the vast northland; its plumage the color of lichens and weathered wood; its soft hooting, part of the wind" (1980, 57). Is it rare or threatened? Who can say for such an elusive bird? Nero estimates as many as fifty thousand great gray owls in North America, but what does even so large a number mean over millions of acres of forest?

A common link among many of the forest types of the continent is the evening grosbeak, the happy wanderer of the North American forest biome. This stocky, starling-sized finch, with an outsized bill sturdy enough to crack cherry pits, lives and breeds in much of the northern and western coniferous forest belts. The winter range of the evening grosbeak extends into southeastern Mexico, across the plains, and nearly throughout the deciduous forest region of the eastern United States. Winter migration is irregular and unpredictable, related to the availability of food; like some other finches, the evening grosbeak turns vagabond especially when its normal staple of conifer seeds is in short supply because of a poor or failed crop. Some years, waves of grosbeaks move eastward and southward from the coniferous belt—even westward from eastern Canada—into the wooded margins and groves of the plains and the winter woods of the East. Here noisy flocks of this gregarious bird spend the winter roving about looking for seeds. The seeds of the boxelder, a maple, and the tulip poplar are especially favored, and when a flock descends on one of these trees it is likely to "camp" there or stay nearby until the tree is stripped.

In *Evening Grosbeaks*[9], Bateman depicts the birds perched on a weeping spray of the speckled twigs of a white birch ladened with seed-packed catkins. The scene is early winter,

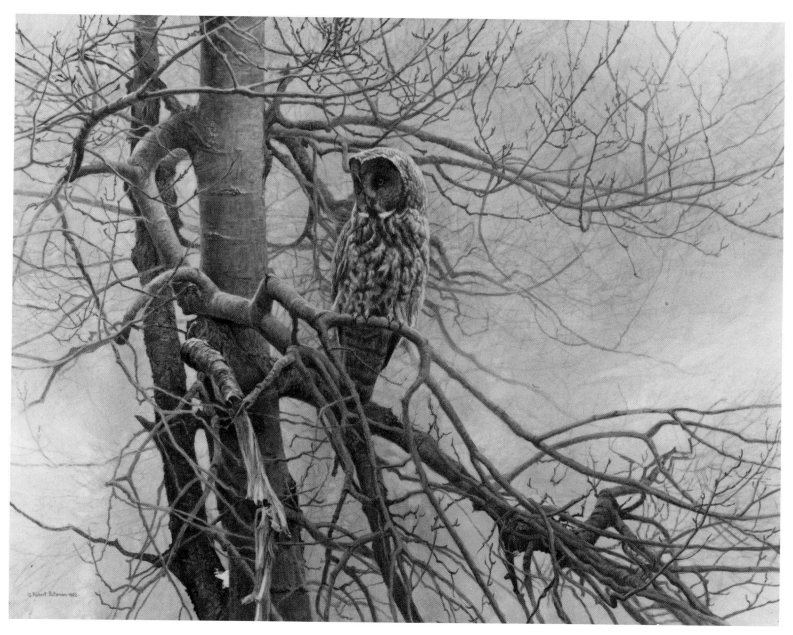

Ghost of the North—Great Gray Owl

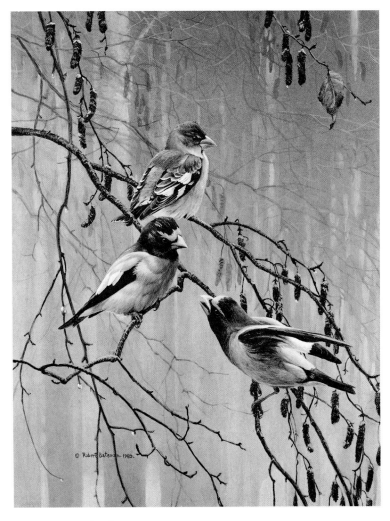

Evening Grosbeaks

one of "those cool, moist days before the first real snowfall" (Bateman 1985b, 137). They are chatting, we might suppose, about their lucky find—a tree that still holds its seeds. These seeds are vital winter food for pine siskins, redpolls, and other finches, too. The evening grosbeak is basically a yellow

bird with a black tail and black-and-white wings. A king-sized goldfinch painted in banana yellow and rich old gold rather than bright lemon yellow, it adds a warm golden glow to the somber winter woods and an exotic splash of color to the homogeneous green of its coniferous haunts. But the bird would be unknown to most people were it not for its winter habit of visiting bird feeders across the continent. At the feeder, the birds are quite social and chatty, and the strident calls of a whole flock blend to sound like so many whirring wheels at a roller skating party.

The white or paper birch is a ubiquitous component of northern forests, both deciduous and evergreen. It is a storied tree of many life-sustaining virtues for "man or beast," as Peattie puts it (1966, 167). Most notable is its long use by the Indians for birchbark canoes and snowshoe frames. As a source of food for wildlife, apart from the seeds, its slender twigs provide winter browse for deer and moose and the inner bark, delectable nibbles for beavers.

Cordilleran Forest

The great Cordilleran forest of western North America is the richest coniferous forest of the continent and probably on earth. Stretching from the eastern foothills of the Rocky Mountains to the shores of the Pacific Ocean and from the mountains of central California to the northern limit of trees in Pacific coastal Alaska, it is, in fact, not one uniform forest but many forests—a diverse array of distinct but ever variable forest types and transitions and floras and faunas.

The Cordilleran forest has many superlatives to offer. The whole world knows about the ancient big tree groves of the Sierra Nevada and the forest of giant redwoods—the world's tallest trees—in northern California. But for sheer luxuriance and grandeur the lofty forest of the Pacific Northwest is second to none anywhere on the globe. Here the great halls of the forest are muted. Greenery grows everywhere, and everything is a shade of green. Luxuriant growths of mosses

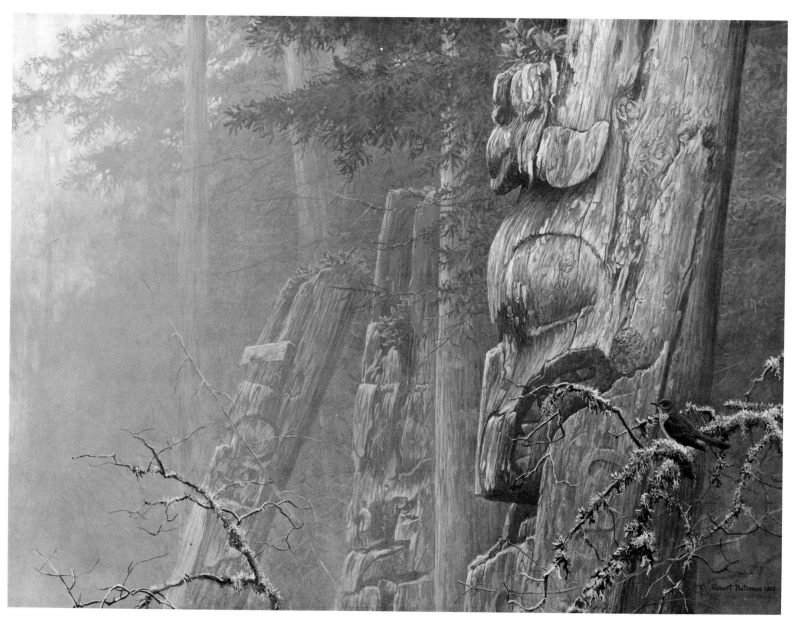

Spirits of the Forest—Totems and Hermit Thrush

45

and lichens form a spongy carpet underfoot, and they felt and festoon every branch and twig of the forest, dead or alive. It is that rare terrestrial biome where the lower plants are able to rise from the forest floor and vie with the higher plants for attention. The Pacific Northwest forest reaches its zenith on the Olympic Peninsula in the state of Washington, where it has often been called a temperate rain forest.

Bateman's *Spirits of the Forest—Totems and Hermit Thrush* impressively conveys something of the awesome scale and the serene splendor of the northwest forest. It is an exquisite distillation of the forest's ecological reality, environmental mood, and spiritual feeling. Like the pipes of a great organ, the totems set the scene for the avian concert underway in this natural cathedral. The totems and the moss-cushioned "pews" set a tone of hushed reverence, and the singer is one of nature's grandest—the hermit thrush (foreground and background). This unprepossessing bird begins its beautiful flutelike song on the scale where many birds quit and rises to stratospheric heights of ecstasy. Though belonging to a family of noted songsters, the hermit thrush is supreme. Because it sings mainly at dawn and dusk in its northern or mountain summer home, few ever hear it, but counting all seasons, the hermit thrush qualifies as a nearly ubiquitous forest dweller, and virtually anyone on the continent can know it. To hear its ethereal, liquid tones come floating through the deep forest is to be transported, as the artist was when he visited the scene (on the Queen Charlotte Islands off the coast of British Columbia) and heard "ringing through the trees . . . the delicate song of a hermit thrush" (1985b, 126). The hermit thrush in the foreground, dwarfed into insignificance by the mighty totem, would seem to do little more for the scene than provide scale for the forest. But to those who know it and the joy of its song, the thrush imparts ecological harmony and melodic beauty to the scene. One might fancy the giant totem as the thrush's flute, standing on end.

Carved by Indians, the totem poles stand where they were first erected, with the forest that once gave them up now slowly taking them back. Testimony to the ageless kinship of forest and man, they preside with an uncanny hint of animation that elicits an uneasy self-consciousness and adds to the faint sense of foreboding that always emanates from the dimly lit recesses of the tall coniferous forest. About the "great carved totem poles of the Pacific Northwest," Bateman has this to say: "The real world was abstracted by these Haida Indian artists with as much sophistication as was shown by Picasso. . . . The images carved on these poles are of totemic animals and spirits that represent family heraldry. . . . I have shown a totem pole with the image of an orca or killer whale" (1985b, 126).

Deciduous Forest

The ancient Appalachian Mountains, stretching from the Gaspé Peninsula to northern Georgia, are the epicenter of one of the most extraordinary vegetation formations on earth—the deciduous forest formation or biome. Deciduous or summergreen forest is also found in central Europe, the Caucasus, eastern Asia, and in limited parts of southern South America, but nowhere is it so highly developed and renowned as in eastern North America. Here it is a forest of many manifestations and distinct seasonal aspects, and in one or more of its manifestations it occurs throughout the entire eastern United States (except peninsular Florida) and adjacent Canada. It is an epic forest, the historic soul of the American wilderness, famed for its geologic history of repeated change and migration in the face of continental glaciers; its human history of Indians, frontiersmen, pioneer immigrants, and modern inhabitants; and its natural history of floristic and faunistic riches, including great timber and game stores, and legendary tales about their exploitation and squandering.

The deciduous forest differs from the other forest formations of the continent in being dominated by hardwoods rather than conifers and in showing much sharper seasonal

Woodland Drummer—Ruffed Grouse

changes. Registering the four seasons more dramatically than any other biome, the deciduous forest is characterized by trees that lose their leaves each autumn and gain new ones each spring. The annual cycle is—spring leaf-out, summer green, fall color and leaf drop, winter dormancy. In summer, the trees manufacture food in their leaf factories at a furious rate and ship it down to the roots. This energy store is the battery that starts the engine again the next spring and keeps it charged until the new leaves are able to take over. Fall colors are fabled, particularly in regions with maples to set the woods aflame with fiery reds and oranges. The leafless winter woods has its own special charms. The trunks of the trees stand out in stark relief, displaying a forest of bark landscapes of a thousand different patterns of smooth and sculptured relief. Spring in the deciduous forest is marked by a special herbaceous flora of colorful sun-loving plants, adapted to rush through their reproductive cycle before the canopy closes over and shuts out most of the vital sunlight.

The rich natural heritage of the deciduous forest biome, as of any biome, obviously cannot be symbolized by a single scene or species of wildlife. But Bateman's *Woodland Drummer—Ruffed Grouse* [10], depicting a male in its trademark

act of courtship, brings this biome to life in a delightful way. Many take notice of the deciduous forest in spring when the forest is experiencing its annual rebirth, and they do not think of one apart from the other. It is appropriate, therefore, to characterize the forest with the spring, as Bateman does in this painting. The vernal aspect of the forest is apparent from the soft fresh greens, from the warm flood of filtered, early morning sunlight that comes streaming through the still-open canopy to illuminate the pulpit of the bird, and from the fact that the grouse is still courting. The chickenlike ruffed grouse, garbed in the earth tones of bark and dried leaves, is one of the most wide-ranging and popular game birds of the North American forest. In the deciduous forest it is found in the northern regions and south from the Gaspé to Georgia in the Appalachians.

Bateman has painted a convincing scene of the type of wild, rocky, wooded terrain where the ruffed grouse is most often encountered in much of its rugged, mountainous Appalachian range. The very exuberance of the early spring morning is palpable. The male grouse, in one of nature's quaintest and most famous rituals, has mounted his territorial log to "drum"—to announce his territory and his general availability to all females by cupping and beating his wings so fast that only a fast camera shutter can stop them. Starting slowly and discretely he builds up to a rapid thumping of indistinguishable beats (up to 20 strokes per second) that then quickly decay into silence, the whole process soon to be repeated. The drumming—felt as much as heard—seems to serve the behavioral purpose of song in other birds. The ruffed grouse is the percussion section of the woodland orchestra.

Probably no forest biome of temperate North America has been so modified by human activity as the deciduous forest, very little of which remains in its original state today. The ruffed grouse, denizen of the wilder regions of the remaining forest, is a welcome bellwether of still viable wilderness. Its drumming is the heartbeat of a healthy forest.

Bateman's vignette illustrates several other features of the deciduous forest. It is a forest community of layers or stories—ground layer, shrub layer, and tree layer. The trees form the canopy. Often there is an understory of tall shrubs and sapling trees just beneath the canopy. In *Woodland Drummer*, the shrub layer is quite obvious, and in the ground layer one can identify polypody, a common fern that grows on rocks. Bateman also portrays another common element of the deciduous forest: the conifer, with its bole mostly hidden behind a foreground trunk. From the small spray of needles it appears to be a white pine or possibly a hemlock, both widely present in the deciduous forest formation.

Tundra

Tundra develops in arctic and subarctic regions and in the alpine zones of high mountains of lower latitudes. Along with grasses, the vegetation is dominated by sedges, mosses, and lichens, usually interspersed with barren areas. In the High Arctic, the more or less continuous heath gives way to a cold rock desert of scattered grasses and herbs and eventually to nothing but barren ground. So the tundra biome is really a special case of the grassland biome—a vegetation formation sharing many of the same traits of grassland and the same genesis but lacking the bona fides of true grassland in other basic respects, especially in its frequent lack of continuous grass cover.

Arctic tundra forms an irregular but contiguous, circumpolar zone, sandwiched between the boreal coniferous forest and the polar barrens and icecap. Alpine tundra, on the other hand, comprises enclaves of the Arctic outside the Arctic, which have gained by altitude what they have lost by latitude—though not quite. This tundra, forming a belt between timberline and rocky peaks or permanent caps of ice and snow, is fragmented into a thousand parcels held in common by all the higher mountains of the world. The highest mountains of temperate latitudes can produce some fancy imitations of arctic tundra but never surpassing the

best that the Arctic itself can offer. Further commentary here refers only to arctic tundra, as is customary in discussions of this biome. The tundra biome rings the top of the globe, occupying about ten percent of the globe's surface.

Anyone who sets foot anywhere in the Arctic notices first and foremost the complete absence of orthodox trees. Although many woody plants may be present, they are nothing more than shrubs, usually dwarfed and hugging the ground, except in the Low Arctic where an occasional patch of tall willows and alders—perhaps twice the height of a person— might grow in sheltered gulches or on river bars and banks. This treeless, prairielike vegetation is "tundra," from the Finnish word meaning "treeless rolling plain." Much of the immense tundra region is flat or low rolling plain.

Beneath most of the tundra the ground is permanently frozen, except for the few inches that thaw out each summer. Coupled with the often flat land, this permafrost, which may be only a few feet or many hundreds of feet deep and in parts of the Arctic nearly a mile deep, blocks drainage and runoff. It also blocks the penetration of roots and undoubtedly is responsible in large part for the lack of tree growth. Bog soils develop, and everywhere the tundra is wet, packed with innumerable lakes, ponds, and pools and laced with ribbons of meandering streams. Differential annual freezing and thawing gives rise to patterned ground and a tussocky or hummocky microrelief. Indeed, in many respects the tundra is like a gargantuan, worldwide bog.

The tundra can be very cold and very barren, but it is by no means a lifeless place. Abbreviated though it may be, the shirtsleeve summer that comes to much of the tundra region permits a remarkably diverse and luxuriant seasonal growth of plants, which in turn supports a surprising variety of breeding birds and animals. Tundra meadows suddenly turn from winter's brown to summer's green and burst into colorful flower gardens. Tiny, prostrate willows soon poke their mature catkins barely a thumb's length above the mat, the better to disperse their seeds. Dwarfing is the universal tundra motif as plants make themselves scarce to the harsh elements

by reducing their surface area to the biological minimum. The plants have done away with every vegetative flourish that the life cycle can spare, retaining little more above ground than the inflorescence of blooms, which may be reduced to a single flower. Consequently, the flowers themselves often take on exaggerated prominence; the tundra's diminutive wildflowers make up for this insignificant stature with captivating beauty and adaptive ingenuity.

The rigors of the environment have greatly limited the *resident* animal life of the tundra biome. Among the famous animals, the wolf or gray wolf, as it more properly is called, is a symbol of the Arctic that always commands respect and not a little fear and awe. In the annals of man and nature the legendary wolf, among all of the Arctic's wildlife, has occupied a singular place in the heart and mind. The very soul of the north, this premier predator of the realm sits at the pinnacle of wild creatures, the most authentic and authoritative embodiment of the entire northern biota.

Robert Bateman understands the animal's mystique and strange power and he has often painted wolves with a consummate touch of reality and pathos. Keenly perceptive and sympathetic, his paintings are charged with feeling, variously depicting mood and activity—innocence and cunning, relaxation and readiness, ease and tension, indifference and excitement or curiosity. He has portrayed the solitary ways of parenthood and the social art of hunting, capturing in several paintings something of the diversity of the wolf's haunts, from tundra to forest and forest edge.

Arctic Evening—White Wolf [11], a winter portrait of the tundra biome that places the wolf front and center on the ecological stage, juxtaposes the raw forces of beast and environment under the benign glow of the fading evening sun that disguises the mortal odds of this unforgiving land. The tundra rolls on to infinity, but its summer riches are utterly frozen or hidden under the borderless blanket of ice and snow. A scene that would in summer enthrall and

intoxicate, marred only by the legions of mosquitoes, now radiates a fearful, foreboding sense of desolation and desperation. Even the evening light, which in summer would be an exhilarating omen of surging plants, serenading birds, and other bustling creatures, all busily pursuing their livelihoods almost nonstop under the midnight sun as twilight insensibly yields to dawn, now is the eerie, melancholy portent of the long, frightfully cold arctic night that is about to descend on the wolf.

Bateman's white wolf is "a female standing on an esker, a high gravel ridge that was once the bed of a river under the ancient continental glacier. These eskers, which crisscross the boggy Arctic tundra, serve as dry den areas for the wolves as well as good vantage points" (1985b, 108). The lone wolf, looking friendly and domestic like the big dog that it is, intently watches for prey. With matchless wit, it can conquer its vulnerability to the elements and to starvation with eternal vigilance. The color of its fur lessens its chances of being detected by potential prey. Arctic or tundra gray wolves tend to have thicker coats of almost white fur, making the species typical of the resident mammals and birds that have adapted to the arctic environment by putting on a white camouflage at least in winter.

In North America, the gray wolf once ranged throughout the continent from the High Arctic to tropical Mexico. It became widely known in the forested regions as the timber wolf, a name whose mere mention has always struck terror and wonderment among the lay populace. Today, the North American range of the gray or timber wolf is reduced to strongholds in the boreal forest and tundra regions of Alaska and Canada, reaching down into northern Minnesota, Wisconsin, and Michigan. There doubtless is no wilder, more unsettling sound in the North American wilderness than the howling of a wolf pack.

Arctic Evening—White Wolf

In summer, the tundra is a paradise for birds, when the ranks of the few resident species are swelled by about a hundred species of migrant birds, which come here to nest every year. Millions of waterfowl—some arriving when the lakes have only begun to thaw—along with gulls, terns, shorebirds, and songbirds saturate the seemingly limitless tundra in a stag-

gering annual gluttony of reproduction that replenishes many global populations for yet another year and thus makes the tundra one of the most fertile and crucial biomes of the earth's ecosphere.

We have already met two of the most lordly of the summer nesters: the tundra swan and snow goose. Of all the birds of the arctic tundra, however, none is more genuinely endemic and thus representative than the magnificent gyrfalcon. To passionate bird-watchers, especially bird-of-prey fanatics, falcons hold a special place, and nothing exceeds the thrill or stirs the instincts quite like the sight of a rare falcon, particularly a peregrine falcon or a gyrfalcon. The mystique and glory of the falcon stem both from its reputation as an incomparably swift pursuer and grand master of the skies and from its preferred status in the royal sport of falconry, which traces back into antiquity at least four thousand years.

The gyrfalcon is the largest of the world's fifty-some species of falcons, eight of which occur in North America. It is native in summer throughout the tundra biome into the barrens of the High Arctic around the Pole, including Greenland and Iceland. In North America, gyrfalcons nest from Alaska to Labrador on high rocky promontories and bluffs in foothill country and by the sea. The gyrfalcon hunts birds, predominantly the ptarmigan. Every wild creature seems to have its nemesis; for the ptarmigan, it is the gyrfalcon. This powerful king of the falcons is less likely than the peregrine falcon to hunt from high in the skies and then stoop (dive) at great speed to strike its prey in mid-air. More often, like a goshawk, it surveys the landscape for prey from such vantage points as low rock outcrops and small hills or cruises over the contours of the land near the ground trying to take a ptarmigan by surprise. The gyrfalcon seems to be supremely adapted for such tundra pursuit.

As a species the gyrfalcon has three color phases—white, dark (gray-brown), and gray. The white phase lives mainly in Greenland and northern Siberia; the other phases predominate on the North American continent, the dark phase in the Western Arctic and the gray phase in the Eastern Arctic.

Bateman has painted both the white and the dark phases. The white phase has a pristine splendor that seems the most befitting on the tundra. The majesty and regal bearing of this bird are portrayed in Bateman's *Evening Light—White Gyrfalcon* [front cover]. Here on "low sandstone cliffs . . . near Fort Churchill on Hudson Bay" (Bateman 1985b, 114), a white gyrfalcon, with a commanding view, serenely surveys its coastal realm, perhaps at any moment to stoop with lightning speed on some hapless duck or gull as it flies beneath the falcon's eyrie.

Although here it looks out over an actual sea—the vast icy waters of the mighty Hudson Bay—the gyrfalcon could just as typically be overlooking an equally vast, flat "sea" of tundra anywhere across the Arctic. Viewed as sea or imagined as tundra, Bateman's scene is a portrait of the Arctic that conveys the feeling and the mesmerizing image of this incomparably vast and bleak land. But the gyrfalcon, like the many other precious forms of life in the tundra biome, make this a magical land—a place of sheer poetry when the time is right. Now generally rare throughout its worldwide range, if the gyrfalcon ever vanishes, the tundra biome and the continent will have lost one of their noblest species. The gyrfalcon epitomizes the paradox of the tundra—a hardy yet delicate land, it has been called "the crown Earth wears around its head" (*Grasslands and Tundra*, 1985, 129).

Grassland

All continents of the earth but Antarctica have immense interior grassland formations, and each has its own special kinds. In North America, we find prairies and plains; in South America, the llanos, pampas, and savannas; in Eurasia, the steppes; in Africa, the grasslands, savannas, and velds; and in Australia, the grasslands and savannas. Either grassland or savanna—grassland with enough annual moisture for shrubs or scattered trees—tends to form in regions having a hot, dry season; the longer the drought the less likely tree

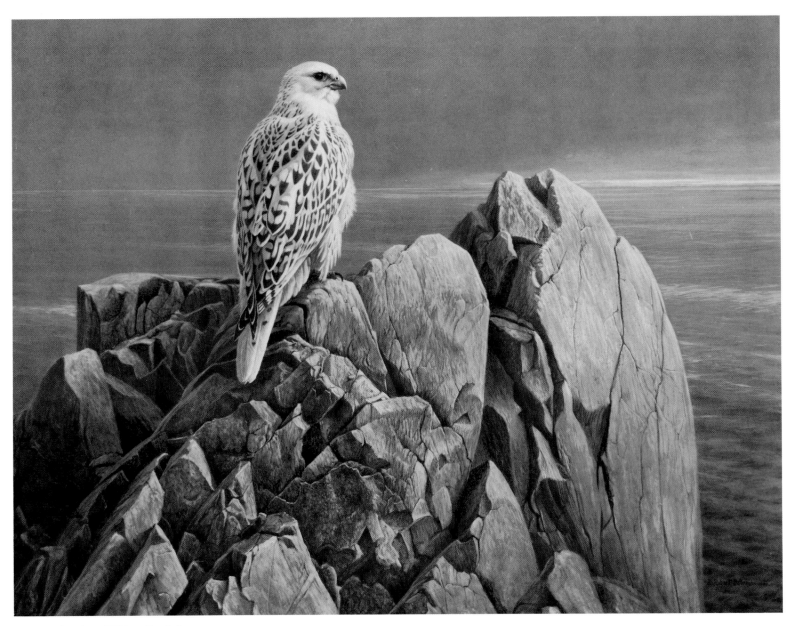

Evening Light—White Gyrfalcon

or shrub savanna. As plants go, grasses are extremely tough and can survive environments that would be too harsh for most vegetation.

Grasslands have been vital to human welfare since the dawn of mankind. They are the great natural pastures of the earth that provide forage for nature's zoo of wild herbivores, animals on which man has depended for food or other products from earliest times. Grasslands also have supported man's domestic herds and yielded more easily than forests or deserts to agriculture. The world's most important food plants are grasses, especially the cereal grains, which long ago were domesticated to feed people and livestock. Wheat and barley were first cultivated ten thousand years ago. It has been said that civilizations have lived without oil but none without grasses, notably such major crop grasses as wheat, barley, rice, bamboo, and corn or maize.

Far from being the monotonous monocultures they appear to be at first glance, grasslands are as rich and varied in their own way as forests. Some grasslands are, indeed, monocultures of a single species or two, but most are complex tapestries of numerous, interwoven species of grasses and herbs, even woody plants. Taken as a super biome—though it really is several distinct biomes—the grassland is a layered web of plant-animal relationships at all levels of life, from burrowing rodent to thundering buffalo, prowling lion, or stooping eagle. The grazing, wandering herbivores are nature's mowers and cultivators, which also enrich the soil with their dung. They in turn are food for the carnivores, and various scavengers round out the ecosystem. Worldwide, the fauna that subsists on the grassland's plant riches is large—thousands of species if one includes the insects and other invertebrates, not to mention the vast soil fauna of microorganisms. The largest mammal fauna is the magnificent and fabled African fauna, where a whole caste of herbivorous consumers evolved and, along with it, a caste of carnivorous consumers. The Eurasian steppe, stretching nearly four thousand miles from eastern Europe to Mongolia, is the most expansive grassland and ranks next to Africa in its original roster of herbivores. By contrast, the North American prairie has had only two large herbivores in historical time—the bison and the pronghorn antelope—and Australia only one—the kangaroo, though many different species.

Grasslands spawned not only nomadic animals but nomadic peoples. These nomads, man and beast, roamed from place to place, harvesting nature's surplus and then moving on before causing serious overgrazing and erosion. Central Asian peoples took up a lifestyle of nomadic herding that did take its toll on the native herbivores, while in North America the Indians left little imprint on the prairie ecosystem. Permanent settlement and overpopulation quickly change the odds against the grasslands.

Robert Bateman has portrayed wildlife of the North American plains and the African savanna in a number of paintings that also give us vivid ecological portraits of the grasslands of two continents. Two stand out—*Coyote in Winter Sage* [12] and *Wildebeests at Sunset* [13].

Bateman's extraordinarily lifelike coyote on the sagebrush plains was painted for the Cowboy Hall of Fame, now in Oklahoma City, Oklahoma (Bateman 1985b, 126), and nostalgically evokes the bygone world of the cowboy in the Old West. Could any view of the land be more American? It is a scene that, in most of its elements, could be painted almost anywhere in the more arid prairie regions, especially along the western margins of the Great Plains bordering on semidesert. The prostrate cactus of the cholla type suggests a southwestern locale; the "sage" might in fact be rabbitbrush of habit and habitat similar to sagebrush. But for the nearly hidden beer can, it is a timeless tableau that could represent the plains wilderness past or present. The artist tips his hand, however, with the flip-top can, the kind of land-defacing, material graffiti that is the unmistakable sign of today's neo-cowboy who bravely ventures into the wilderness on all manner of wheeled, off-road vehicles in summer and on snowmobiles in winter, riding roughshod over everything,

Coyote in Winter Sage

including nature's frailest habitats.

In today's crass world where man often obliviously or wantonly violates nature and, like a dog, leaves his sign to mark the land, the coyote is a survivor that one can only admire, despite its reputation as an undesirable, even despised animal. "Coyotes," Bateman writes, "are thought of as slinking, skulking animals, and are often reviled as vermin, particularly in the West, but they are a successful, resourceful species, and should not be discriminated against." He decided to paint "a really magnificent male I had once seen, and to put him in a noble stance" (1985b, 126). If the pose seems a touch majestic to those who know the coyote best as a mangy-looking, tail-heavy dog trotting foxlike across the sagebrush plains or as a nightime marauder of livestock

around the farm, it must be remembered that the coyote is incredibly cunning and adaptable, and surely there is majesty in the animal's story of ecological conquest and invincibility in the face of ever-intensifying human interference. Unlike the larger wolf, which has retreated everywhere from man's presence, the coyote has adapted to human activity and has advanced aggressively eastward to Maine and adjacent Canada from its original home on the plains.

The primeval prairie of central North America, from Texas to the boreal forest of Manitoba and the Rockies to the midwestern margins of the deciduous forest, was something to behold. In *Grasslands of the Great Plains* John Weaver and F. W. Albertson describe it this way: "On level land the vast prairie in summer is a sea of waving grasses dotted with flowers of many forbs" (1956, 24). The immensity of this "sea" and its stupefying herds of bison and pronghorns staggered the minds of the first Europeans to lay eyes on the prairie. They came unprepared to comprehend the limitless expanses of grass, stretching from one horizon to another, or to expect the spring and summer variety of wildflowers in the midst of seemingly unending uniformity.

Savannas are grasslands of perennially warm, tropical and subtropical regions of the world where there are basically two seasons, wet and dry, which vary in length from place to place on the earth. Though dominated by grass, they typically are covered by at least a smattering of drought-resistant trees or shrubby plants. The trees may be so frequent and uniformly spaced as to give the savanna a parklike aspect, and often their branches and foliage are armed with spines or thorns that thwart browsers. Fire during the dry season is a universal force in the savanna environment and a key to its perpetuation and expansion.

Savanna is the commonest kind of grassland, and it forms a broad equatorial belt around the globe. Most extensive in Africa and South America, it also occupies significant areas in Australia and Madagascar, as well as parts of India and

Wildebeests at Sunset

southeast Asia. It is Africa, however, that is renowned for textbook savanna. Here savanna is the predominant vegetation, occupying a third of Africa, in the heart of the continent.

The savanna ecosystem is really a boom or bust biome. From the prodigal luxuriance of the rainy season to the parched landscape of the drought season, the savanna ex-

periences great fluctuations in plant growth and—particularly in Africa—animal populations. Once the rains come, the scorched earth experiences a sudden miracle of rebirth, almost explosively sprouting new growth and blooming. In Africa, the grasses, depending on the species, rapidly grow as high as 15 feet and the trees green up and burst into bloom. The abundant, thorny, and diverse acacias glow with their powdery, pollen-yellow blossoms.

With the rains and the greening of the savanna come the great herds of migrating animals that have roamed the vast African plains for eons. Africa's mighty herds of wild grazers, though but a vestige of the thronging hordes that once roved here, still number in the millions. East Africa is the last stronghold of such large herds of native grazing animals that once characterized nearly all savannas of the world. The herds survive here only because of the protection they and their habitat are now afforded in sanctuaries such as Tanzania's 5,000-square-mile Serengeti National Park, one of the world's great wildlife arks—some would say the greatest. Extending for a hundred miles eastward from Lake Victoria to the Rift Valley and reaching Kenya's border, it is an ark for both the dazzling wildlife of East Africa and their disappearing savanna biome.

The wildebeest or gnu stands higher at the shoulder than at the rump and comically resembles—as Africa legend has it—an animal put together with the spare parts of others. It is a dominant and archetypal member of the precision grazing corps that has evolved in Africa and has migrated in teeming masses back and forth across the African savanna with the wet and dry seasons since the dim, distant past. The early Dutch in South Africa called it the "wildebeest," meaning wild beast, for its ferocious appearance when, like a berserk bucking bronco, it goes on its customary rampage of frolicking, thrashing territorial behavior. A large antelope, the wildebeest may weigh 350 pounds—a bull as much as a quarter of a ton.

In the Serengeti, the wet season begins in November and lasts until June. As the rains begin, about 1.5 million wildebeests slowly move a hundred miles southeastward from the wooded savannas south of Lake Victoria to the often short-grass plains, where they move back and forth from one section to another in an instinctive mowing cycle that keeps rejuvenating the grasslands without overgrazing them. As the rains come to an end, the movement is reversed, and the herds slowly wind their way back to the northwestern woodlands to spend the dry season. The animals may cover 50 miles a day and 800–1,000 miles a year in their ceaseless wanderings.

Migrating with the wildebeests in search of forage and water are hundreds of thousands of zebras and Thomson's gazelles. Their massive, mingled herds are joined from place to place by many other, nonmigratory grazers and browsers—Grant's gazelles, impalas, elands, dik-diks, giraffes, rhinoceroses, African buffaloes, elephants. Feasting on the margins of these herds and pruning them of the weak and sick, are the resident carnivores, notably Africa's celebrated cats (lions, leopards, cheetahs) and scavengers (hyenas, jackals), not to mention the predatory birds.

Of Robert Bateman's many expressive paintings of African wildlife, *Wildebeests at Sunset* [13] is particularly effective in expressing the mood and the reality of the savanna biome. The setting is Amboseli Park (Masai Amboseli Game Reserve) in southern Kenya south of Nairobi and just northwest of Kilimanjaro. Toward the horizon of the short-grass plain are trees with the distinct shapes of savanna acacias. More vast than the land or heroic than the wildlife, the African sky always overwhelms, reducing the most imposing ecological landscape to humble scale. Evident is the paradox of the African savanna—extravagance in an environment of many hardships. The mellow mood of the evening belies the white heat of the day that leaves a burned and desiccated landscape still glowing with a patina of "liquid gold," as though poured molten from the bucket of a cosmic foundry. It is hard to fathom how vast armies of huge beasts can scrabble a daily living from the slender spears of short grasses. But the ungainly looks of the ponderous wildebeest mask its amazing fitness

for grazing the tender young sprouts of grass even without benefit of upper teeth, while leaving other succulent tiny nibbles for the gazelles and the tougher mature culms to the zebras. Some fear the sun is as near to a sudden setting on the savanna, the wildebeest, and the other great African mammals as it is in Bateman's scene. But thanks to Serengeti National Park and other preserves in the larger Serengeti ecosystem, there is hope. Indeed, the wildebeest is one animal that has made a remarkable comeback in the last twenty-five years.

Desert

Desert covers more than a third of the land surface of the earth, including parts of every continent, even Antarctica if cold desert is counted. It might seem to be the most widely understood of the earth's major biomes because nearly everyone presumes to know a desert, usually thinking of it in easy stereotypes, formed perhaps from grade school tales of exotic camel caravans crossing the Sahara or from romantic stories of desert explorers. The desert of literature and legend is a limitless, lifeless expanse of inhumanly hot, dry, shifting sands and dunes except for the rare oasis. There are, of course, famous deserts fitting the storybook stereotype, such as North Africa's Sahara Desert and the Namib Desert of Southwest Africa, but only a small percentage of the world's desert regions are so extremely hot and arid.

Popular conceptions of desert are changing, however, thanks largely to today's many fine nature films on desert life. Many people have learned that the desert is in fact a richly diverse biome—indeed, a genre of biomes—with enormous variation in environment, habitat, and biota. Generally, "desert" is understood to mean "warm desert," which is characterized by extremes of heat and little rainfall (usually five inches or less a year) that is sporadic and unpredictable. Summers are very hot, and winters are mild to hot. The elevation usually is 3,000 feet or less, and some deserts, such as Death Valley in California and Nevada, are below sea level.

There is, however, another kind of desert called "cold desert" that occurs in arid but cool or cold environments at higher elevations and latitudes, as, for instance, in the Great Basin of the western United States and in the Arctic and Antarctic. Polar deserts—the cold deserts of the polar regions—have already been mentioned in our discussion of the tundra biome. Further discussion here is confined to desert in its usual or traditional meaning of warm desert.

The deserts of the American Southwest and Mexico have been studied extensively, perhaps more than any other deserts, and they are world-famous for their unusual animals and plants, especially their cacti. The cacti are native only to the temperate regions of the Americas. The desert formation of the American Southwest comprises three major deserts: the Mojave Desert, mainly in southeastern California; the Sonoran Desert of southern Arizona and adjacent Mexico; and the Chihuahuan Desert of southern New Mexico, western Texas, and adjacent Mexico. The Mojave Desert is known for its Joshua trees—treelike yuccas; the Sonoran Desert for its treelike cacti, most notably the giant cactus or saguaro; and the Chihuahuan Desert for its scrub vegetation and such plants as yuccas and mesquite.

The saguaro is the world's largest and most distinctive cactus. A giant columnar cactus that may reach a height of 50 feet, it branches above a height of about 15 feet to form a candelabrum-shaped tree. It is extremely slow growing, achieving only about an inch in height in the first ten years and not blooming until it is fifty or more years old. The saguaro lives for 150–200 years and usually succumbs in the end to uprooting by wind or water because of its shallow roots, which may have to support tons of water-ladened tissue in the enormous branching trunk. The shallow roots spread widely under the surface of the desert to garner moisture for the huge plant body.

Many animals and plants are *precise* indicators of ecological place, geographical place, or both. Outstanding examples of

Young Elf Owl—Old Saguaro

this are portrayed by Bateman in his *Young Elf Owl–Old Saguaro*. What could better symbolize the biome and pinpoint the place on earth? The cactus at once indicates desert, specifically American desert, and the particular species, the saguaro, can only mean the Sonoran Desert. Indeed, the saguaro of travel magazines spells *Arizona* desert. Arizona and saguaro are inseparable; the beautiful white blossom is, in fact, the state flower. A typical "forest" of this massive cactus looks like an extraterrestrial landscape.

In one of those exquisite little coincidences of nature, the world's smallest owl—the sparrow-sized elf owl—commonly nests in the cavities of the world's largest cactus—the saguaro. The elf owl, too, is found only in the North American Southwest, where it is common in the desert, although not wholly restricted to this biome. It summers in the desert regions, wooded canyons, and some montane forests, mainly in Arizona and northern Mexico, and winters largely south of the border in Mexico. In spring and summer the best place to see an elf owl is at the mouth of a hole in a saguaro cactus at dusk.

Bateman's portrait tells much of life in the desert world. The tough, thorny cactus is a monarch of the ages, a symbol of the stability and continuity of life in this withering environment where life itself seems most improbable. This colossus of the desert is a veritable water tower. It is more vulnerable to too much rain, which may wash away its underpinnings, than to too little rain. In Bateman's painting, the strong, rodlike strands of its skeletal structure protrude from the broken-off branch. Covered with spines, the cactus is an armored fortress for such fragile forms of desert life as the elf owl, which makes its home in the cool, insulated cavities where the cactus has fractured (as here), or, more typically, in the abandoned holes of woodpeckers. Bateman highlights the fragility of the tiny owl's existence by depicting a young bird, still with down, beginning to venture outside the cavity—a moment of maximum vulnerability in the life cycle of the species. The labile young owl gives pulse to the timeless old saguaro and thus to this desert scene.

Owls are famous for their nocturnal habits and the elf owl is no exception. Likewise, the desert is famous for its nightlife: "I've shown a young owl ... taking a look around in the enchanted hour between sunset and dusk, the most glorious and active time in the deserts" (Bateman, 1985b, 198). In this, the desert's finest hour, the twilight shift of insects, birds, and other animals busily takes advantage of the cool between sunset and dark while there is still some light, and the night shift rouses and begins to forage. The crepuscular creatures may also put in another shift of activity in the hour before sunrise. Even the plants may oblige moths and other crepuscular or nocturnal pollinators by blooming at night, as the saguaro does, although its flowers may last into the day.

Wetlands

All things being equal, the abundance of life on the land is directly proportional to the abundance of water. The major continents are richly endowed with lakes and rivers, great and small, and with all kinds of wetlands. Wetlands are terrestrial habitats with soils that are saturated or submerged beneath shallow standing water at least part of the year. Ecologically, wetland habitats are the antithesis of desert habitats.

Wetland may form wherever the water table reaches the surface or the land meets open water, as around a lake or pond or along a waterway. Thus a wetland may be kept charged by either ground water or runoff. The broader and more gradual the transition from dry land to saturated soil or water's edge, the larger and more variable the wetland. Of the many kinds of wetlands, the three basic types are marsh, swamp, and bog. Marshes are of two types: saltwater and freshwater. The former is characterized by periodic tidal inundation with saltwater; the latter, usually by shallow standing freshwater. Both are wide open expanses of grasses, sedges, and other herbaceous plants. Swamps are wetlands

with standing freshwater, at least in winter and spring, and a cover of trees and shrubs. Mangrove swamps have formed in saltwater along many of the world's coasts. In other words, the swamp is wooded and the marsh, open. The bog is a special kind of freshwater swamp that develops where drainage is limited or trapped, organic matter builds up, and the soil becomes quite acidic. It is most typical of northern, glaciated topography. Often the lakes, ponds, and streams that have given rise to the wetlands are considered integral parts. Open water clearly enhances the marsh or swamp ecosystem for wildlife, particularly waterfowl.

Wetlands do not constitute a natural biome but rather an artificial grouping of habitats and ecosystems with certain common features. As a class, they constitute some of the world's most productive ecosystems. The coastal salt marshes are particularly important as spawning grounds and nurseries for fish and shellfish, and in the United States alone half or more of the commercial fisheries may depend on healthy salt marshes. Wetlands, often viewed as useless obstacles to rational land use, have been easy targets for elimination ever since the coming of the white man to North America. Belatedly, the American public has been sensitized to their values, but needless destruction continues. Today, perhaps half of the nation's original wetlands have been drained, filled, dammed, or otherwise destroyed or permanently altered.

The world of the marsh and, to a lesser extent, the swamp is a world of high drama and intrigue in season. It exerts a magnetic pull on birds and animals for miles around and on every naturalist in the territory. Throughout the summer months the marsh or the swamp is nature's commons, shared by the separate lives of the many unrelated creatures—from beavers and bears to water birds and songbirds—that come here to raise their young, hunt for food, have a drink, or merely play in the water or hide in the reeds and thickets. It is always a more cosmopolitan world in summer than, say, the forest or the field. But the zenith of excitement comes during migration, especially in spring when the marsh be-

comes a stopover for a thousand journeys. Then for one brief moment the marsh becomes a crossroads of the continent. Water is the universal attraction and migratory birds, the tie that binds all wetlands together. Not surprisingly, therefore, wetland birds—particularly waterfowl, wading birds, and shorebirds—form an ecological brotherhood with a higher degree of universality in their distribution and haunts than most other birds and animals.

The great blue heron, literally standing head and shoulders above all the other birds of the realm, is a virtual mascot of marsh and stream in North America and as universal an inhabitant of wetlands generally as any bird. Freshwater or saltwater, from river banks to lake shores, marshes to swamps, and brooks to wet meadows and pools—this bird inhabits them all. And when it flies by, lumbering low overhead in typical heron fashion with neck folded back but legs trailing outstretched, the alert observer knows that water cannot be far away. Though it is a nearly ubiquitous bird in North America, breeding from southeastern Alaska and southern Canada to southern Mexico and the West Indies (even the Galapagos Islands), the great blue heron is so stealthy and undemonstrative in its daily haunts that it often escapes notice.

Bateman's *Great Blue Heron* [14] is a mesmerizingly real portrayal of this magnificent bird, at four feet the largest of the dozen North American herons, as it waits motionless at the reedy edge of a stream or lake to strike with lightning swiftness at some hapless small fish, frog, crayfish, or other passing prey. This consummate fisherman, a serene sentinel of the waterways, quietly stalks and waits, stalks and waits. A study in patience, it could give lessons to any fisherman of the human species, and not infrequently the two do meet eye to eye in the habitat, intent on the same ends, only to cause the heron to fly off in squawking disgust. Perhaps the most elegant of the common summer residents of the wetlands, the great blue heron always stands out from the groundmass, delighting the usually startled observer.

Great Blue Heron

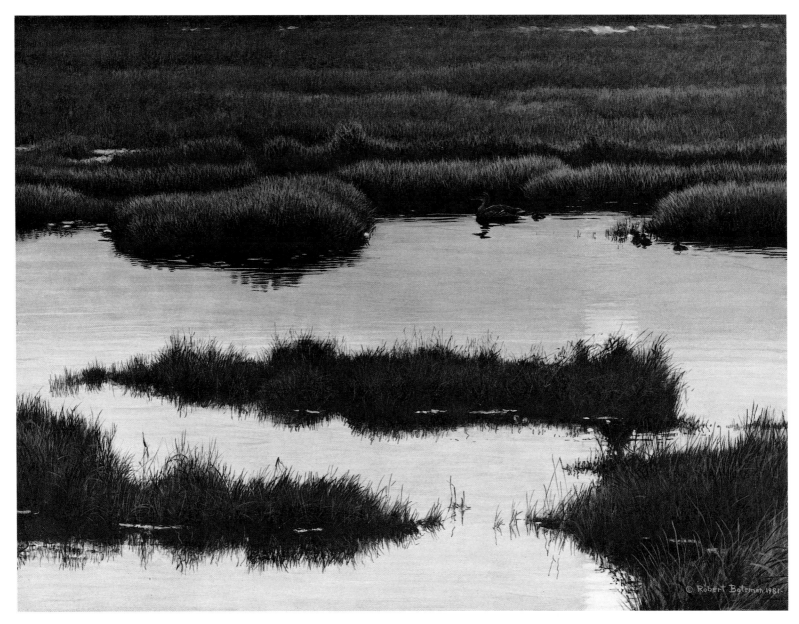

62 *Mallard Family*

A marsh is not a marsh without mallards. Everyone who knows a duck knows a mallard—at least the drake—if not from the wild then from parks, zoos, or even the barnyard; the mallard is everyone's idea of a real, wild, quacking duck. This is no coincidence because the mallard is not only the commonest duck in the wild throughout the Northern Hemisphere and perhaps throughout the temperate regions of the world (introduced in Australia and New Zealand), but also the wild ancestor of nearly all domestic ducks. Domestic stocks of mallards showing little outward difference from the wild ducks often grace the ponds of parks, and during migration the wild and the domestic mallards may mingle freely. Not infrequently pairs of wild mallards stay behind and become permanent residents, living in a semiwild state and nesting sometimes in the midst of cities, as a pair recently did in a hedge in front of the National Academy of Science headquarters along busy Constitution Avenue in Washington, D.C. Even under circumstances of domestication, the mallard's splendor is often taken for wild splendor, perhaps falsely giving reassurance that unspoiled nature is close at hand.

Bateman's *Mallard Family* [15], a small family by duck standards, puts the mallard where it belongs—in the wild marshes, its perennial home. Bateman has resisted the urge to feature the predictable gaudy male, front and center, that would spell instant recognition, painting instead a more subtle portrait of the mallard. It is a soft and tranquil study of ordinary family life, showing the unpretentious hen in her subdued tones watchfully paddling through the cordgrass and salt hay with her inquisitive little ducklings trailing behind, oblivious to such voracious predators of the marsh as the snapping turtle, which already may have pruned the family. In the golden evening hues, the family blends into the marsh almost to the point of escaping notice, forming part of the organic whole and symbolizing the inseparable bond between mallard and marsh.

The scene is sunset over the salt marsh at Cape May, but it could be a marsh almost anywhere on the continent or elsewhere in the Northern Hemisphere. Saltwater marsh or freshwater marsh, the plant species may change, but the aspect is much the same—a vast sea of grasslike plants. Although a seeming monoculture, the marsh can be a diverse plant world of grasses, sedges, rushes, cattails, and, punctuating this reedy groundmass, a colorful though often hidden variety of wildflowers. The mallard, a dabbling duck, finds an abundance of succulent shoots and aquatic invertebrates for its diet in the shallows of the marshes. It is partial to freshwater marshes.

The poignancy of Bateman's *Mallard Family* is its reminiscence of sunset over the prairie pothole country. Although the mallard is an extremely prolific species, it is vulnerable nonetheless—as vulnerable as the rapidly disappearing marshes on which it depends. Many other species of ducks—not so prolific—are much more vulnerable. The prairie potholes of North America, the prime cradle for mallards and ducks in general, are disappearing at an especially alarming rate. As the marsh goes, so goes the mallard; and as the mallard goes, so go many other waterfowl species. What is the value of a land without marshes? Or a marsh without mallards? On a bracing spring or fall morning, nothing is so reassuring and electrifying to the naturalist or outdoorsman as to tramp the marsh and jump mallards, watching them explode from the water almost vertically with thunderous wings and boisterous quacking and then vanish in an instant. Mallards also are the heartiest of waterfowl and often are the sole lingerers waiting to greet the one who ventures to the nearest open water on the coldest winter day.

Coasts

Coasts are edges—gargantuan edges of great continents where the land meets the sea, sometimes with jolting, precipitous abruptness, sometimes with intoxicating, insensible gentleness. Here, irresistible force meets immovable object, and the landscapes are sculptured by the sea waging eternal warfare

on the land, wearing it down, softening it up. Crushing, carving, gouging, filling, inundating, transporting—the sea inexorably reduces mighty cliffs and boulders to immortal grains of shifting sand, in the process creating rocky shores and sandy beaches, islands and lagoons, strands and dunes, bays and marshes. The shores of the continental rim are a cosmic compromise between land and sea, resulting in a realm of greatly differing and ever changing environments existing side-by-side and a sometimes staggering kaleidoscope of plant and animal life.

The great variety of coasts in the world can be reduced to two basic types—rocky and sandy. In North America, the Atlantic Coast is rocky in Canada and New England and sandy from Long Island to Florida and the Gulf Coast. Two basic types of vegetation characterize the world's sandy shores—salt marsh and mangrove swamp. Along the mid-Atlantic and Gulf coasts there are incomparable salt marshes (see earlier discussions of *Across the Sky* and *Mallard Family*). Mangrove swamps characterize sandy shores of tropical and subtropical waters, including parts of the coast in Florida and the Gulf of Mexico. The Pacific Coast is largely rocky, in many places with ragged, high cliffs plunging straight down into the sea.

One of the everlasting wonders of the seacoast is the biannual migratory passage of hordes of shorebirds, especially along sandy coasts such as the Atlantic Coast of North America. The world of shorebirds is highly cosmopolitan. Many of the two-hundred-odd species from a dozen different families are essentially circumpolar, and in season many of the species can be seen almost anywhere in the Northern Hemisphere. Shorebirds have some of the longest migration routes among birds; in spring they all seem to be heading for the High Arctic to nest, and in autumn many head for south temperate regions, often going as far as southern South America.

Along the coasts the shorebirds are usually to be found on the emergent tidal mudflats and short-grass marshes behind the barrier dunes, where they probe for crustaceans, mollusks, and other invertebrates. They are always on the move and in perfect harmony with the tides, taking advantage of low tide and keeping ahead of high tide. They often swarm the beaches and flats as far as the eye can see, by numberless thousands running to and fro, stitching the sand and mud to probe for food, or flying back and forth among the tidal flats with a beautiful precision, as though choreographed. Lively, long-legged, graceful, and ever energetic, shorebirds are an aesthetic experience to the beholder.

The happy wanderer of the lot is the sanderling, a plump, sprightly little sandpiper at water's edge, always feeding just ahead of the crashing waves, as in Bateman's *Surf and Sanderlings*. It scoots along, running as fast as its little legs will go. With mechanical precision, it masters the rhythm of the water, chasing after retreating waves but always managing to stay out of harm's way. The circumpolar sanderling is probably the commonest shorebird of the outer beach on both the Atlantic and Pacific coasts of North America. A mini-mascot of the beach, it might be called the swimmer's shorebird because it is one of the few sandpipers to be found in little knots of birds consistently at surf's edge even in the middle of the day when bathers are out in force; busy hunting for minute crustaceans and mollusks it pays the swimmers no mind. The sanderling nests in the Arctic and winters over large parts of the northern and southern hemispheres; it is one of the few shorebirds to be found along southern coasts of the United States in winter. Bateman's intimate portrait of foraging sanderlings is an appropriate symbol of the world of sandy shores and shorebirds.

The rocky Pacific rim of North America is a world unto itself, a coast that, like the ocean it backstops, is awesome and grand beyond easy comprehension. It is a heroic, coastal world of glaciers, fjords, towering sheer cliffs, massive rock headlands, low rocky shores; a world that is often beachless, though it has its strands and pocket beaches and occasional broad sandy stretches that are the delight of sunbathers; a

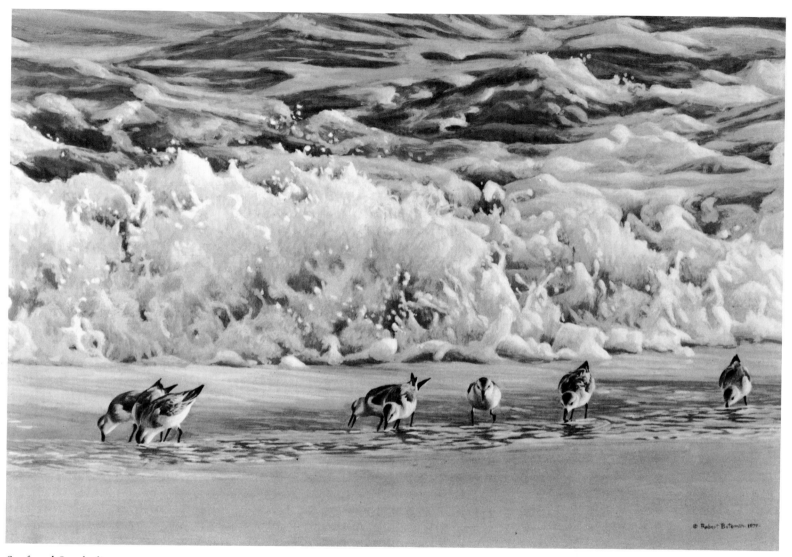

Surf and Sanderlings

world of starfish pools, kelp, and barnacled boulders; and above all a world of monstrous waves, complex and imposing tides, and ceaseless pounding surf, seemingly too punishing for life itself. Yet life abounds in profusion, from the Gulf of Alaska to the Gulf of California.

Bateman's *Misty Coast,* depicting the Pacific shore at a truly pacific, intertidal moment, certainly captures the mood and the ecological texture of this often shrouded and foreboding realm. The gulls, mollusks, and kelp are perfect tokens of the rugged forms of life that have evolved or adapted to cope with this capricious environment. About this scene, Bateman writes,

> My favourite coastline is the low rocky shore, where the solid outcrops of rock give a firm foothold for a whole range of marine vegetation and animals. Here … there are bladderwrack seaweed, the typical kelp of the Pacific coast, barnacles, limpets, and other molluscs. They get plenty of light and oxygen and are alternately covered and exposed by the changing tides. With the tides come fish, crabs, and shrimp. When the tide goes out, some of the fish and crabs are stranded and they become part of the diet of the waiting gulls (1981, 132).

There is no more universal symbol of the sea and particularly the coast than the sea gull, and there is no more universal gull than the herring gull, which, apparently, is what Bateman has painted. (It matters little that the bird's pose leaves one in doubt about the almost indistinguishable Thayer's gull and the strictly Pacific glaucous-winged gull.) The herring gull is a scavenging tramp of the Northern Hemisphere, at times the "weed" of the seabird world.

The North Atlantic coast is a land of stupendous, absolutely mind-bending bird cliffs and seabird colonies. The bare, scarcely vegetated granite cliffs that preside over the sea are clothed with a live, ever transforming, seamless cloak of sleek gannets, penguinlike alcids (species of the Auk family), and other seabirds. So continuously packed with birds from ledge to ledge are some of the dizzying cliffs that they appear, as it were, stippled from end to end and sea to summit. The "Bird Rocks" of Newfoundland have been famous since the days of the early European explorers, and John James Audubon himself visited here in 1833. While today's colonies are still impressive, the once vast populations have been decimated greatly.

The Atlantic (formerly "common") puffin, looking, with its colorful, muzzlelike bill, rather like a cross between a parrot and a penguin (sometimes dubbed "sea parrot"), has become the trademark of the North Atlantic bird cliffs, thanks to its popularity with bird artists such as Bateman. *Atlantic Puffins* [16] is an instant essay on ecological and geographical place in nature. The puffins are members of the Auk family (alcids, twenty-two species), which are open-sea birds of the northern oceans around the globe. They resort to land only during the breeding season to nest on rocky islands and mainland cliffs. The Atlantic puffin is the only puffin of the North Atlantic. Often called the penguins of the north, the largely black-and-white alcids may look like penguins and take the place of penguins in the ecological order, but they fly and otherwise are believed to be quite unrelated. The bird's comical and improbable, if not bizarre, looks belie its fitness for the sea; like the other alcids, the Atlantic puffin is superbly adapted to drive and swim for fish, using its stubby wings to "fly" under water.

Focus on Foreground: Habitats Close Up

As we conclude our sweeping look at nature's landscapes from the perspective of biomes and habitats, we now turn up the focus of our cosmic zoom lens one last notch to fill the field with the ordinary details of foreground. Here Robert Bateman comes across more as naturalist than artist. No longer focusing on the grand, the heroic, the panoramic—in short, the predictable images of obvious beauty and mean-

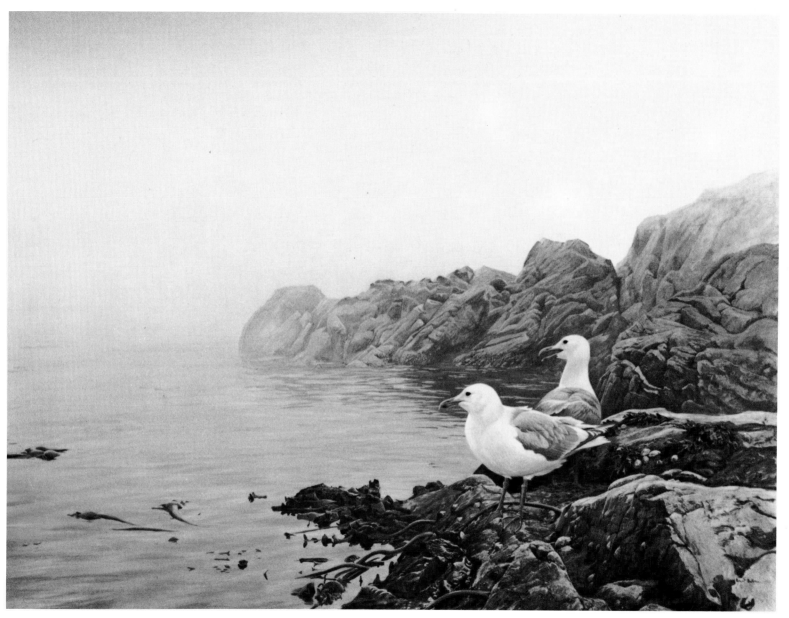

Misty Coast

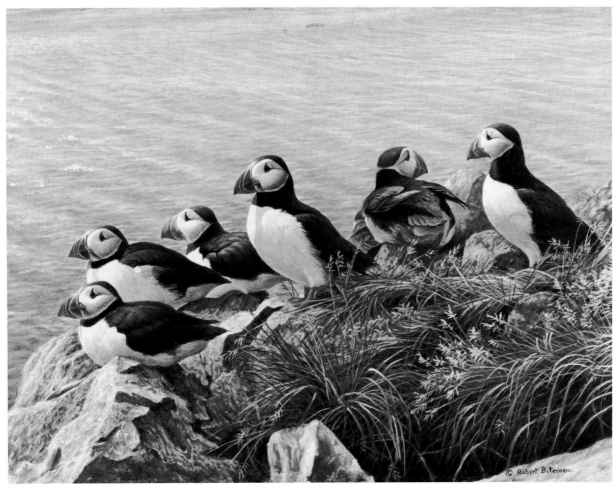

Atlantic Puffins

ing—these paintings highlight the quiet little scenes of life that compose both the diversity and the unity of nature. Now we see some of the warp and woof of the ecological fabric.

Take a streambank, for instance. It can absorb the inquisitive naturalist for hours on end and year-round. As Bateman reminds us, even Charles Darwin once waxed eloquent about streambanks (1981, 8). Bateman's *Stream Bank—June* [17] is a study in shapes, sizes, and textures and of identity in the midst of anonymity. The habitat is about as ordinary as a patch of nature can be, yet it is full of life and the promise

Stream Bank—June

of much more to come. It is a puzzle that keeps teasing us to name and explain the pieces. The plants, taking advantage of the stream's moisture and the available light at the edge, have filled every space with greenery. But the artist has left most in a generic state, not showing their telltale flowers or fruits. It is June, and spring's early wildflowers have either died back or grown beyond recognition, while summer's blooms are still to come. In July and August, the streambank will light up with the snowy white flowers of yarrow, the pendant orange corollas of jewelweed, perhaps the brilliant

cardinal flower, and many others. Meanwhile one must be patient, satisfied to recognize the ferny leaves of the yarrow, a lone bloom of a wild strawberry, a grass (or is it a sedge?), a dandelion leaf or two.

Yet just when the scrambling plants, reaching for the light like so many outstretched hands begging for recognition, threaten to overwhelm the observer's eye, a perfectly recognizable focal point emerges. The cryptic song sparrow, a bird of endless variations in plumage and song, seems about to poke around under the dark, cool bank among the roots and rootlets with the shrews, looking for nesting material or, more likely, an insect or two for ever ravenous nestlings. Despite first impressions, Bateman has subordinated the plants to the bird, suggesting how much easier it is for the painter as well as the naturalist to deal with the identities of birds than of plants.

Joy along the streambank does not end with summer. Over most of the United States, the song sparrow is likely to tough it out in winter, grubbing for a living under the same streambanks long after the tender foliage has been killed by frost, advertising its presence only by its distinctive call note. Joining it will be such welcome northern visitors as white-throated sparrows and winter wrens.

Downy Woodpecker, an exquisite vignette of winter foreground from old field or wayside, tells several stories in one. The intrepid bird-watcher who bundles up on a cold and blustery day in the dead of winter—heading into the wind and blowing snow in search of some (any) sign of activity, stopping now and then to listen for any sounds coming over the wind—sooner or later will pick up the soft, irregular rat-ta-tat-tat of a downy woodpecker drifting with the wind, fading in and out like a weak radio signal, as it drills a dried corn stalk or goldenrod gall in search of a juicy larva. With patience and a little aural triangulation, the ventriloquist can be spotted, sometimes a lot closer than expected. The bird suddenly stops its halfhearted pecking and watches the

Downy Woodpecker on Goldenrod Gall

watcher intently, more bothered by the intruder than the blizzard.

Face-to-face with one of nature's petite glories, the bird-watcher is let in on one of its little-heralded ecological sagas. This bit of foreground is what Bateman has captured so vividly and authentically. The male downy woodpecker has been caught by the artist on a dried and shriveled goldenrod just after the moment of victory, finding a "morsel of food" in the goldenrod ball gall (Bateman 1981, 116). This gall represents the little bulbous "house" the plant built around the larva that hatched from an egg laid on the stem by a small spotted-winged fly last summer. The larva bored into the soft, growing stem and commandeered the biochemical apparatus of the plant for its own ends, namely to elaborate the protective swelling, where it will overwinter. Only if the larva is so lucky as to escape all parasitism and predation will it pupate and emerge as an adult fly the next spring. This fly is a "botanist" and attacks only the Canada goldenrod of all the goldenrods, so that one can always identify a plant in this group of cryptic species by the presence of the ball gall.

Like a Chinese box, nature is a series of ecological worlds within worlds. Whatever the level of the habitat, always there is order, always remarkable harmony and interdependency, always beauty and intrigue. In proper focus even the commonplace foreground of nature can be fascinating.

Color Plates

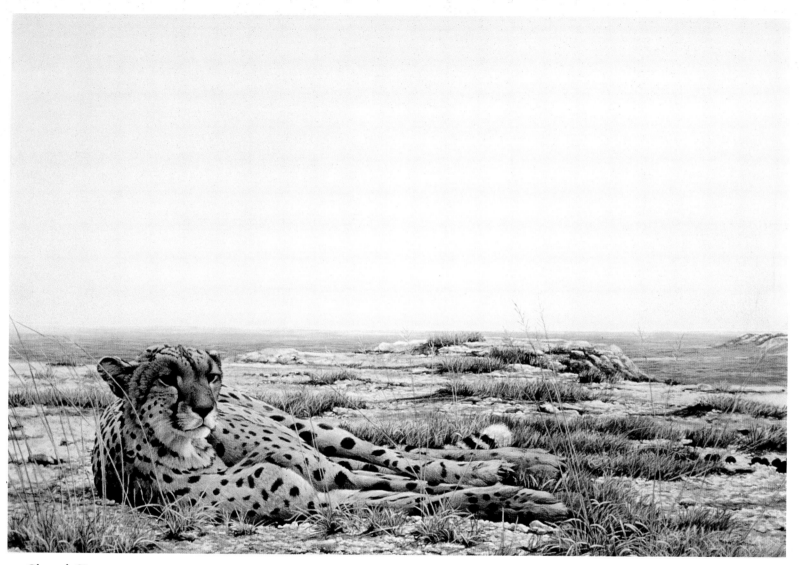

1 *Cheetah Siesta*

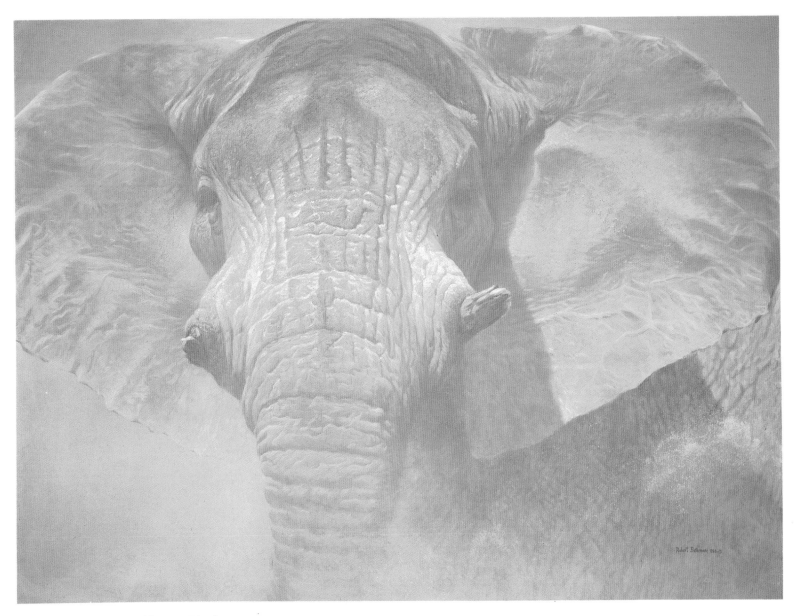

2 *The Wise One—Old Cow Elephant*

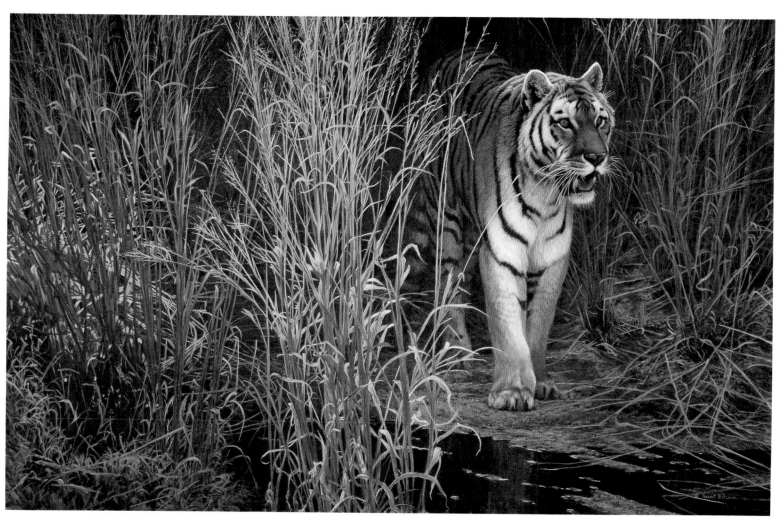

3 *Tiger at Dawn*

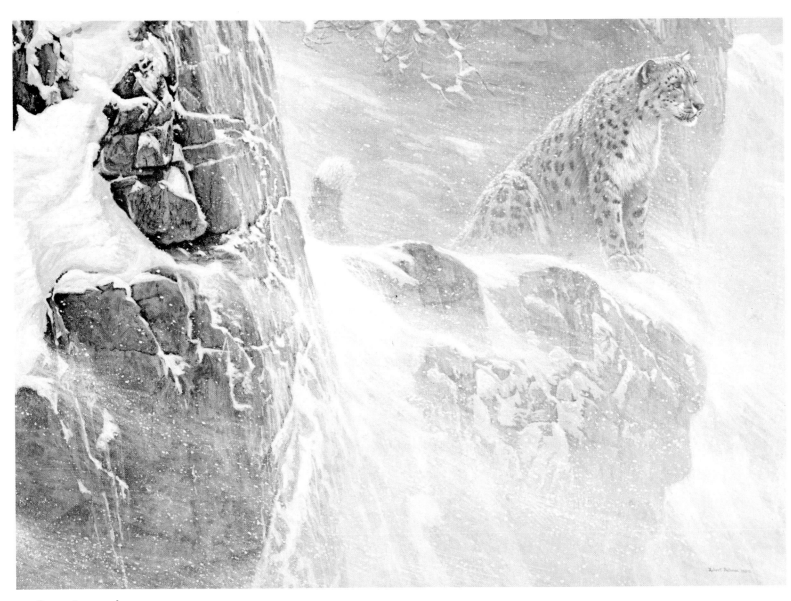

4 *Snow Leopard*

5 *Awesome Land—American Elk*

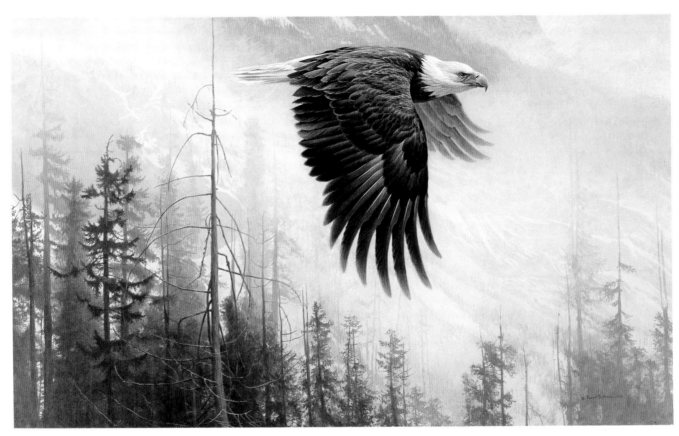

6 *Majesty on the Wing*

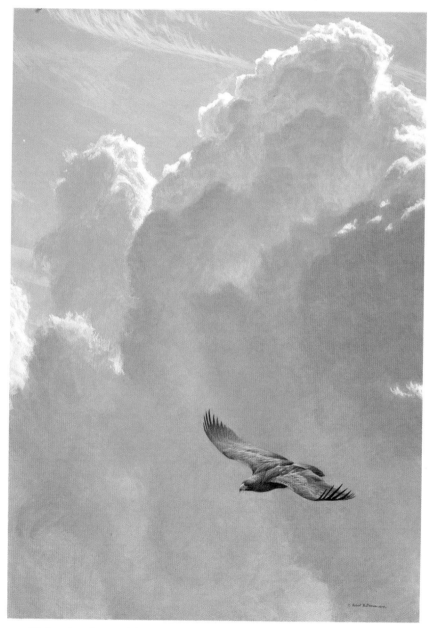

7 *Flying High—Golden Eagle*

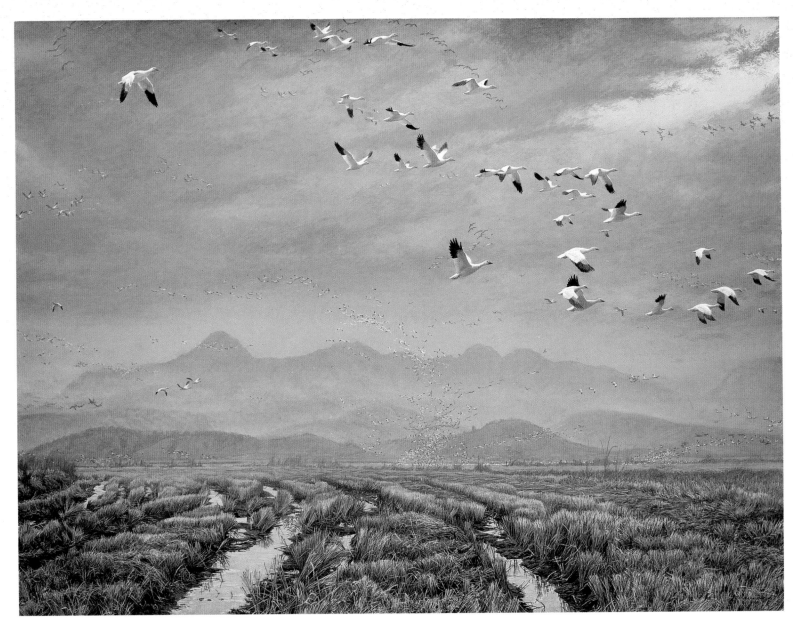

8 *Across the Sky—Snow Geese*

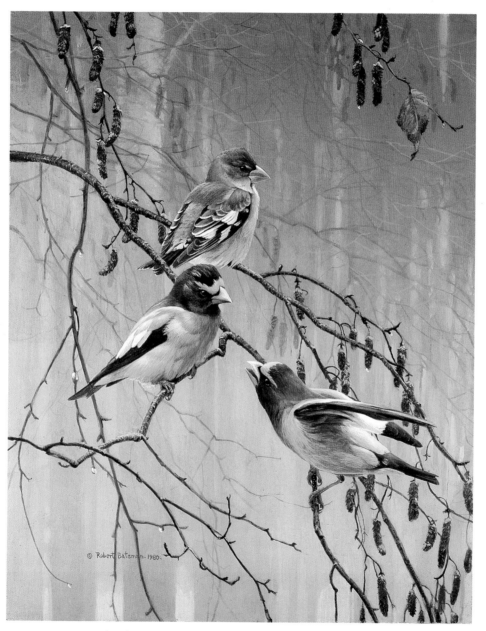

9 *Evening Grosbeaks*

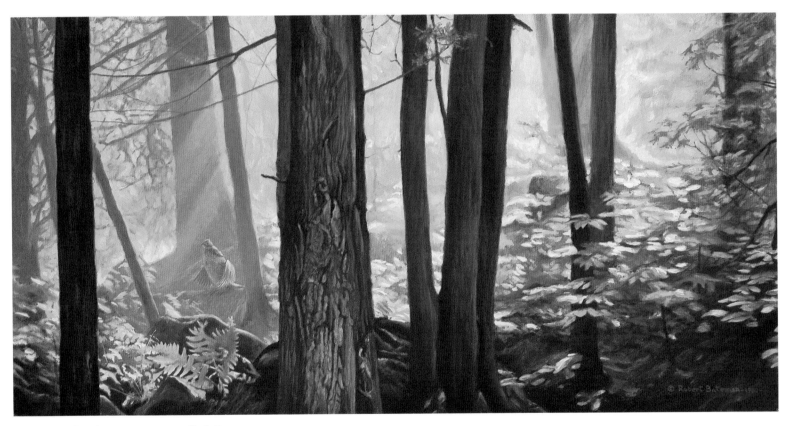

10 *Woodland Drummer—Ruffed Grouse*

11 *Arctic Evening—White Wolf*

12 *Coyote in Winter Sage*

13　*Wildebeests at Sunset*

14 *Great Blue Heron*

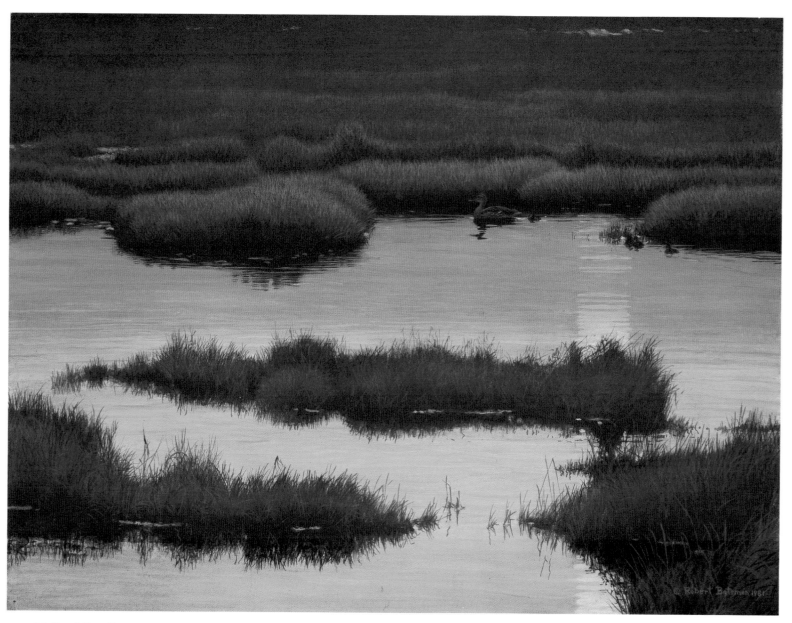

15 *Mallard Family*

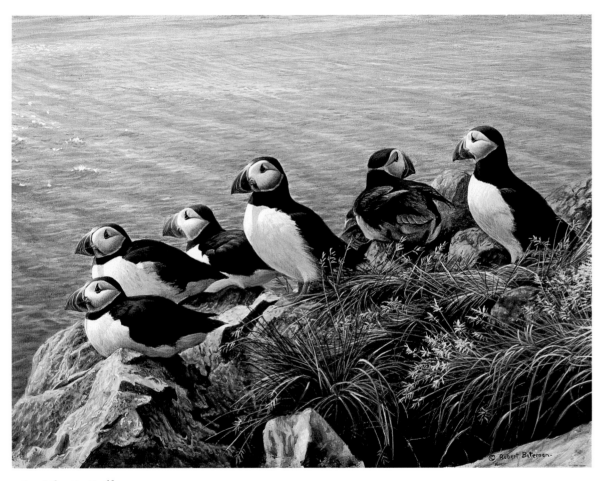

16 *Atlantic Puffins*

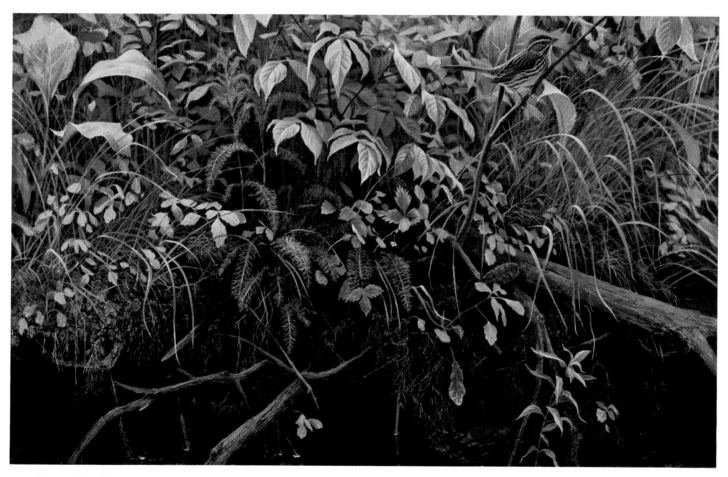

17　*Stream Bank—June*

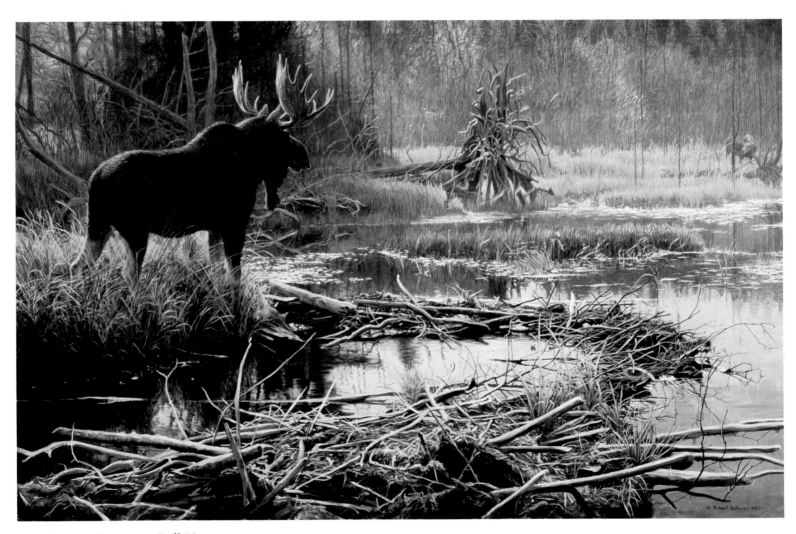

18 *Autumn Overture—Bull Moose*

90

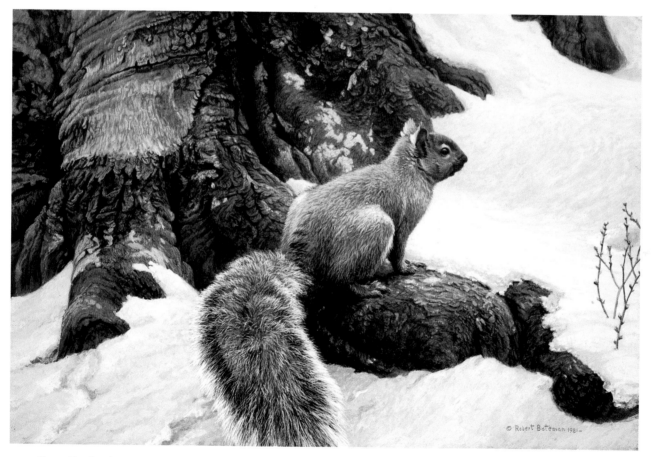

19 *Gray Squirrel*

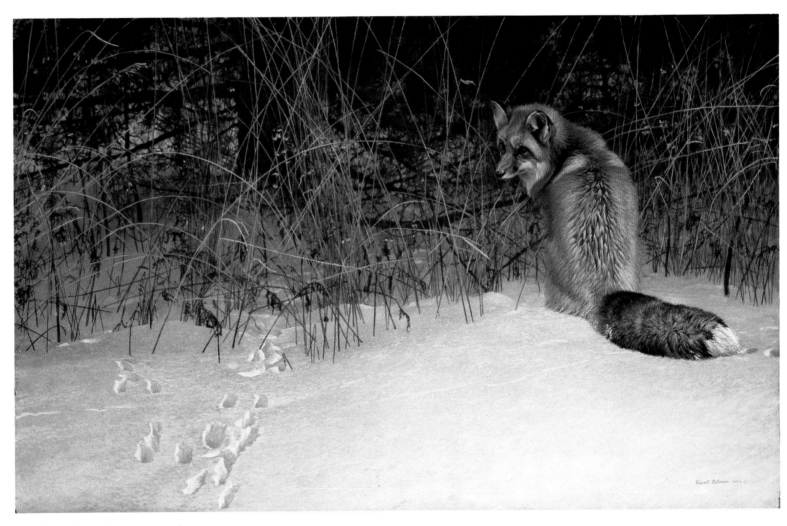

20 *Red Fox—On the Prowl*

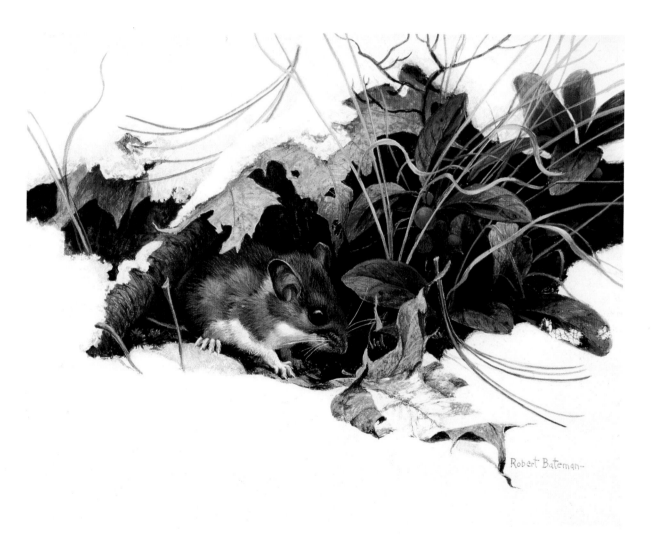

21 *White-Footed Mouse in Wintergreen*

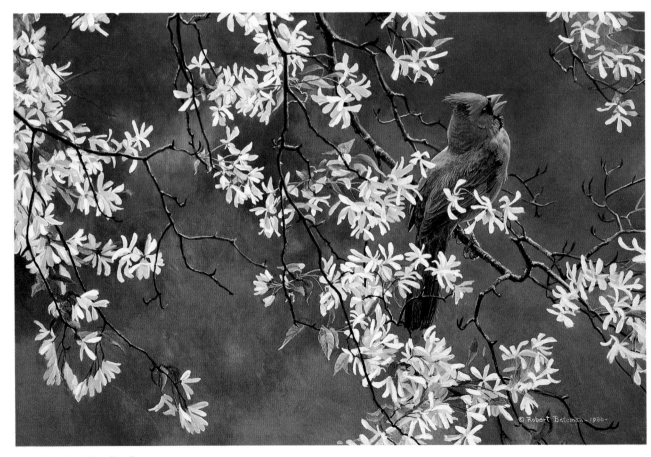

22 *Spring Cardinal*

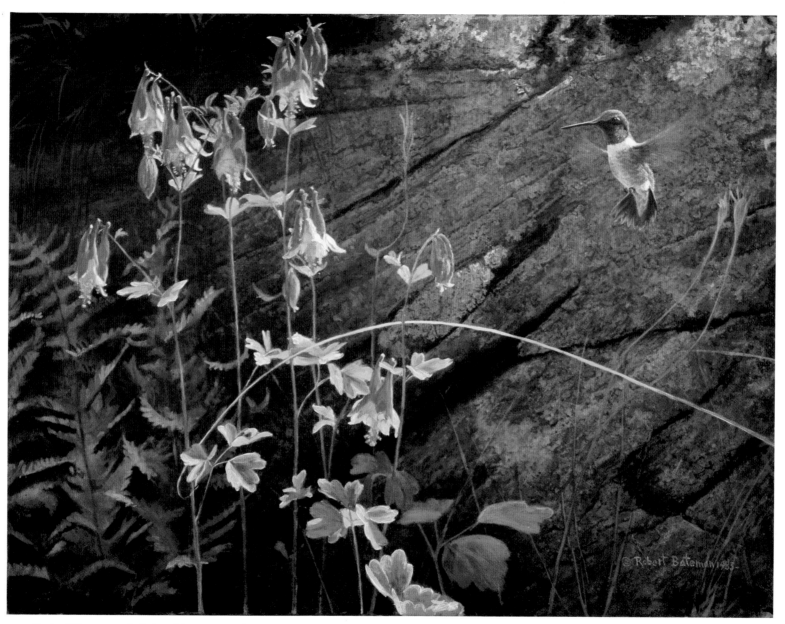

23 *Ruby-Throat and Columbine*

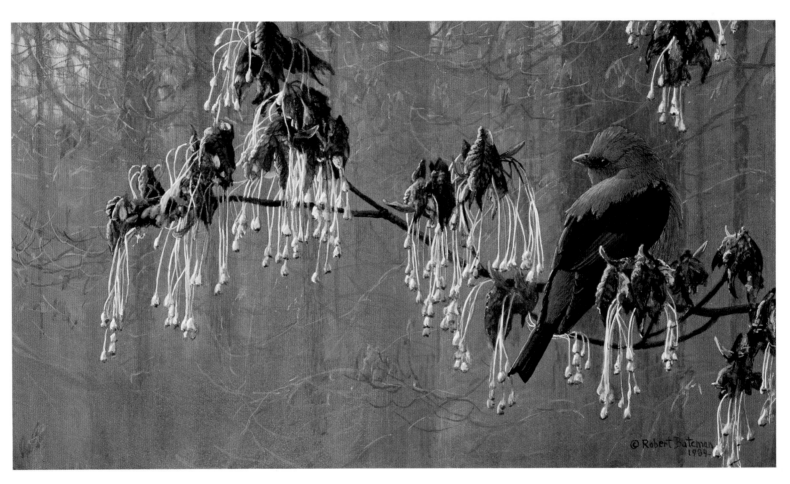

24 *May Maple—Scarlet Tanager*

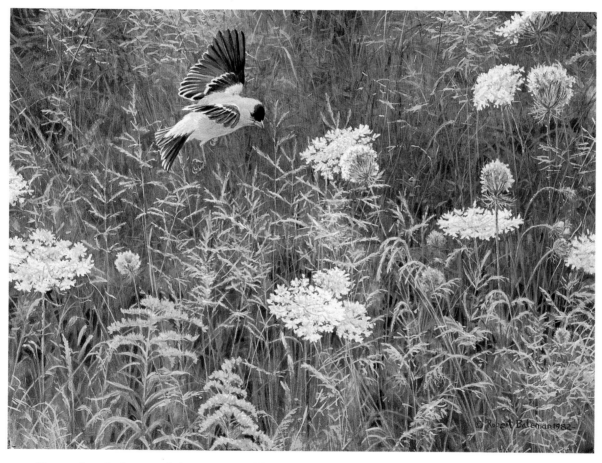

25 *Queen Anne's Lace and American Goldfinch*

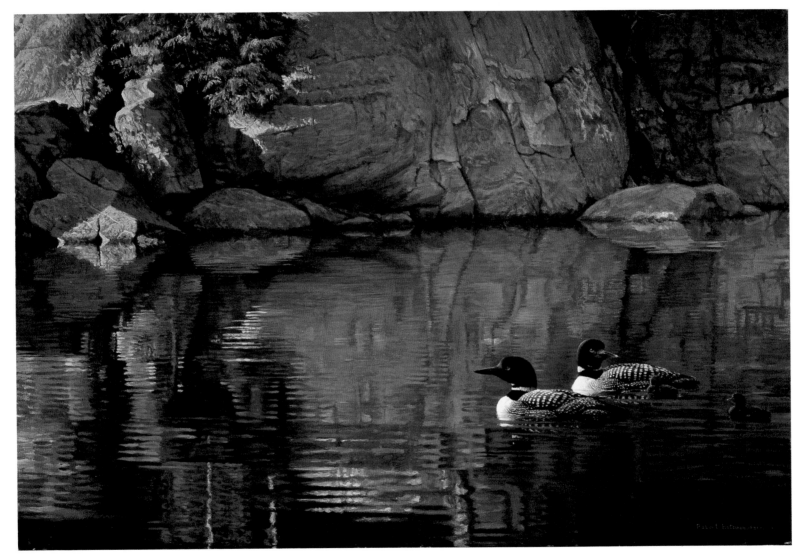

26 *Northern Reflections—Loon Family*

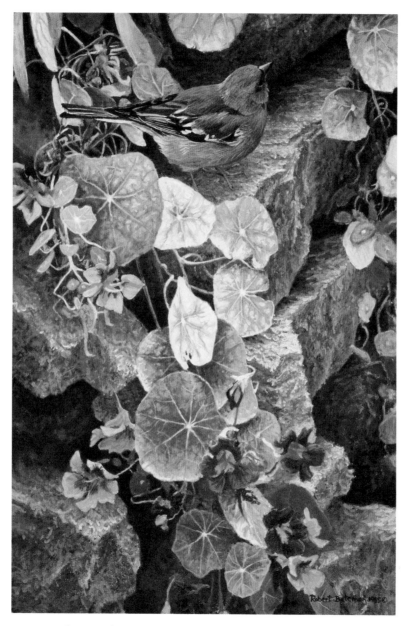

27 *On the Garden Wall—Chaffinch and Nasturtiums*

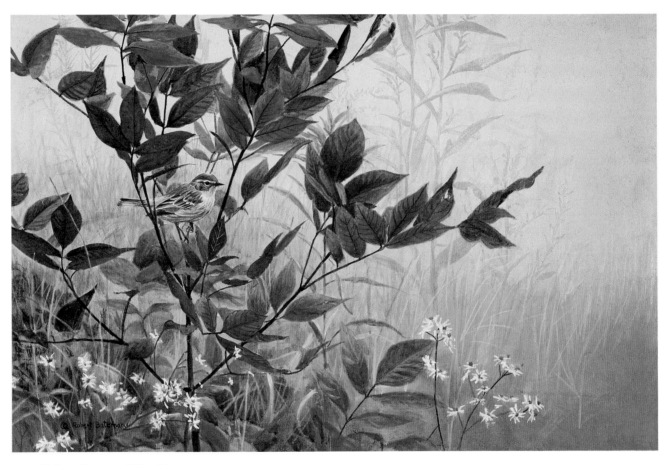

28 *Yellow-Rumped Warbler*

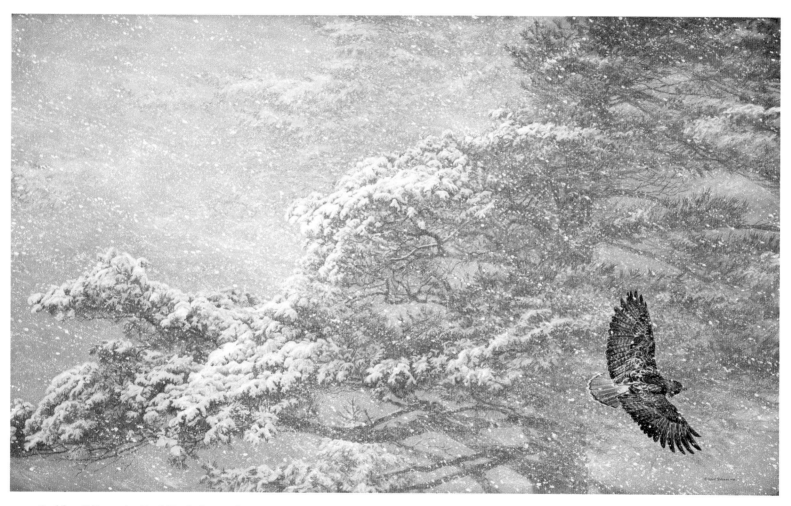

29 *Sudden Blizzard—Red-Tailed Hawk*

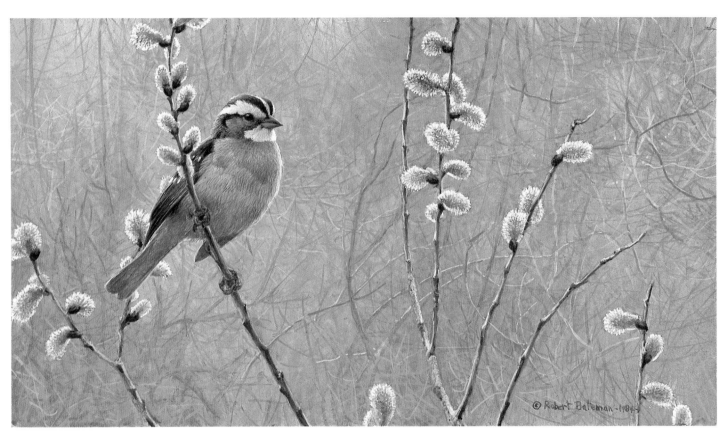

30 *White-Throated Sparrow and Pussywillow*

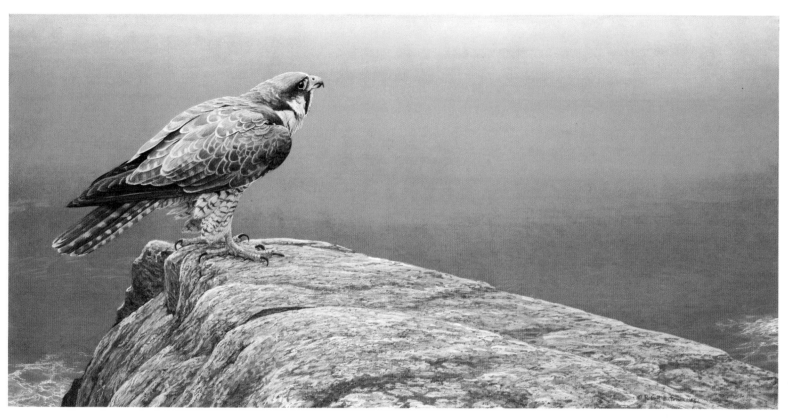

31 *Ready for Flight—Peregrine Falcon*

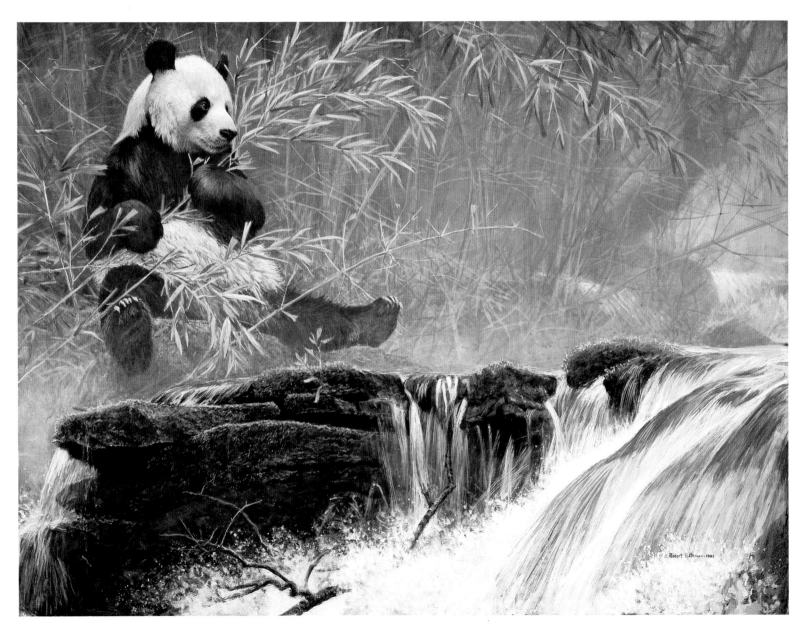

32 *Giant Panda*

3
Evocations of Wilderness
Far and Near

Wilderness? What is wilderness? To most, it is the original state of things—nature without man, without the sight or sound of human activity. Vast, unspoiled, untamed, wild domain. But man is part of nature, his intrusions here to stay. And today there are strict limits to the amount of the vast beyond that can be preserved forever at arm's length. If wilderness is nature's fastness beyond the frontier, it is also the frontier itself, the very threshold of the wild fortress which, no matter how fragmented, is always the frontier of discovery.

In today's world, the wilderness beyond—the wild fastness beyond the frontier and, indeed, the frontier itself—has nearly disappeared if it is not already long gone. The notion, then, of wilderness as distant, untouched wild space is becoming more and more relative. Increasingly, one must turn to other kinds of wilderness, to the inner spaces, to the green or natural spaces in the midst of where people live—the urban and backyard wilderness in the pocket wildlands of cities,

rural communities, and farms. Ultimately, wilderness reduces to a state of mind. Rather than undefiled nature and natural space, grand and fulfilling as they are, wilderness becomes a sense of wonder and discovery. Wilderness dies only when the sense of wonder and discovery dies, and as long as this innate sense is alive, the wilderness frontier can be as close as one's doorstep. In this chapter, our evocations begin with the universal notion of real wilderness as wild fortress beyond distant frontiers, which needs little elaboration. We then explore in greater depth the much less familiar idea of fragmented wilderness near at hand, perhaps literally in the backyard.

Nature's Fastness Beyond the Frontier

To the person who perceives wilderness in simplistic stereotypes—dangerous beasts, poisonous snakes, noxious plants,

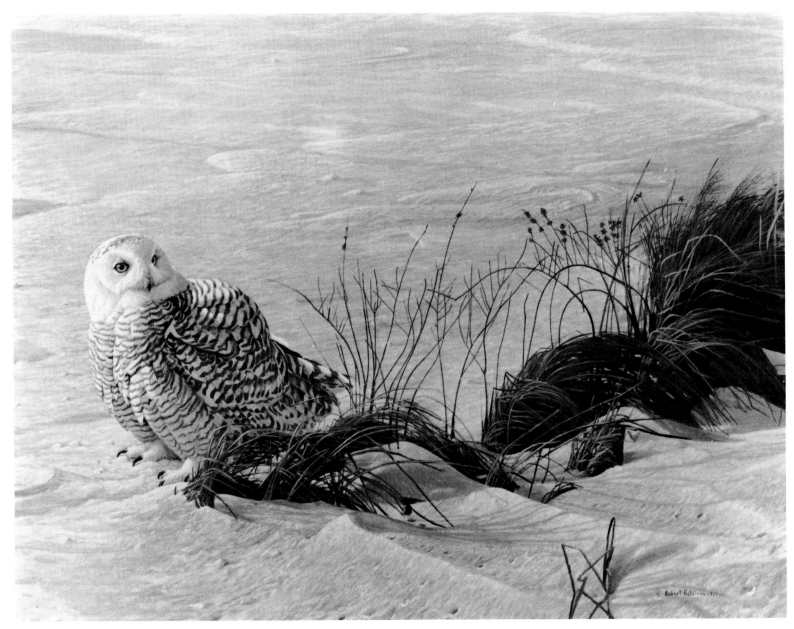

Afternoon Glow—Snowy Owl

biting insects, mysterious diseases, uncharted pitfalls—wilderness spells insecurity, even fear. The ignorant are impelled to conquer or destroy wilderness—to stamp it out, pave it, mow it, spray it, dump on it, drain it, develop it, or turn it into some kind of manicured or manufactured amusement park or a recreation playground with all the amenities of home. In short, they are impelled to create cozy synthetic biomes in their own image. But to naturalists, poets, mystics, and their ilk, wilderness is pure idealism—the word itself, one of the most idyllic, sentiment-filled in their entire lexicon.

Wilderness is both symbolic and real, both a state of mind and a tangible preserve. And the symbolism is as important to mankind's goals and ideals as the preservation is to mankind's very survival. If wilderness in the purest sense is the fortress preserve, the last bastion or reservoir of mankind's natural heritage of natural diversity—nature's bank of diversity to support the biological well-being of the globe—it also is a psychological Fort Knox, providing a symbolic wellspring of faith in the health and continuity of the environment and the continental or global ecosystem. It is also a wellspring, the very soul, of scientific, aesthetic, and spiritual idealism. Thus, even for those who wish to keep the real wilderness at arm's length, the symbolic wilderness is more central to their existence than they could possibly imagine. But, as with the gold in Fort Knox, some real wilderness must always be out there to justify the symbolism.

Robert Bateman is a naturalist and an artist, a realist and an idealist. He is a son of the wilderness, ever drawn to it, molded by it, and given to extolling it through heroic images, his panoramas and portraits of nature writ large. This is clearly both a conscious and an unconscious fact of his work. He is a true romantic, and most of his paintings evoke wilderness feelings, some particularly well.

Few natural realms remain in North America that seem to belong to nature's fastness beyond the frontier. In fact in the purest sense, none exists any longer; all natural realms have been compromised at the edges if not at the very core. Yet, in relative terms, there are three realms where wilderness still exists, not only in the hearts and minds of many people, but in actuality: the Arctic, the Canadian North Woods (including Alaska), and the high mountains.

Afternoon Glow—Snowy Owl creates a strong image of the immense tundra world of the Arctic that is frigid and snowy so much of the year. The pristine beauty of the owl, blending into the medium of its ageless environment and betraying little of the odds of existence in the Arctic, constitutes a haunting beckoning to a land incomparable, a wilderness totally beyond reach of most ordinary mortals. Breeding on the tundra meadows and barrens of the Far North around the globe, usually well beyond the polar limit of trees, this yellow-eyed, cat-faced owl lives mainly on lemmings and other rodents, and its fortunes are tied to the ups and downs of the lemming population. Tailor-made for the treeless land of the midnight sun, the ermined prince of the tundra kingdom typically perches on the ground and is as much at home hunting by day as by night. In North America, snowy owls winter southward over Canada and the northern states, but even in the forest regions they are more likely to perch on poles and buildings than on trees. During the periodic irruptions when the lemming populations crash, this owl appears sometimes as far south as the Gulf Coast. Only in those winters of deep southern incursion does the average person have a chance of tasting the arctic wilderness when it flies to him on the wings of the owl. Though he grew up seeing snowy owls every winter in Ontario, Bateman still experiences "an electric feeling" every time he glimpses one (1981, 108).

Immense areas of the North Woods of Canada and Alaska are lands of great sameness, lying on flat boggy plains pocked with ponds, streams, and lakes that seem to stretch to infinity. It is a wilderness to defy belief. Only the moose and other denizens seem to have any idea where they are. A trip through

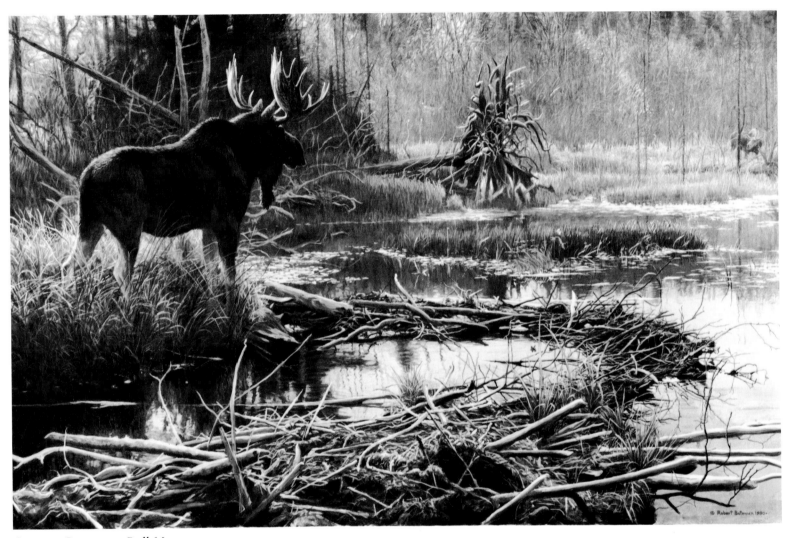

Autumn Overture—Bull Moose

this forest is like going from nowhere to nowhere; one could select a thousand look-alike spots at random that would have swampy clearings with stream and beaver pond to attract moose, which feed on the aquatic plants and often wade in to their bellies and duck their heads under water to reach the succulent nibbles. During the fall rutting season, the swampy edge of the beaver pond is a place to meet a cow as well as to find food.

The moose, largest member of the deer family and by most standards also the largest extant land mammal in North America, is an impressive beast; a large bull can weigh nearly a ton, stand to seven feet tall at the shoulders, and bear six-foot-wide antlers. This animal, despite its awkward beauty, puts the finishing touch on any North Woods scene. Today the species lives north of the Canadian border except for northern New England, Isle Royale, and the northern Rockies. Though canoe and float plane make some of its wilderness accessible, most will never see it. Bateman's *Autumn Overture* [18], depicting textbook moose country, is a stunning evocation of the beauty and wildness in the unending fastness that is the Canadian North Woods. These woods are especially lovely in the fall of the year when they are appointed with warm, glowing, golden tones.

Among wild fortresses, there is nothing quite like high mountains, especially the alpine zones. Anyone who has ever climbed a high mountain to that windswept zone where forest shrinks and hesitatingly defers to tortured shrub; who then has scrambled on to fresh green meadows gay with splashy little herbs; and who finally has picked his way, perhaps on hands and knees, up treacherous rubble slopes to the last rock pinnacles and ledges where tiny drabas and top-heavy bellflowers cling precariously to crevice and scree, and mountain sheep and goats gambol on death-defying cliffs—he it is who knows the alpine wilderness, the fastness that lies beyond the hubbub of the valleys far below.

In *High Country—Stone Sheep* Bateman seems to strand the climber on an alpine ledge with no visible escape, somewhere in northern British Columbia or southern Yukon, up with the stately Stone sheep, the true lords of this realm. The Stone (really Stone's) sheep is a dark race of the Alaskan Dall (Dall's) sheep, which lives only in the high-mountain wilderness of the northern Rockies in northwest Canada. During the summer, the rams keep their own company in the highest pastures, leaving their families to congregate in the meadows below. In this mountain fastness, the number of human intrusions over time must be very small, and few indeed are so fortunate as to take these wary, sharp-eyed animals by surprise in their rooftop refuge.

Backyard Wilderness: Nature Vignettes from Everyday Life

Today many must make do with the fragmented wildness around them, the wilderness at their doorstep. Even a city parking lot will do, if it is bordered with plantings that attract squirrels and mockingbirds and other birds in season. A border of flowering shrubs or trees can provide migrating birds with rest and respite and become a wheel of fortune for the persistent bird-watcher during the peak of migration in spring and fall, one day dealing up warblers, the next, thrushes. The old-fashioned farm orchard, where care is a sometimes thing, is an unparalleled backyard wilderness, especially in spring when the morning symphony of birds is at its zenith. There are always plenty of holes for bluebirds, house wrens, and red-headed woodpeckers; always taller trees for the northern (Baltimore) orioles; and then, in season, fun and fruit for the family. On a sunny day when the blossoms are buzzing with pollinators, a single, well-placed apple tree clothed in glorious bloom can attract a colorful roll call of spring warblers in the space of minutes.

Even the lawn, if it is not sprayed into submission as a grassy monoculture but is allowed some weedy diversity, can be a backyard microcosm of nature. When April's yellow sea of dandelion flowers gives way to May's cottony blanket of parachuted seeds, borne in many-fruited, fluffy orbs, the lawn suddenly is awash with the glow of yellow-and-black goldfinches, methodically combing the dandelion heads for their seeds.

Bateman is obviously fond of the creatures of everyday life that populate the backyard wilderness, and he has painted many of them—squirrels, chipmunks, rabbits, foxes, rac-

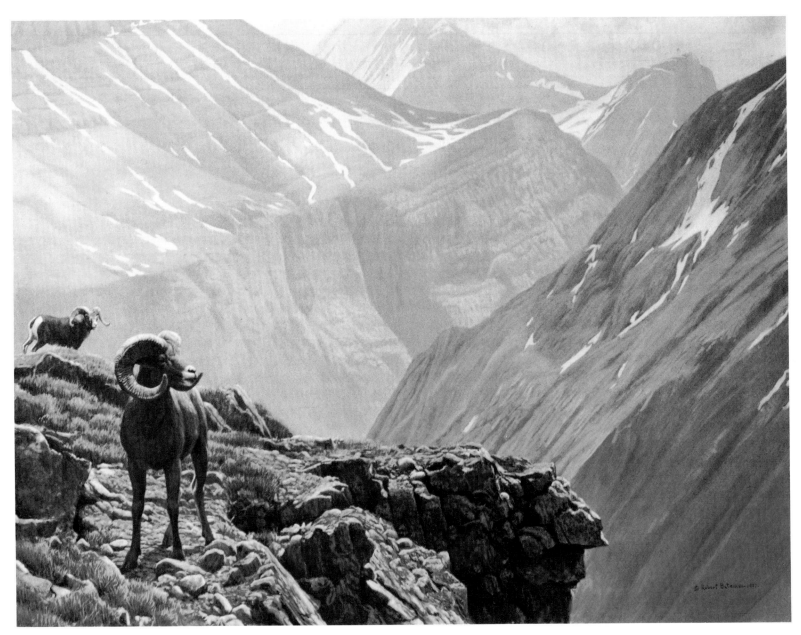

High Country—Stone Sheep

coons, mice, woodpeckers, jays, hummingbirds, bluebirds, cardinals, sparrows, mallards. Even his Canada geese, herons, and owls may sometimes be one's neighbors. The gallery of nature close to home can be amazingly large and diverse even in an urban setting, especially if there are city parks and gardens nearby. A small suburban lot can reward the diligent observer with a list of a hundred or more species of birds in just a few years. Some species of wildlife, including such wilder, rarer delights as the pileated woodpecker, have adapted well to human activity and not only survive but thrive in and around cities and other thoroughly developed areas. Mallards may nest in city parks, and a farm pond may attract a pair of resident Canada geese. A barn, a silo, or even an empty city warehouse may be home to barn owls, from which they make their nightly rodent runs over the surrounding farmland or cityscape. These are but a few of the more unusual neighborly birds vignetted by Bateman.

In *Gray Squirrel* [19], Bateman portrays a frequent neighbor in handsome pose on the rugged roots of one of his favorite trees, the American beech. In eastern North America, the impeccable gray squirrel is a beloved animal of the forest and the urban wild kingdom as well, where it is a highly adaptable, tenacious inhabitant of parks, gardens, tree-lined streets, corner woodlots, and backyards. Many city dwellers would never see a native wild animal if it were not for these omnipresent, bushy-tailed beggars and bandits of the trees, greens, and balconies. Like little people of the animal world, gray squirrels endear themselves especially to children with their amusing antics and seemingly friendly, conscious play. In the relatively sterile biome of the city where for many the notion of wildlife is largely defined by pigeons, starlings, house (English) sparrows, and undesirable rodents, the gray squirrel is a welcome, humanizing touch of nature, admired for the street smarts and mocking resourcefulness that allow it not only to survive but to exploit the environment. Like street people and in competition with them, it has learned to

cull the trash cans for edible morsels and even to unwrap sandwiches tossed out by school children with their bag lunches. Perhaps the animal's ingenuity assuages their little consciences for this surreptitious act of rebellion against well-meaning mothers. Of course, around the house and garden, the gray squirrel can sometimes wear out its welcome. Many have become addicted to bird feeders, especially sunflower seed feeders, where they either charm or infuriate, depending on who's watching—or paying!

Bateman's magnificent vignette is more than a portrait of the animal in its sartorial splendor. It also makes the point that gray squirrels do not hibernate but are active in winter, and the painting is replete with the dried skeleton of the beechdrop, a chlorophyll-less, parasitic flowering plant that parasitizes only the roots of the beech tree. Even without this clue, however, Bateman leaves little doubt by showing a clear patch of the gray, "elephant-skin" bark of the beech, as he puts it (1985b, 132). Here on the roots of an old and mighty beech, the squirrel seems to be sitting, as it were, on the toe of a giant, war-scarred elephant.

The fox, depicted so aptly by Bateman in a mischievously curious pose in *Red Fox—On the Prowl* [20], may be the most famous animal of story and lore and certainly is one of the most familiar of the whole animal kingdom. Often used to exemplify human attributes, particularly craftiness, it is the hero or villain of countless moralistic stories written or told since ancient times, including biblical parables. "Reynard" is the fox hero in the French epic *Roman de Renart*. The original Uncle Remus stories of Joel Chandler Harris, told and retold to generations of children, have immortalized the cunning fox and his nemesis, Brer Rabbit, among other animals.

The crafty red fox is extraordinarily successful at living in close proximity with people. Though not often seen, it seldom is far from sight, and it watches people much more often than people watch it. In another painting, Bateman epitomizes

Gray Squirrel

the hide-and-seek game that goes on daily, even in suburbia, with a curious fox glancing around a corner at some, probably oblivious, intruder. Only when one learns the fox's habits well enough to match cunning with cunning does one begin to see foxes and to realize how common they are. The red fox is primarily a nocturnal creature but it hunts more frequently by day than is usually thought, especially in winter when making a living can be a 24-hour job. Bateman's *Red Fox* is "about to check under the pine tree where the snow is thinner and where some of his winter prey—mice, squirrels,

Red Fox—On the Prowl

or rabbits, for example—might have sheltered. Just before he pushes through the tangle of twigs and grasses he pauses for a moment as he notices some rabbit tracks" (Bateman 1985b, 134). Close up, as in this sensitive vignette, the red fox always looks frail, vulnerable, innocent, playful as a pup, and incredibly more beautiful than imagined. The back and face seem so much redder, the throat, belly and tail-tip so much whiter, and the legs and feet so much blacker than anticipated.

White-Footed Mouse in Wintergreen

Turning to the mice brings us to the moment of truth in the backyard wilderness. The lowly mouse has a hard time getting any respect. Nobody loves him, and most of nature is against him. Sitting near the bottom of the food chain is a terrible burden to bear; just about every carnivorous creature can pick on him. Hawks hunt the mice by day, and owls and foxes hunt them by night. Then there are the snakes and the weasels and the list goes on. As if this weren't enough, everybody has cats that patrol day and night, guarding all the portals to safety. Life for the mouse is an

endless gauntlet of mortal threats and life-defying hazards.

Yet no discourse on backyard wilderness would be complete without mention of the world of the mouse. It is a world apart, even if only a stone's throw from one's doorstep. Most mice keep their well-ordered places in the ecosystem and go about their unpretentious lives silently and out of sight, never threatening anyone; they help to keep the earth from being smothered in vegetable matter or eaten up by insects. The white-footed mouse is a common inhabitant of dry forests and woodlands, especially oak-pine woods, in eastern North America. It is active chiefly at night and year-round, except in the coldest winter weather when, as many woodland mice, it may only do limited foraging in tunnels through the litter under the snow.

Bateman's Christmas cameo, *White-Footed Mouse in Wintergreen* [21], shows that the animal's realm is a world in miniature. Here in this tiny passage under the snow, lined by dried sugar maple leaves and white pine needles, the protectively colored mouse suddenly comes upon some food—standing hay and the glossy, bronze-green leaves of the hand-high wintergreen or teaberry, which is loaded with juicy red berries. The mouse's long whiskers are important sensors for feeling its way through the tunnels.

The backyard wilderness—doorstep nature—symbolizes the priceless values of wilderness great and small and of the intercellular green space that keeps the man-made cells of our urban estate from coming unstuck. It is an essential reminder of a natural sanity and order in the midst of an artificial environment that too often spells madness and disarray.

bright white.

Fox Sparrow scratching in leave
Mar 28/80

4

The Cycle of the Seasons

Nature is characterized by rhythms on every hand, some more obvious than others. All plants and animals have life cycles and reproductive cycles, at times one and the same thing. The full life cycle begins with fertilization and germination or birth, then progresses to sexual maturity and regular breeding and reproduction, and closes with senescence and death. Many animals, birds, and plants breed on an annual cycle, synchronized with the seasons.

In the equable climates of tropical regions, life tends to proceed on a more or less even keel throughout the year, and the biological rhythms are not so obvious. Some regions of the earth have marked wet-and-dry cycles, with dramatic effects on the plant and animal rhythms. Nothing is more pronounced, however, than the annual seasons of cold temperate regions, particularly the north temperate regions with deciduous forests. Here the four seasons in their classic sense are marked by sharp climatic differences that strongly affect the cycles of the plants and animals. Thus the seasons provide the scale for following and measuring the progress of some of nature's many cyclical events through the year. A cycle, like an orbit of the earth from which the seasons derive, is a closed loop; the end is the beginning and the beginning is the end. Without such mileposts as the seasons or the different events in reproduction, it is difficult to follow the sequence of the cycle and mark the course around the loop.

Spring

We live surrounded by a world of trees and grasses and flowers. Our very lives depend on these green factories, which drive the food chains sustaining all other living things. They also cleanse the air we breathe and recharge it with life-giving oxygen. Yet only in spring do the green things break

out around us with such force as to capture our thoughts for a moment, renewing our conscious reverence and our zest for living on a vegetated planet. The plants, suddenly unshackled from the clammy grip of winter, seem to outdo themselves in shapes, sizes, and colors—and fairly seize our notice. From the first brave blooms of crocus and hepatica and bloodroot in late winter, spring charts a quiet course until it no longer can conceal the secret growth. Then it bursts upon us in a loud and joyful pageantry.

Longer days, warmer and wetter soil, and a higher angle of sunshine call forth an explosion of new growth that heralds the beginning of another reproductive cycle. Buds swell and burst, green shoots pierce the soil and spread their delicate leaves, fiddleheads unfurl, and trees bedeck themselves in pastel greens and cottony masses of blossoms and rich-colored fruits. And, all the while, birds return, animals come out of hiding, and suddenly everything is in a family way.

If we must pick a time to begin, spring is the season. Of all the seasons, it is surely the most evocative—a mood as much as a condition, a place as much as a time. Spring is rebirth, the reassuring first act in the annual reenactment of nature's drama, a warm reminder of the regularity, rhythm, and order of life. Spring's recapitulation allows us once again to refresh memories, especially familiar ones from childhood, and at the same time to catch the scenes of the drama that were missed on every previous pass—the warbler never glimpsed or the wildflower that always eluded the search. For a fleeting moment, everyone seems to become a naturalist, as nature parades her finest wildflowers and flashiest song-birds across the stage.

Spring's birds and flowers—vernal jewels—distill in vivid form and song all the beauty and wonder in the natural landscape. The bluebird, long one of North America's best-loved birds, may also be its most famous harbinger of spring. Probably no other American bird has been so often celebrated in song and verse as symbolizing the worthiest human traits and emotions, notably winsomeness and happiness. The "bluebird of happiness" has cheered numberless souls since the invention of greeting cards. A bird that evokes rich memories, for many it is *only* a memory: the bird was almost brought down by the unwise introduction long ago of two aggressive aliens, the house (English) sparrow and the European starling, and by the twin plagues of more modern times—pesticides and habitat destruction.

The memory of the bluebird's predawn warble or of a sunbathed flash of this flying piece of sky lives forever. Few birds symbolize the pristine beauty of the original American wilderness—the wilderness of the Indians, even Audubon—or the idealism of the American experience more guilelessly. An emblem of nature's moral conscience, the bluebird is a living poem, a crystal note, that evokes the warm reassurance of the rural environment for which so many seem to yearn. In *Early Spring—Bluebird*, Bateman has distilled the essence of these sentiments and the chilly, damp realities of its early spring habitat on the bird's first arrival. Sitting on the handle of the pump, itself a nostalgic hallmark of another era, in tree-dotted open country bordered by woods, is a male eastern bluebird, its paler mate (no doubt) perched in typical fashion not far away on a post. Though nowadays in greatly reduced numbers, this species occurs south of the tundra throughout eastern and central North America up to the Rocky Mountains. Its range is complemented on the west by the overlapping ranges of the similar western and mountain bluebirds, the latter reaching east-central Alaska and the former, north-central Mexico. If the three species are taken together, the bluebird is about as widely native on the continent as any bird.

The eastern bluebird loves short-grass country—open woodlands, edges, fields, and even lawns—with scattered trees, posts, or wooded borders that provide woodpecker holes for nesting and perches to scan the grass for insects. The oldtime farm fields with scattered trees and constantly rotting fenceposts, as Bateman seems to depict, were ideal. Nowadays, a golf course or lawn will do just fine, if partially

Early Spring—Bluebird

wooded and provided with artificial nesting boxes. Thus Bateman's scene could be yesteryear's farm or today's golf course (beyond the fence). The bluebirds usually make their first appearance during the soggy days of late winter and may begin desultory house hunting while the land is still burdened with snow. Eastern bluebirds migrate southward from the northern reaches of their range, but in the southern areas at least some are likely to stay around all winter. Thus, when the bluebird first "arrives" in springtime, it may only

be coming out of hiding from the deeper woods and bottomlands. Regardless, the first appearance is a time to look up with hope and celebrate the arrival of spring.

The bright, cheery cardinal, a favorite of everyone, makes friends with its voice as well as its looks. The always striking, all-red male, known to many as the "redbird," is unmistakable. As in Bateman's joyous *Spring Cardinal* [22], it is

Spring Cardinal

painted with a warm, cherry red, punctuated only by the coal-black face and bib; its other instant-recognition features are a conspicuous crest and a heavy, conical, reddish bill, used for cracking seeds. The bill gives away the bird's close affinities to the grosbeaks.

The cardinal is the neighborhood harbinger of spring because it stays in the vicinity all year, telling the seasons not so much by its movements as by its changing personality. When the time is right, something stirs within the resident cardinals that have been socializing at the sunflower-seed

welfare trough all winter, and they suddenly go their separate ways, mount their favorite soapbox perches, and, especially in the moments before dawn, begin to declaim their territorial intentions in loud clear whistles that any youngster can imitate. The species seems to have an endless repertoire of whistle permutations, but individuals have their own vocal signatures. Some cardinals get a headstart on territorial singing on a warm sunny day in winter long before they can be truly serious about mating. Singing starts in earnest when the first blooms begin to appear in the forests—early April to early May, depending on the place. This time can be marked approximately by the sudden appearance of the smoky white puffs of shadbush flowers here and there in the barren woods on the hillsides. As Bateman notes, it is the first tree to flower in the spring (1984, "May"). When it lights up, the whole woods glows with warmth and promise that decisively dispel the woodland's winter monochrome and put the cold season behind. The shadbush, which passes under a variety of regional common names, is a twiggy shrub or small tree with smooth gray bark, long pointed buds, and flowers with five delicate, fingerlike petals that betray its place in the rose and apple family. The blueberrylike fruits, sometimes called Juneberries, are juicy and tasty, but the birds usually get to them long before would-be human foragers.

Contrasting starkly with the bluebird, the cardinal radiates success. Far from threatening its existence, the massive disturbances since the first Europeans came to America have multiplied its preferred habitats by creating untold new edges, open woods, thickets, parks, backyards, and ornamental plantings of edible fruits. All this help, coupled with widespread winter feeding, has enabled the cardinal to expand its range greatly in the present century, especially northward. No matter how common, the cardinal is never commonplace and is always welcome, summer and winter. It remains an all-time favorite at the winter feeder.

Naturalist connoisseurs of spring, especially the birding faithful, often mark the progress of the season by the migrating birds, particularly taking notice when the neotropical migrants return—the birds that summer in temperate North America and winter in the American tropics. Many of these amazing species are adapted through their long evolutionary history to live on two continents each year and to make the precarious semiannual journey between their two homes. Thus their ecosystem spans two hemispheres and a migrating corridor in between. The young of the year must make the first round-trip without prior experience. The riddle of migration, although much has been learned about it, is still largely unsolved. The lay public also takes note of migration as a measure of spring, avidly following such well-publicized annual events as the return of the swallows (cliff swallows) to Capistrano.

One of the most amazing neotropical migrants is the ruby-throated hummingbird. The hummingbirds, the tiniest birds, are truly the jewels of the bird world, and, as John Terres puts it, "almost everything about hummingbirds is unusual" (1980, 140), starting with their dazzling iridescent colors. They are the "helicopters" among birds, almost more like insects than birds in their behavior and feeding habits. Like oversized hawk moths, they can hover at flowers to feed as well as fly backwards, sideways, and straight up and down. The long needlelike bills, curved in many species, and tubular tongues are peculiarly adapted to sip nectar from the hearts of long tubular flowers.

The thumb-sized ruby-throated hummingbird, or ruby-throat, is the only species of this large New World family (three hundred species) to nest in eastern North America, where it is a common summer resident well known to anyone who pays attention to flowers and flower gardens. One of the smallest hummingbirds, the ruby-throat has one of the widest ranges, extending across all of the East to the Great Plains and to southern Canada as far west as central Alberta, occasionally to Alaska. Winters are spent from southern Texas to Costa Rica.

The ruby-throat arrives back in the United States with the first spring flowers, often after making a 600-mile nonstop flight across the Gulf of Mexico, and works its way north with the flowers, arriving in the northern states and southern Canada about the time the eastern wild columbine is in bloom. *Ruby-Throat and Columbine* [23] is a glorious glimpse of spring in April or May, freezing this fantastic tiny flier as it hovers on buzzing wings before a wild columbine in full bloom. In this charming and fastidious portrayal, Bateman has extended his usual palette to include bright greens and reds, and this is the genius of the painting's convincing springtime look. The blur of the wings, beating up to seventy-five times a second, is perfectly shown, and sunlight falls on the bird at just the right angle to show off its metallic green back and fiery red, iridescent throat, which in any other light would appear dull black.

The columbine, one of the ruby-throat's favorite red flowers, is a buttercup gone astray. Its five petals are scarlet with yellow centers and are fashioned into tubular spurs that project upward from the daintily dropping flowers, so that the hummingbird must come in from below to drain the nectar from the spurs. This red-flowered columbine is a native of eastern North America of more or less the same range as the ruby-throat. A delicate flower of rocky wooded slopes and cliffs, which grows in sun or shade, it also thrives in the wildflower garden where it is sure to attract ruby-throats.

The ruby-throat in Bateman's scene would shortly fly off to the next flower on its regular beat—now you see it, now you don't. So swiftly does it dart about its territory that one instinctively does a double take everytime this avian "insect" passes by. To be lucky enough to see this frail wizard of forest and garden pause briefly on a branch to "catch its breath," is to be let in on a moment of divine enchantment.

One of the outstanding highlights of spring birding in the cool forests of eastern North America is to see a male scarlet tanager nonchalantly sitting in full view on the limb of an oak or maple in the midst of leafing out. There is no more exotic sight and probably none more gorgeous in all the forests of the East. The thrush-sized tanagers—more than two hundred species of them—are New World birds almost entirely of the tropics, and they are some of the most colorful of all birds. In tanager-starved North America—there are only five species, of which two occur widely in the East— the scarlet tanager lends a tropical touch to the forest. With its flaming orange-red body and jet-black wings and tail, the bird brings brand new meaning to the word "scarlet."

The scarlet tanager arrives in the Northeast from its winter home in Colombia and western Amazonia when spring is at its zenith, around the first of May, just about the time when the sugar maple is leafing and hanging out its curious, long-stalked little flowers. Bateman's spectacular *May Maple— Scarlet Tanager* [24] brings together these two treasures of the eastern forests in a brilliant symphony of spring. The sugar maple is one of the most valued and storied trees of the North American forest, and these pendulous flowers, like so many tinkling bells, ring out their timeless music of the season, while the tanager adds colorful harmony. In summer the maple and the tanager occupy similar ranges—most of the eastern and central United States, except the deep south, and southern Canada. In the southern parts of the range, the tanager and the maple tend to be confined to the mountains, and to many they epitomize all the glories of an Appalachian spring. The scarlet tanager is partial to tall trees, especially oaks, where despite its loud colors, it can be extremely difficult to spot among the thick green of summer. Playing hide-and-seek among the high leaves and only now and then popping into the sunshine to afford a breathtaking glimpse, the tanager is best located by its unmusical robinlike warble of sometimes incessant, tiresome phrases.

Many of North America's most beautiful and treasured summer birds, such as the scarlet tanager, are migrants from the neotropics, residing here only to breed. The ever accelerating destruction of the tropics and the continual destruction and fragmentation of habitat in North America threaten the

Ruby-Throat and Columbine

very existence of the neotropical migrants. If spring ever comes without these annual visitors, it will be no spring at all.

Summer

No one tolls a bell or sounds a warning when summer begins. It just happens, slowly, inexorably. Like air or water filling a void, summer seeps quietly into forest and meadow, mountain and shore, as spring seeps out. Spring is obvious—rushed, loud, boisterous, chaotic; summer is subtle—relaxed, hushed, genteel, orderly.

June 1 is as good a date as any to designate as the beginning of summer. By then the season clearly has arrived in most parts of the continent, even the more northern parts, although spring has been sowing the seeds of summer from the moment it began to creep northward across the land. By June 1 the pace of plants coming into bloom has reached a crescendo, having gradually built up from a series of discrete flowering events to a blur of bloomings. The forest long since has been darkened by dense leafy canopy. Meanwhile, except for a few late stragglers, the migrant birds have all reached their final destinations and begun their summer homelife, leaving the local woods, fields, and wetlands through which they passed enroute silent once again, save for all the typical resident voices of the summer.

Once the canopy of summer closes over and the hum of ordered daily life in nature sweeps away the ad hoc days of spring, life for the naturalist is less frenetic. Now there is more time to follow events. Spring flowers flash their colors and disappear, but summer flowers may last and last. And the birds that remain are here to stay, at least for the duration of the summer season.

Nature through the seasons is like a feast of many courses, and a new table is spread continually. In the shady summer forest, one finds spring's feast entirely gone, leaving scarcely a sign, and a whole new one of shade-loving jewelweeds and other flowers, ferns, and leafy greenery has appeared. Meanwhile, under cover of the dense green blanket so obligingly drawn by the trees to shroud the forest's lairs, all the many creatures go about their largely secret lives and propagate their kind, passing this vulnerable season unheralded in relative obscurity. Even the once exuberant singing of the birds is now muted, and the woods are often strangely silent.

In the fields and meadows and the swamps and marshes, nature all the while has been laying comparable tables of ever changing feasts. Summer flowering gets started later in the open habitats; especially in the wet habitats, the water, slow to gain heat but also slow to lose it, exercises a year-round moderating effect. In the fields and wetlands, summer begins later but lasts longer.

This is a lush and extravagant season when all the landscape is arrayed with a profligacy of living things; all the spaces are filled with green, gilded by the many hues of a bewildering assortment of flowers and livened by a teeming world of animals, large and small. Indeed the summer landscape is such a mass of overlapping species and lives that the observer has difficulty finding the will and the way to focus. Nature's great matrix in summer, however, is composed of everyday species. Summer is the time, therefore, to push aside our penchant for chasing after the rare or unusual in favor of the common or ordinary.

Queen Anne's Lace and American Goldfinch [25] is a lovely portrayal of summer's ordinary lives and, indeed, of the season's ecological texture. An uncut meadow is a work of art, crowded to overflowing with the blades of an endless variety of grasses and the stalks of many colorful herbs. But few people ever stop to notice. Bateman has concentrated on form and impressions, choosing not to be taxonomically specific for the ground mass of uncountable blades, stems, and seed panicles in this small patch: "My main aim . . . was to give form to these few square yards of meadow. . . . Although it may suggest great detail, this is not a detailed

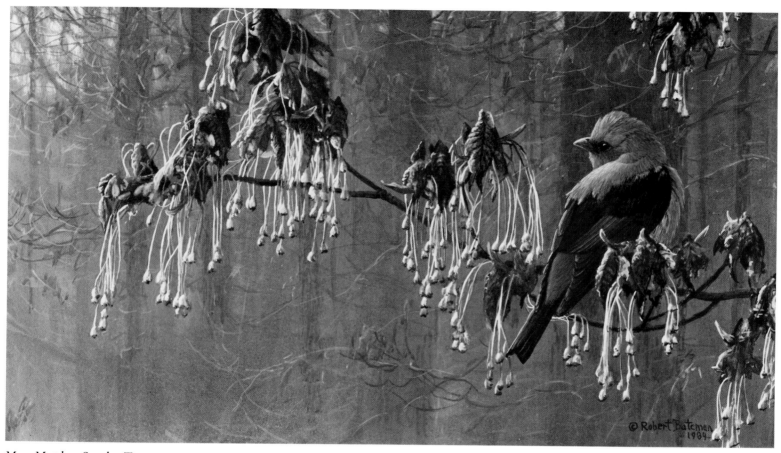

May Maple—Scarlet Tanager

painting" (1985b, 150). Clearly identifiable, of course, are the goldfinch, which becomes the main focal point, and the Queen Anne's lace and foreground goldenrod, probably the early goldenrod. The American goldfinch and Queen Anne's lace are two of North America's most attractive and admired wild species. They also are two of the most abundant and wide-ranging elements of the summer matrix. Both are characteristic of fields, meadows, and waysides, but inhabit many places. The juxtaposition of goldenrod and Queen Anne's lace indicates mid to late summer, perhaps about the time the goldfinch, a late breeder, is nesting.

Queen Anne's lace, really the wild carrot from which the garden vegetable is derived, is a European plant that long ago became naturalized in North America and has since spread across the United States and southern Canada. It belongs to the Parsley family, and its large (2–4 inches across) flat-topped inflorescences—umbels—are made up of numerous tiny white florets, each with five even tinier petals. The

Queen Anne's Lace and American Goldfinch

whole effect is lacy and lovely. Before and after peak flowering, the umbel is cupped, suggesting a bird's nest, the basis for the common name "bird's-nest." Though really a weed, it is one of the best known and most cherished American wildflowers, often picked for bouquets.

Known to most people as the "wild canary," the American goldfinch is a distinctive and lively little finch, characterized by its undulating flight and *per-chik-o-ree* call as it bounds over woodlands, weedy fields, and various other open habitats. Gregarious and carefree until it nests in midsummer, it usually travels in small flocks about the countryside most of the year, like so many vagabonds. Goldfinches are permanent residents over a wide belt of the central and northern states from coast to coast. It breeds as far north as southern Canada, and winters to the Gulf Coast and northern Mexico, with the northern birds shifting southward in winter. Common at winter feeders stocked with sunflower or thistle seeds, the cheery little bands are especially welcome visitors on the coldest days. After the breeding season, the male loses its lemon-yellow plumage and black cap and takes on the yellow-olive plumage of the female. The goldfinch and the Queen Anne's lace speak, as it were, for the common folk in nature, and they both imprint authentic signatures of summer on the land.

Loons, Bateman tells us, are among his favorite birds and he has often painted them. His intimate portrait *Northern Reflections—Loon Family* [26], commissioned in 1981 by the Canadian government as a state gift to Prince Charles, provides a sharp contrast to *Queen Anne's Lace and American Goldfinch*. It is a portrait of an utterly different summer landscape and a different kind of summer. Neither ordinary nor common, in the sense of occurring in our everyday surroundings, the common loon is one of the precious gems set *in* the matrix of nature, not, as the Queen Anne's lace or the goldfinch, part of the matrix itself.

To muse on *Northern Reflections—Loon Family* is to be transported beyond the borders of ordinary experience to a northern summerplace of wild, lonely lakes and immense enfolding forests or to a summerplace of the mind filled with inexpressibly wild and solitary feelings. It is to dream of Canadian hideaways, summer vacations, and sunsets—of the pure essence of north woods and wilderness. The loon is incorrigibly wild; it lives in the wilderness and has the wilderness within. In many ways it *is* the wilderness, upholding the ideal of the wild wherever it lives in summer.

Only the sly and the stealthy ever see loons close up. From his clever hiding place, Bateman brings every viewer face to face with untamable wildness. The loon, half suspecting the surreptitious intrusion, glances furtively over its shoulder. Bateman's real setting is Killarney Provincial Park at the head of Georgian Bay in northern Ontario. As he tells us, the loon's ghoulish laugh or yodel is "one of the North's most memorable sounds" (1985b, 160).

The common loon is a water bird of North America that spends its summers on lakes and slow-moving rivers on the arctic tundra and in the northern forests, largely north of the Canadian border, and also in Iceland and Greenland. It winters mainly in marine waters along all the coasts of the continent, as far north as Labrador and Alaska and as far south as Baja California, but sporadically appears on ice-free inland waters. Most who know this bird know it from its winter haunts or in migration. In winter it trades its striking formal summer attire for a nondescript black-and-white garb and is far less handsome.

From the Canadian wilderness to a neglected English garden wall, summer takes still another, perhaps unexpected turn. At first thought, Bateman's *On the Garden Wall—Chaffinch and Nasturtiums* [27] might seem quite out of place in a North American discussion of the seasons. But the seasons are not an American invention, and the same summer comes to all in the Northern Hemisphere. Moreover, the English were celebrating summer long before their descendants came

127

Northern Reflections—Loon Family

to America. They brought their gardens and their sensibilities with them, and North Americans owe much of their appreciation and sense of gardening to the English.

Bateman's portraits of nature afford an opportunity to examine both the union and the communion of man with nature. The previous two paintings illustrate the communion; *On the Garden Wall* illustrates the union. Summer is the time to garden, and man has been gardening from time

immemorial. What is a summer without garden flowers? The English have been growing flowers with exquisite skill for centuries, and they have combed the world systematically for interesting and beautiful things to grow. Garden flowers inevitably are merely ordinary plants away from home. Wherever man goes, he surrounds himself with his favorite plants and animals, and the English have been masters at this.

Take the South American (Andean) nasturtium, for instance. Its pea-green, shieldlike leaves and rich orange and yellow blossoms grace walls, trellises, hanging baskets, and dooryard gardens all over the world. What could be more lovely in summer or more typical of the season than a garden wall with cascading nasturtiums, especially an old neglected wall where the annual nasturtium keeps reseeding itself? The ubiquitous European chaffinch of forests, parks, and gardens adds a delicate and compatible counterpoint to the scene to remind one of the animal kingdom as well. "Whenever I visit the English countryside," Bateman writes, "I am struck by the ancient, complex, and familiar relationship between the domestic and the wild" (1985b, 84).

Fall

In the naturalist's year, fall is a season of mixed emotions, of highs and lows. It is a time filled with exhilarating weather, brilliant fall leaves, and colorful late-blooming flowers—but also a time of sullen skies, somber birds, and withering vegetation. It can be a time of great excitement and discovery, if one gets caught up with hawk-watching, hunting mushrooms, or sorting out the warblers, butterflies, or asters—or a time of melancholy, if one dwells on autumn's fading life. Everything is either shutting down or transforming into some other, often scarcely recognizable form or state, getting ready for the cold season. Herbaceous plants die back to the ground, while many woody plants lose their telltale leaves and pass more or less incognito through the winter months.

On the Garden Wall—Chaffinch and Nasturtiums

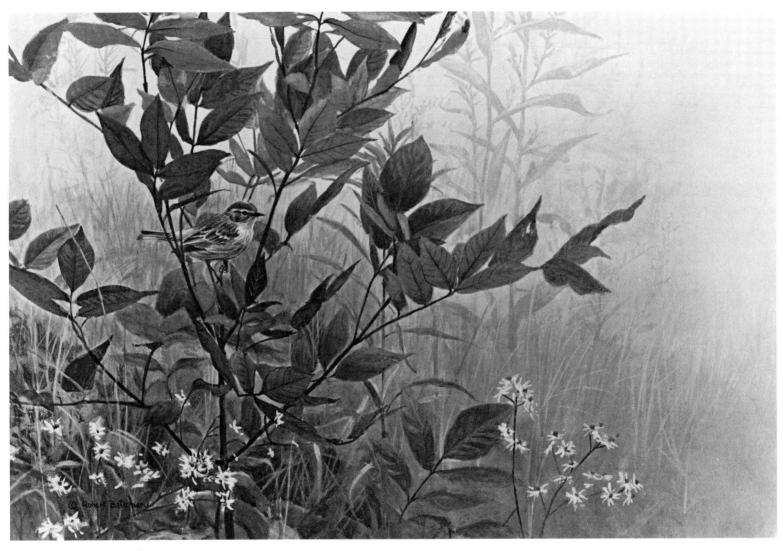

Yellow-Rumped Warbler

Indeed, everything seems to lose its identity in the fall. The plants shed unnecessary parts and do everything possible to prepare themselves to keep out of winter's way. Next year's life is carefully packaged or stored to pass the winter in underground parts or as dormant seeds or well-protected buds.

Eastern North America's most famous fall feature is its colorful foliage. It is fired up especially by the maples, but

every species contributes its own distinctive hue, including such instant standouts as the pastel pink of sassafras. The most outstanding tree is the sugar maple with its brilliant blends of reds, oranges, and yellows, followed by the red maple and its bright, clear reds and yellows.

Fall is also a time of great subtleties. Some of the most beautiful wildflowers of North America are the many fall goldenrods and asters, which seem to come in every shade of purple and blue in addition to white. But the asters and goldenrods are some of the most difficult species to distinguish from each other. Many birds also have taken on more subtle garb for the winter season after shedding their colorful breeding plumages in a post-breeding (postnuptial) molt. Suddenly, many adult males either look like the usually less colorful females or like the offspring of the season whose immature plumage is similarly subdued. At the same time, the birds are mostly silent, uttering at best only weak, lisping call notes of a generic variety that are as confusing as their plumages.

Most famous, even notorious, of these birds are the fall warblers, often called the "confusing fall warblers." These are the once colorful neotropical migrants now returning to their wintering grounds in camouflage. To the serious birder, they offer excitement and challenge; to the casual bird-watcher, they are a mystery and a frustration—birds to be ignored. To everyone else, they don't exist at all.

Nothing in nature epitomizes fall's highs and lows, exhilaration and melancholy, agony and ecstasy, better, therefore, than the proverbial "fall warbler." Bateman's *Yellow-Rumped Warbler* [28] instantly conveys the mood and ecological aspect of fall. Long called the "myrtle" warbler, for its predilection for the Atlantic coastal wax-myrtle, this warbler, including its western color variants, ranges almost throughout North America, nesting across Alaska and Canada, in the Rockies and in the northern parts of the East, and wintering over a wide swath of the southern United States south through Mexico to Panama and northward along both the Atlantic and Pacific coasts. It is the "weed" of the warbler world,

and can be extremely common in migration and on the wintering grounds, especially along the coasts. It is the only warbler picked up regularly on northern Christmas Bird Counts. Bateman has depicted a male in winter plumage, showing the telltale yellow rump and cap, always present regardless how nondescript the plumage. The misty background, so typical of cool foggy fall mornings, masks the dying plants, except for the generic white aster and bush, an opposite-leaved, viburnum- or dogwoodlike shrub. No one seeing this scene could fail to know the season portrayed.

Winter

Winter to the naturalist is not a season of doldrums or a time to hibernate indoors but a choice and invigorating season to be afield, a season filled with tracks and traces and a thousand little ecological riddles waiting to be solved. The snowy winter woods is a serene and enchanting place. One moment it may be a muffled, vaulting cathedral where one can meditate in the wondrous solitude of the dead stillness, interrupted, perhaps, only by the wind, sighing and eerily creaking its way through the trees, or by the hushed but insistent tapping of a forlorn woodpecker intent on finding a life-sustaining morsel. The next moment that same snowy woods may become a stage, erupting into a lively theater of fast-moving one-act plays. A sharp-shinned hawk picking off a cardinal, the silent glide-by of a shadowy barred owl, a pickup conference of friendly chickadees and titmice, the explosive flushing of a grouse, a white-tailed deer edging through the underbrush or bounding off through the trees, or a gray fox peering down from an arboreal perch—the possibilities are legion even in the humblest of woodlots.

Robert Bateman is no stranger to winter, and winter is a constant element or theme in his paintings. Many of his finest portraits of nature are winter scenes. The farther north one goes, the longer and more authentic winter becomes and the more pervasive and heroic nature's evolutionary adaptations

and accommodations. Thus the natural heritage of winter is much richer and more fascinating in the North. This is the land of birds and animals dressed in winter whites. It is also the land of owls (great gray owls) that actually can plunge deep into the snow for mice. No one knows this world of real winters better than this son of the North, and no one paints its winter wildlife heritage more majestically and authoritatively or with greater feeling.

Life never stops in winter but goes figuratively, if not literally underground. Winter is the time when nature's economy is running at its leanest. Much is hidden, tucked in and resting in a dormant or hibernating state or in some in-between state of limited or episodic activity. The animals largely go about their lives under wraps. Some, such as bears and groundhogs, are truly hibernating, while others, such as the chipmunk, go into semihibernation. Most, however, continue their regular activities, except, perhaps, on a reduced schedule, as when skunks hole up for a few days during the worst weather. The birds that are around must remain constantly active to keep up their high rates of metabolism, but they too may disappear from view, seeking shelter and food.

Birds, often the only obvious animal life in the winter habitat, provide a special kind of warm and friendly companionship in the cold months. The winter birds are the birds that remain after all the summer residents have dispatched their young and headed south. They fall into two basic classes: permanent residents and winter visitors. The permanent residents—the cardinals, chickadees, crows, and many more—never leave. Summer and winter, they are always in the neighborhood, although their habits may change. The winter visitors are the dark-eyed juncos ("snowbirds"), white-throated sparrows, and other birds that move southward from their breeding grounds to take up winter residence in the neighborhood. Because this southward shifting takes place regularly among many species, one never knows whether the winter's jays or

chickadees or finches are one's own from last summer or someone else's on winter holiday from farther north.

In every clime there seem to be the "undecideds," those species or individuals that never quite make up their minds to go or stay. They "play it by ear" and decide only at the last moment, perhaps when they see the snow falling or the river freezing and covering up their food. (Birds find food largely by sight, and it is always amazing how thin a mantle can keep them from their food, even when it is in a predictable place as at a feeder.) Finally, there are the wanderers—the evening grosbeaks, cedar waxwings, finches—that rove from food source to food source, wiping out the supplies as they go. For them, winter is one big movable feast. The modern phenomenon of the bird feeder, the instantly replenished food supply, is a bonanza for such species as the evening grosbeak. By begging its way from feeder to feeder, it has moved across the continent.

Bird life around a lake or stream in winter is always more varied and interesting if the water is open rather than frozen. Inevitably, some of the "undecideds" will stay behind, even if only the slightest rapids or pool is unfrozen. One bird whose decision rests entirely on the availability of open water is the belted kingfisher. In summer it ranges over the whole of North America to the northern limit of trees; in winter, it migrates as far south as Panama but frequently is a winter resident around open water over the southern two-thirds of the United States and as far north as southern Ontario and coastal southeastern Alaska. This quaint, almost comical bird with the stocky body, large head, and top-heavy crest lives along streams, rivers, coasts, and around ponds and lakes, where it fishes for food. It hovers and perches watchfully and then plunges straight down. A solitary bird, it is best known for its nosy dry rattle, which it often utters as it flies back and forth along a waterway. Coming from a woods, this call is a dead giveaway of a woodland pond or stream somewhere in the recesses.

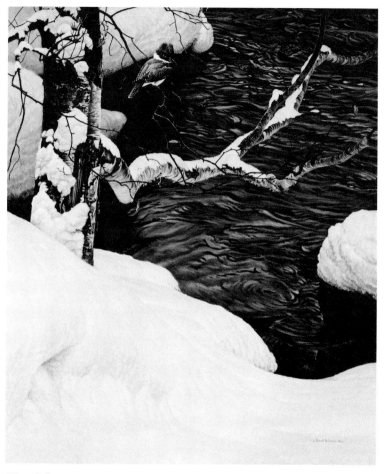

Kingfisher in Winter

wonders how many headaches or inglorious casualties the bird suffers from miscalculation. Bateman's female kingfisher sits on the paper birch twig intently looking for fish in the swirling pool, quite unmindful of the season and no doubt oblivious to having been forsaken by all her summer friends.

Many North American hawks are permanent residents over much of their territory and vacate only the more northerly regions in winter. Many parts of the permanent area of distribution, particularly the northern edges, experience an influx of northern birds in winter. The ubiquitous red-tailed hawk is the continent's most common buteo and best-known hawk. The buteos are broad-winged hawks that soar in high, wide circles. As a species, comprising several geographical races, the red-tailed hawk occurs throughout North America, north to the polar limit of trees and south to Panama. The permanent range is mainly south of Canada, and the northern red-tails migrate south into the United States in winter. Because of this seasonal influx, the red-tailed hawk is more common in winter than in summer over many parts of the United States.

Winter can be a tough time for hunting, particularly when the ground is covered with snow or ice. Red-tails will soar in the wintriest of weather if the frigid winds are strong and buoyant, but on still or sullen days they often will sit tight on low perches in trees or on roadside poles, watching for prey and waiting for the sun to come out and warm up the earth enough to start updrafts.

In *Sudden Blizzard—Red-Tailed Hawk* [29], Bateman's red-tail is probably trying to reach the shelter of the white pines in the pinetum before the blizzard grounds it, but then again it might be getting out of the way of the intruder or patrolling the edge of the grove for a mouse before the storm or nightfall overtakes it. Bateman's winter portrait shows what special moments may reward the seasoned observer who ventures into the snowy landscape even in the face of a storm. The land is so peaceful and pure in the falling snow,

Commonplace in summer, the belted kingfisher is always a treat in winter, an unexpected bright spot in what otherwise can be a rather bleak and lifeless waterscape, as in Bateman's *Kingfisher in Winter*. A kingfisher should get extra pay for diving into the icy winter waters. Kingfishers often work streams that seem too shallow for diving, and one always

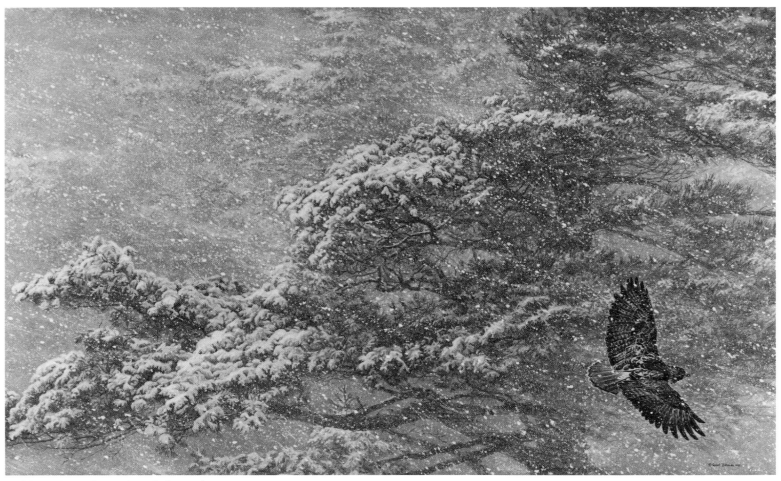

Sudden Blizzard—Red-Tailed Hawk

especially when the winds and temperatures are gentle, and the feeling is so intoxicating. The snowy landscape always casts a spell, and nature seldom disappoints the venturesome naturalist, who can count on having the wild realm and its never-ending surprises all to himself, at least until spring.

Sparrows are little brown and white birds of the finch family that all dress alike. They are the blue-jeans clan of the bird world. In their only fling with individuality, some wear formal stripes or capes, others officious caps. If bars and stripes indicated rank, some would be high officers in the service. Often it is only when they speak or sing that one really knows who they are. Sparrows never get their due. They are either ignored or dismissed as background noise in

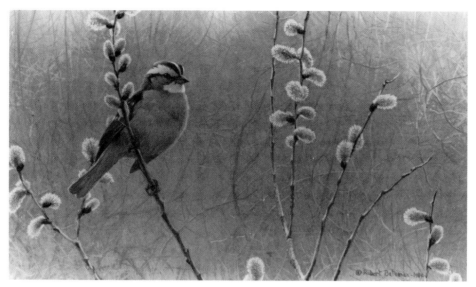

White-Throated Sparrow and Pussywillow

the ecosystem—the necessary price to pay for the greater good and beauty of the system. Yet to disdain such precise if quiet beauty, such fastidious behavior, and such intricate adaptation is to ridicule and demean nature's superb ecological order.

The resplendent white-throated sparrow is one of the most distinctive of the sparrows, both in plumage and song, and one of the commonest winter visitors in the East, where it is a sure draw at any feeder on the ground. The highlight of the plumage is the vivid lemon-yellow spot between the eye and the bill. The bird utters a highly distinctive *chink* as a call note; it only needs to say a word, and one knows instantly who's there. Its plaintive song, a quavering whistle—sometimes up the scale and sometimes down—is easy to imitate and frequently is sung on the winter range, especially toward spring. "Its song," says Bateman, "speaks to me of a world of peace and clear, clean air" (1985a, "May").

About the time when the pussy willows are in bloom, the white-throats begin to thin out under the garden shrubs, and the laggards do less scratching and more singing. Mounting the heights of the nearest bush, they fill the air with their beautiful farewells and shortly head back to their northern breeding grounds. They nest in the northern coniferous forests across Canada and in the Canadian zone on the mountains of New England and the Adirondacks. If one vacations in these parts, these cheery little friends can be seen in summer, too, especially up near treeline.

Bateman's beautiful portrait, *White-Throated Sparrow and Pussy Willow* [30], is a perfect memento of the white throat's modest little story. Like so many birds, it depends on two different worlds to live; however, it is one of a select band of species that spend their summers in the northern forest wilderness and their winters in the doorstep wilds around us.

5
Vanishing Tableaux:
The Emotional Roots of
Conservation

Today nature is under siege all around the globe, and the natural heritage of every continent is being decimated daily. Flagrant and insidious forces, implacable forces, are ceaselessly at work on every hand. They are the forces of greed and gratification, self-indulgence and over-indulgence, self-defined need and so-called progress, over-population and improvident exploitation, insensitive and wanton destruction, and, above all, vast ignorance, both willful and unwitting, and the arrogant denial of the future and the higher human values—social, aesthetic, ethical, moral, spiritual.

The story is, by now, all too familiar and sad, too easily the cause for deep melancholy. Death is coming to the natural realm of the planet, to the natural heritages of the continents, the biomes, and the habitats. It is a pervasive death, by times violent, obvious, and painful; by times gradual, hidden, and seductive, even euphoric. On the one hand, forests are being leveled and lands cleared, instantly and openly snuffing out immemorial wells of biological diversity and ecological richness for a few fast bucks and a few fast bites—literally for a "mess of pottage." It is a violent destruction that knows no end. On the other hand, the air, the water, and the earth are being polluted from without and within by legions of sources, and slowly but relentlessly the biosphere, land and sea, is dying; species are being poisoned into extinction; whole biomes are slowly being suffocated and habitats rendered sterile—all beneath the euphemistic banner of progress and with so little fanfare and such sleight of hand as to go largely unnoticed until it is too late. Meanwhile, nature, abhorring a vacuum, obliges by filling in the spaces left by the extermination of the rare and the lovely with the commonplace and the ugly, leaving the ignorant to their specious arguments about the worth of diversity and of the natural realm in general.

But this book is a celebration, not an elegy, of nature and of what one man has been able to do with his wildlife art to

educate and alert the world to its natural heritage while there is still time to save much of it. Every day there is a new threat, and one is called to constant vigilance. The real need is to dispel ignorance and thereby the complacency that prevents action. Discovery is the beginning of knowledge, and biological and ecological knowledge is the beginning of environmental wisdom. Wisdom is the beginning of effective action—meaningful conservation. Discovery should always proceed on the basis of the timeless principle of learning about nature from nature itself. Underpinning it all is inspiration. Without inspiration there can be no discovery, knowledge, wisdom, or action. Inspiration arises from the wellspring of our emotions, and the roots of conservation are ultimately emotional roots. This is why paintings and word pictures—idealized, emotional images—are crucial to the cause of conservation. And it is why Robert Bateman has become such a powerful influence on a world scale in the conservation of wildlife and nature. He is lending his name and his works—his considerable and growing moral influence—to an ever growing number of major conservation causes. His is not the voice of the shrill crusader but the earnest persuader. He is a man of deep personal conviction and commitment on the issue of the environment, and thus he is not only a naturalist and a painter but an ardent conservationist. On conservation and its relationship to his beloved Canada, he has said:

> The Canadian outdoors is my favorite studio and subject. It is America's last true wilderness, and painting is the one way I can help to preserve this great natural legacy. I want others to see something that few have been privileged to see—the same world that was seen by the first explorers and trappers. I want others to appreciate its beauty and complexity and to realize the need to protect it from our careless encroachment (personal interview).

Conservation has been a running theme of this book, and we conclude by turning our spotlight on a few species that are well-known symbols of the conservation cause. Whether these or any other species in this book are endangered or threatened in the legal sense is beside the point. Everything in today's world is endangered at some level, and in some ways it is unfortunate that the world conservation movement continues to place so much emphasis on the ten percent of the species that are in the worst trouble, often to the exclusion of the other ninety percent that constitute the bulk of the world's fauna and flora, much of which is little known or understood. Many species that are not officially listed are in fact in serious trouble in parts of their range, and literally one man's weed is often another man's endangered species. Whether or not a given species is rare or endangered is as relative to place as to species.

The word "tableau" is used because it connotes context, the reality that species do not live in isolation but in ecological contexts. Usually, a species is threatened because its habitat, community, or biome is threatened, and it cannot be rescued apart from these natural contexts. Bateman paints contexts; his paintings are truly portraits of nature, of natural settings, of wildlife in context, and conservation must be viewed in the same holistic manner. "Tableau" also suggests a moment frozen in time, a momentary glimpse at the ecological stage and what is on it now. Indeed each of these images carries a sad irony within it, for it could portend a scene as lifeless as a staged tableau. All of these portraits of nature represent tableaux that are vanishing to some degree; the only question is how soon.

As portraits that provide an emotional basis for conservation, Bateman's paintings can be grouped in three kinds of tableaux: nostalgic views of the land; threatened and endangered species; and disappearing habitats and wildlife landscapes. Several of Bateman's paintings symbolize these three faces of the land and our vanishing natural heritage particularly well.

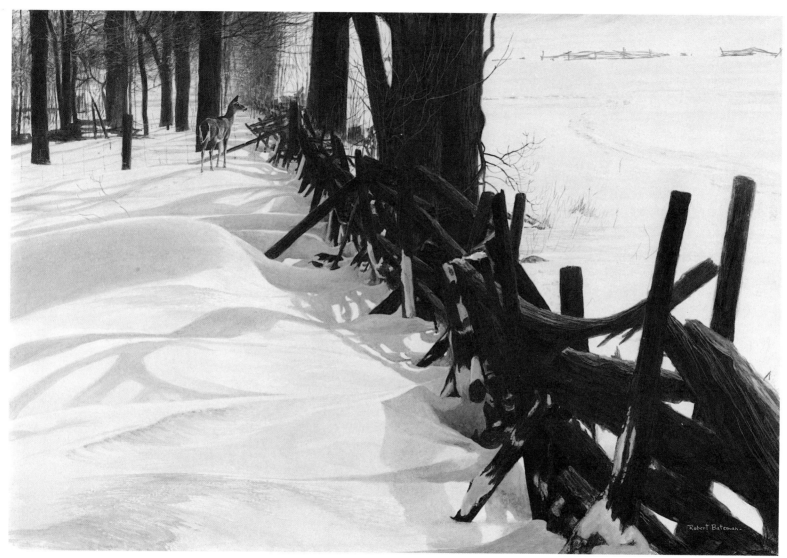

Edge of the Wood—White-Tailed Deer

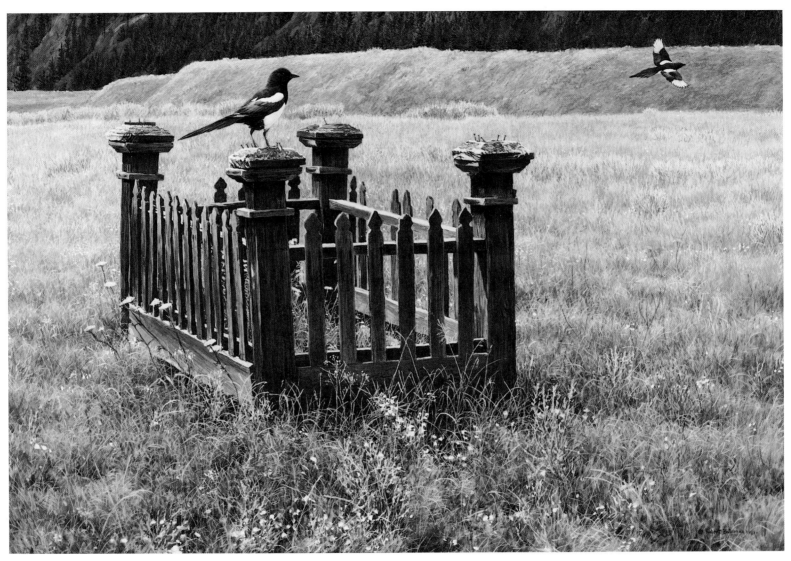

Pioneer Memories—Magpie Pair

Nostalgic Views of the Land

Edge of the Wood—White-Tailed Deer is an idyllic flashback to another time—an era of rail and stump fences, woodlots and sugar bushes, pastures and fields, orchards and gardens, farm animals and abundant wild game. Only the healing scars of the snowmobile disturb the idyll and betray a more modern scene. Today many people yearn for that time. In North America and particularly in the United States, the last twenty-five years have witnessed an enormous reaching out for simpler times, for going back to nature and rural living. Countless people are tiring of the synthetic urban biomes of our man-made estate. If they could make one wish, it might well be to glimpse, if not actually to return to, the wilderness of the first Americans, the Indians, and our founding fathers. There is something of the frontier and rural ethic in all of us—a longing for the real thing, for things the way they were, the original condition. The human spirit seems to demand constant reassurance of native roots, continuity, and unchanging ideals, even while accepting and adjusting to ceaseless change.

Nostalgic and romantic views of the land of early America and our forefathers, especially through the idealizing eyes of the artist, bring this reassurance and help to give the present a perspective that can make change understandable and tolerable, if not always desirable. Bateman is an optimist and romanticist at heart, and many of the paintings we have already encountered (e.g., *Early Spring—Bluebird*) would fit this category. Many of his images arouse a deep nostalgia for the continent's magnificent past, a nostalgia that goes far beyond dated individual memories. Rather it is framed by our timeless collective memory, the common memory we are trying to keep alive for our children and the generations yet to come.

We are fortunate that such nostalgic Robert Frost scenes as this are not entirely gone, thanks to long-lasting stump and rail fences, many still extant rural farms, and the persevering success of the white-tailed deer, which reminds many of abiding rural values. With the help of conservationists and game managers, the white-tailed deer population of North America has come from a low ebb of a half million at the turn of the century to about twelve million deer today—this despite an annual harvest by hunters across the continent of at least two million animals. No wildlife species has had a greater influence on conservation policy and practice (Halls *in* Schmidt and Gilbert 1978, 43). Unlike so many birds and animals of North America, the deer thrives in the successional second-growth habitats, agricultural land, and developed environments created by human activity in forested regions. The white-tailed deer has been successful in populated, even urban, areas because it is widely admired and is protected from hunting by the sheer density of the human population. It represents one of the true success stories of America's urban wilderness.

A nostalgic flashback of a different sort is evoked by *Pioneer Memories—Magpie Pair*, a flashback to the hard-luck lives of the early settlers of the Old West. It commemorates western pioneering as *Edge of the Wood* commemorates eastern pioneering. Though it is a prairie in the relatively hospitable forest region of interior British Columbia, the setting—but for the forested slopes in the background—could easily be almost anywhere on the western plains. Here, instead of the rail fence, the relic of the past is the forgotten grave, a stark testimony to a bygone experiment, entombing, perhaps, the failed dreams of an early homesteader. Symbolizing nature's reassuring persistence in this land, apart from the prairie flowers and grasses, are the irreverent magpies, which probably have been desecrating or, depending on one's point of view, gracing this grave since the day of burial. The black-billed magpie, like the deer, is ubiquitous in its realm; it is as characteristic of the brushlands and wooded edges of the plains biome as the deer is of the forest biome. The magpie also lives in open woods all the way to Alaska.

Pioneer Memories is an indelible portrait of the western plains and foothills, with special meaning for anyone who has ever lived or communed there. It has special poignancy for me personally because my mother was born to homesteaders in a sod shanty on the plains of Montana. My memories center mainly around the vast fields and rangelands, punctuated here and there with groves and thickets, the ruins of past inhabitants, and such birds as the magpie. To Bateman the "resilient, resourceful" magpies have "qualities that seem to represent the spirit of the early settlers" (1985b, 101).

Threatened and Endangered Species

The monumental elephant, the world's largest land animal, is a beast of unreal proportions. It takes a giant-size ecosystem to contain a giant-size animal. Africa is such a place, and the Serengeti is one such ecosystem. In former times, elephants roamed over a large part of Africa in the central and southern portions, but centuries of hunting have brought the African species to the brink of disaster. This mighty beast, which alternately can be playful, destructive, or dangerous, would seem to be invulnerable, like an impregnable fortress, but the long tradition of killing elephants for their tusks has accelerated in recent years. Although some two thousand elephants now roam the Serengeti where formerly there were few, most of these have taken refuge here from the pressures of agriculture, hunting, and other human activity on all sides, so that it is difficult to know how many elephants there still are in East Africa. Unfortunately, the elephants are not safe from poaching in the preserves, and the elephant is now second only to the black rhinoceros as the most endangered animal in the Serengeti (Alexander 1986).

Bateman's majestic *Bluffing Bull—African Elephant*, commanding warrior of a vanishing race, may already be a monarch of the past. Yet it still stands supreme as a symbol of the whole African zoo, whose future is as fuzzy as the outlines of Bateman's bull in the swirling haze of dust. Aside from the fate of the species as a whole, the old bulls with great tusks themselves are vanishing, according to writer Shana Alexander (1986, 588). A great tusk may weigh as much as 70 pounds, a great elephant, over 6 tons! Here is the real question posed by Bateman's heroic tableau: Is the defiant "Bluffing Bull" leading the parade of the animals in an elephant walk into the jaws of extinction or the ark of safety? Fortunately for many of Africa's big animals, maybe including the elephant, there is considerable hope, thanks mainly to the great game preserves and the increasing conservation efforts in East Africa's Eden, which in many ways is still a scene out of the ageless past.

Of all the chapters of life on earth, none is more poignant nor dramatic than the contemporary story of the peregrine falcon and its stunning, sudden plunge toward extinction. And none is more frightening in the message it tells and the warning it sounds of the interrelationship and ultimate continuity of all environment and life on the planet. Surely there is no better known or more celebrated symbol of birds in peril than this noble sovereign of the skies. Many would rank it first as the torchbearer for all species in mortal danger.

The peregrine falcon, whose very name means alien or wanderer, has spread to the ends of the earth and once vied with the raven and the osprey as one of the most widely distributed birds on the globe. It has lived in all corners except Antarctica. A raptor whose prey is other birds, the peregrine is a denizen of the air as much as the land, and when it does come down from the skies it lives on high cliffs and canyon walls in lonely, windswept eyries, a wild and lofty realm far above the madding crowd of nature's ordinary lives. Sometimes in the world of man it has elected to inhabit man-made cliffs, perhaps the tower of a suspension bridge or a skyscraper, where, in the Eldorado of pigeons, it can survey the canyons and ledges of the city to pick and choose at will among its favorite prey. As natural habitat, its ageless predilection has been the high rocky cliff or headland along

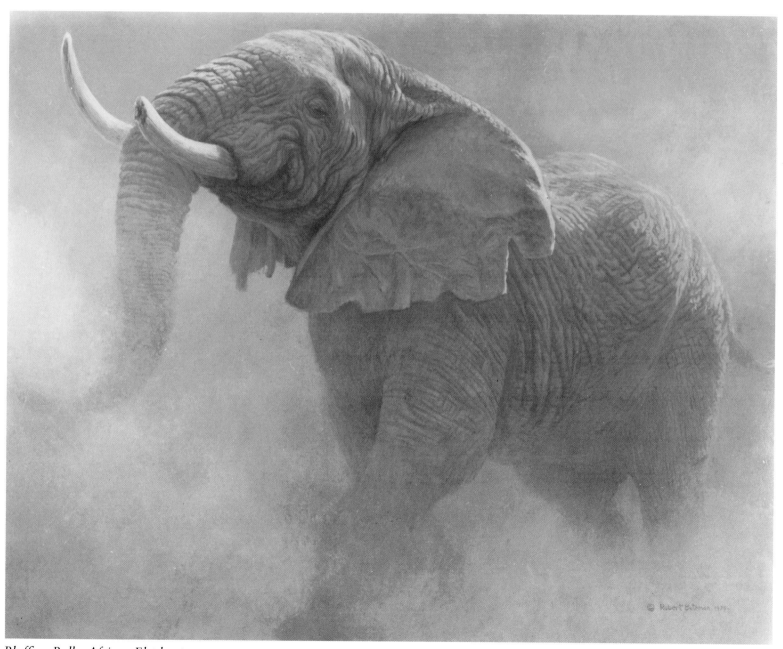

Bluffing Bull—African Elephant

143

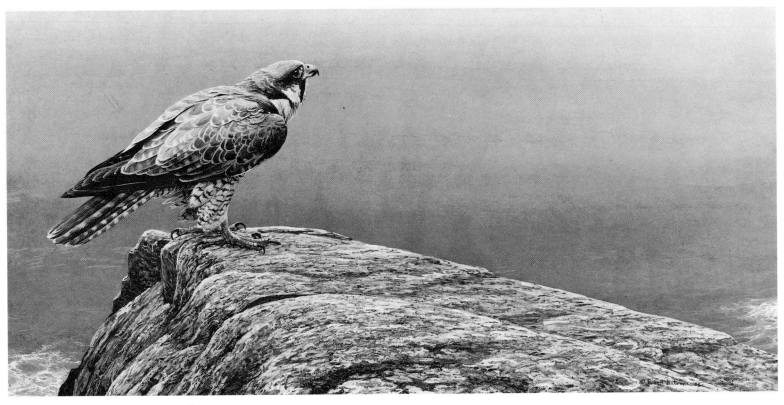

Ready for Flight—Peregrine Falcon

a coast or river, the better to stoop (dive) without warning or reprieve on passing prey. Here, from the ramparts, is a ready supply of such favored food as ducks, shorebirds, and colonial seabirds.

Poised or in action, the peregrine falcon is a poetic study in power and beauty, as portrayed so elegantly by Bateman in *Ready for Flight* [31]. The conspicuous black "mustache" is its most famous trademark. Flying pigeonlike, it is a bird of tremendous speeds, probably the fastest of all winged creatures, able to reach 175 or more miles-per-hour in a power dive. Birds are killed instantly by a blow from the fist-clenched talons, and then the prey is scooped up in mid air. Owing to its hunting skills, the peregrine is a legendary bird of royalty, having always been the falcon of choice in the art and sport of falconry practiced by kings and princes since ancient times. Fortunately nowadays, in most parts of the world only captive-bred falcons may be kept legally.

Suddenly, in the 1950s the peregrine populations began to nosedive. Like a thief in the night, something began to creep through the environment and strike down this magnificent bird of prey. Rachel Carson sounded the public alarm about the threat to raptors, but before anyone knew what was

really happening the peregrine was teetering on the brink of catastrophe. We have learned long since, of course, that the problem was pesticides—mainly DDT—which were used on the land but got into the water, building up in the fish and other aquatic organisms eaten by the ducks and other birds being preyed on by the falcons. The pesticides interfered with the peregrine's ability to reproduce. When the water is poisoned, ultimately there is no place to hide for organisms that live in it or make their livelihood from it.

In fifteen short years, roughly from 1950 to 1965, the Appalachian peregrine falcon was wiped out. This peregrine of eastern North America folded its wings and made its last stoop—into oblivion, a whole race brought down by DDT in the food chain. And nearly everywhere else the peregrine was in deep trouble. Only in the Arctic did the tundra race of the falcon remain more or less free of this plague and its population healthy, and the Arctic continues to be its principal stronghold. These northern birds still migrate over the coastal beaches and marshes in the spring and fall, going to and from their breeding grounds.

The pesticide web of death is now a familiar story. Although the wild and lofty cries of the peregrine falcon have long since been stilled over the rugged Appalachians and nearly throughout the western United States as well, there is hope. Captive-breeding programs, pioneered by ornithologist Thomas Cade at Cornell University, have been extraordinarily successful, and falcons have been put back into the wild in places such as the Catskills and the Atlantic coastal marshes, both traditional homes, as well as in some cities and in various places in the Rocky Mountain region. Some of these captive-bred falcons have begun to breed again in the wild. It is just possible that the peregrine's wild cries will one day ring out again as a familiar call above the Appalachians and the Rockies—and all across North America. As the well-know falconer Al Nye once said to me, the peregrine falcon is "the top of the line in God's creation."

Disappearing Habitats and Wildlife Landscapes

Giant Panda [32] is one of Robert Bateman's latest and most impressive works, and there could be no more fitting conclusion to this celebration, through Bateman's many eloquent paintings, of nature's grand diversity, especially the wildlife heritage of North America and the world. Perhaps the most famous face in the whole animal kingdom, the giant panda is to mammals what the peregrine is to birds. One of the world's rarest species, it would win the popular vote anywhere for the most recognizable and endearing symbol of threatened and endangered animals. This is true in part because the World Wildlife Fund, working cooperatively with the Chinese, has made the preservation of the giant panda a world-wide cause célèbre; the panda is its mascot, incorporated into its now familiar logo. How appropriate, then, that reproductions of *Giant Panda* were sold worldwide to benefit the World Wildlife Fund's panda conservation project, thanks to Robert Bateman's concern and generosity. This painting has special significance to zoogoers in Washington, D.C., because Bateman based it in part on his observations of Hsing-Hsing and Ling-Ling at the National Zoo.

The giant panda—the "bear-cat," in Chinese—once roamed widely through the bamboo forests of eastern China and northern Burma, but centuries of hunting and destruction of its habitat have reduced the panda's numbers to perhaps a thousand animals in the rugged high mountains of east-central China. Only about half of them live in reserves; however, the species is protected by the Chinese government as a national treasure, and persons convicted of killing pandas are subject to a jail term. The pandas live in cool, wet bamboo forests on the high mountain slopes to about 13,000 feet, where snowy winters are relatively long. Here they blend into the white snow and the black forest shadows. Bamboo of several species is the main staple in their diet, even though the panda has the stomach of a carnivore, not a herbivore, and processes the bamboo very inefficiently. Consequently,

Giant Panda

the panda must eat constantly. Alternating periods of eating and resting, it is active around the clock and around the year (see Schaller 1986).

Pandas and bamboos—one automatically suggests the other. Each, with a history that goes back into the mists of time, symbolizes an entire natural heritage of its own; together they symbolize China's great wealth of fauna and flora, indeed China itself. One has built and fed a great civilization; the other has enriched the mind and spirit of a great people.

In the giant panda's mountain realm, the bamboo's fate is literally the animal's fate because cycles of starvation among the pandas are inextricably linked to cycles of bamboo die-off. Consequently, solving the riddles of the panda has first meant solving some riddles of this woody treelike grass. From the research of such world bamboo experts as the Smithsonian's Thomas Soderstrom, we now know a few of the answers. The bamboo only rarely flowers and produces seeds as normal grasses do, and when it finally does flower it dies back to the ground; new shoots from underground parts may take some time to grow. A further point of mystery is that the plants of a particular bamboo species are all synchronized, and they flower and then die en masse in a communal orgy that comes only once every 40 to 120 years, depending on the species. (There are over one thousand in the world.) Because the different bamboos flower and die on different cycles, each additional species in the habitat is added insurance for the panda, increasing its chances of survival when a major die-off strikes. A diversity of bamboos in the habitat means a diversity of food options, and the panda should never have less than two bamboo options at its disposal at any one time.

The stories of the peregrine and the panda provide a conservation study in similarities and contrasts. Both are endangered species that have been brought back, if only just barely, from the brink of doom, and both had been brought down—one precipitously, the other gradually—by man's destruction or despoiling of their habitat. Indeed the oneness of habitat and species is so obvious that *Ready for Flight* and *Giant Panda* could illustrate either endangered species

or disappearing habitats. Both paintings are vanishing tableaux with a powerful symbolism for species and habitats in peril.

But the contrasts between the stories of the peregrine and the panda reveal the significance of selecting the giant panda to exemplify disappearing habitats. The falcon is a citizen of the world that makes its home in the universal realms of land, sky, and sea. Its habitat is not so much destroyed as subverted, poisoned by a chain reaction that, once unleashed, can never be recalled. This reaction spreads to the ends of the earth, the limits of the global environment, striking down hapless creatures wherever it goes with a treachery that may never be fathomed. The peregrine falcon, then, is the preeminent example of the universality of habitat and environment—the ultimate oneness of the ecosystem. It epitomizes the desperate predicament that results when the skies or waters are polluted and the poison of one continent soon becomes the poison of all. Before such insidious tides, all creatures of the earth are vulnerable and may fall.

Though happily adopted by the world, the giant panda, by contrast, is a local citizen of one geographical place with a relatively tangible and highly restricted habitat; the grave threats to its survival are specific and clear, seemingly quite containable and susceptible to direct remedy. But they are the dual threats to species everywhere, especially species of narrow range, which mankind seems so unable to stop: outright killing of the species and destruction of its habitat. Through pressures of human need and want, habitats, if not actually destroyed, are fragmented, sanitized, manicured, and generally domesticated until they are debased and robbed of all value as natural ecosystems. On a larger scale, the end result is to homogenize the land until there are few if any discernible natural wildlife landscapes left. These pressures are driven, of course, by the relentless growth of population, and agriculture is perhaps the greatest landscape-homogenizing force. With a uniform landscape comes a uniform fauna and flora of "weedy" species, which, taken to the limit, may reduce to a grand monotony of boring monocultures.

Habitat destruction is the primary cause of panda decline in China today, as no doubt for centuries. Agriculture, by destroying the bamboo forests, is putting a squeeze play on the pandas, forcing them to their limits on the high mountains and into ever narrower habitat zones where the species may be at the everlasting mercy of a bamboo monoculture. As Schaller sums up: "The giant panda as a species lives a marginal life of quiet desperation, stoically seeing its habitat disappear piece by piece" (1986, 306).

Is is no small tribute to man's abiding altruism, ingenuity, and dogged endeavor, surely, that the stories of the peregrine and the panda are today each touched with a large ray of hope. Given the age of Chinese civilization and the long centuries of human activity in China, it is something of a miracle that the giant panda still survives, and the current concern and conservation effort in China are encouraging signs. "Can the panda be saved?" Schaller asks, and then goes on to answer: "Of course. All it needs is bamboo and peace" (1986, 308).

Bateman's tableau shows the panda sitting and eating bamboo in its inimitable style. Like some meditating oriental mystic, the sad-eyed bear sits in doleful pose as if the weight of the whole species were on its shoulders. Its mossy mountain home is bathed in an ethereal mist—a "luminous fog so dense that the world beyond cease[s] to exist," as Schaller describes it—making this realm "a fitting home for the panda" (1986, 290).

These symbolic vanishing tableaux should ignite our emotions and spur us all to greater vigilance and conservation action; yet there are also broad lessons to learn. Anyone can be stirred to preserve huge elephants, majestic falcons, or giant pandas, but these are a tiny minority in a vast sea of ordinary snail darters and Furbish louseworts. The darters and the louseworts are the commonplace animals and plants, and nature has hundreds of thousands of them. The silent majority of the organic world, they are often so homely or retiring that only specialists know and love them. But who will champion their cause? No one knows how many are in peril. Regrettably, the first public reaction to conserving snail darters and Furbish louseworts is scorn.

Yet every threatened or endangered species, the humble as well as the exalted, is a symbol—a symbol of the last stand for some particular habitat or environment. Each is a symbol of nature's diversity, and the status of each, a measure of the status of this diversity. If we extinguish even one, we not only diminish the spectrum but set off an unbalancing act that, like falling dominoes, may ripple endlessly through the ecosystem in ways we cannot know or control.

Above all, every species or habitat in peril is a ringing reminder of the whole fabric of nature, the unity of the ecosystem. The pattern of a beautiful cloth derives from the drab threads as well as the brilliant ones, the common as well as the rare. One cannot have the beauty without all the strands. Just as the commonplace threads are needed for the ground plan of the cloth, so are the myriad commonplace organisms essential to the ground plan of nature.

If there is a grand lesson to be learned from species and habitats in peril, then, it is that one cannot preserve the natural order of things by merely saving the most precious elements—the peregrines and the pandas. Clearly these have a critical role to play: because they grab our attention and arouse our emotions, they serve both as barometers of the health of the ecosystem and as rallying points for galvanizing general public concern and action. Yet everything in nature is interdependent, and the ordinary prey species and food plants are also vital elements—crucial to the very survival of the falcons and the bears.

Why the concern for vanishing tableaux, for whole scenes or landscapes of disappearing species? Because nature is far more than the sum of its parts, far more than a vast inventory of species and habitats. The genius of nature is natural setting and ecological context—the unending permutation of natural

diversity, of species and habitat, by the timeless evolutionary forces of biology and environment. In themselves, many individual species and habitats may not be endangered, but in today's world an ever greater number of their ecological permutations are, indeed, vanishing. The ultimate consequence of losing diversity, surely, is Rachel Carson's "silent spring." The genius of Bateman's art lies in his peerless ability to convey nature in whole tableaux and to rouse our concern for these ecological landscapes as well as the species they contain.

We are all citizens of a great natural estate. We should be proud to realize we are passing our lives in a world that, despite the urban concrete and steel or the leveled forests and polluted waters, still possesses many of the same natural values our forebears cherished. We should see to it that we understand this world, cherish it as our ancestors did, preserve it for our children, and above all instill in them the wisdom and respect to enjoy and perpetuate this legacy forever. This is the challenge of Robert Bateman's paintings and also, I hope, of this book.

Bibliography

Robert Bateman Books

1981 *The Art of Robert Bateman.* Introduction by Roger Tory Peterson and text by Ramsay Derry. Toronto and New York: A Viking/Madison Press Book.

1984 *The Robert Bateman Naturalist's Diary—1985.* New York and Toronto: A Holt, Rinehart and Winston/Madison Press Book.

1985a *The Robert Bateman Naturalist's Diary—1986.* New York and Toronto: A Random House/Madison Press Book.

1985b *The World of Robert Bateman.* Text by Ramsay Derry. New York: A Random House/Madison Press Book; and Toronto: A Viking/Madison Press Book.

1986 *The Robert Bateman Naturalist's Diary—1987.* New York and Toronto: A Random House/Madison Press Book.

General References

Alexander, Shana. 1986. The Serengeti: The glory of life. *National Geographic Magazine* 169(5):584–601.

Braun, E. Lucy. 1950. *Deciduous Forests of Eastern North America.* Facsimile Edition. New York: Hafner.

Carson, Rachel. 1962. *Silent Spring.* New York: Fawcett Crest.

Farb, Peter. 1963. *Face of North America: The Natural History of a Continent.* New York: Harper and Row.

Fernald, Merritt Lyndon. 1950. *Gray's Manual of Botany.* 8th ed. New York: American Book Company.

Gleason, Henry A., and Arthur Cronquist. 1964. *The Natural Geography of Plants.* New York: Columbia University Press.

Godfrey, Michael A. 1975. *A Closer Look.* San Francisco: Sierra Club Books.

Godin, Alfred J. 1977. *Wild Mammals of New England.* Baltimore: Johns Hopkins University Press.

Grasslands and Tundra. Editors of Time-Life Books. 1985. Alexandra, Va.: Time-Life Books.

Heinzel, Hermann, Richard Fitter, and John Parslow. 1979. *The Birds of Britain and Europe, with North Africa and the Middle East.* 4th ed. London: William Collins Sons.

Horwitz, Elinor Lander. 1978. *Our Nation's Wetlands: An Interagency Task Force Report.* Washington, D.C.: U.S. Government Printing Office.

Iwago, Mitsuaki. 1986. The Serengeti: A portfolio. *National Geographic Magazine* 169(5):560–583.

Jackson, Rodney, and Darla Hillard. 1986. Tracking the elusive snow leopard. *National Geographic Magazine* 169(6):792–809.

Larsen, James A. 1980. *The Boreal Ecosystem.* New York: Academic Press.

National Geographic Book of Mammals. 1981. 2 vols. Washington, D.C.: National Geographic Society.

National Geographic Society Field Guide to Birds of North America. 1983. Washington, D.C.: National Geographic Society.

Nero, Robert W. 1980. *The Great Gray Owl—Phantom of the Northern Forest.* Photographs by Robert R. Taylor. Washington, D.C.: Smithsonian Institution Press.

Newcomb, Lawrence. 1977. *Newcomb's Wildflower Guide.* Illustrated by Gordon Morrison. Boston: Little, Brown.

Ogburn, Charlton. 1976. *The Adventure of Birds.* New York: William Morrow.

Oosting, Henry J. 1956. *The Study of Plant Communities.* 2nd ed. San Francisco: W. H. Freeman.

Peattie, Donald Culross. 1966. *A Natural History of Trees of Eastern and Central North America.* 2nd ed. New York: Bonanza Books.

Peterson, Roger Tory. 1980. *A Field Guide to the Birds: A Completely New Guide to All the Birds of Eastern and Central North America.* 4th ed., completely revised and enlarged. Boston: Houghton Mifflin.

Peterson, Roger Tory, and Margaret McKenny. 1968. *A Field Guide to Wildflowers of Northeastern and Northcentral North America.* Boston: Houghton Mifflin.

Reader's Digest North American Wildlife. 1982. Pleasantville, N.Y.: Reader's Digest Association.

Robbins, Chandler S., Bertel Bruun, and Herbert S. Zim. 1983. *A Guide to Field Identification: Birds of North America.* Illustrated by Arthur Singer. Expanded and revised ed. New York: Golden Press.

Schaller, George B. 1986. Secrets of the wild panda. *National Geographic Magazine* 169(3):284–309.

Schmidt, John L., and Douglas L. Gilbert, compilers. 1978. *Big Game of North America.* Illustrated by Charles W. Schwartz. Harrisburg, Pa.: Stackpole Books.

Shetler, Stanwyn G. 1964. Plants in the arctic-alpine environment. In *The Smithsonian Report for 1963,* 473–97.

Stokes, Donald W. 1976. *A Guide to Nature in Winter.* Illustrated by Deborah Prince and the author. Boston: Little, Brown.

Terres, John K. 1980. *The Audubon Society Encyclopedia of North American Birds.* New York: Alfred A. Knopf.

Weaver, J. E. 1954. *North American Prairie.* Lincoln, Nebr.: Johnsen Publishing Company.

Weaver, J. E., and F. W. Albertson. 1956. *Grasslands of the Great Plains—Their Nature and Use.* With special chapters by B. W. Allred and Arnold Heerwagen. Lincoln, Nebr.: Johnsen Publishing Company.

Zeleny, Lawrence. 1976. *The Bluebird.* Bloomington: Indiana University Press.

Robert Bateman:
A Chronology

1930
Born May 24 in Toronto, Ontario, Canada to Joseph Wilberforce Bateman and Annie Maria Bateman.

1938
Begins annual family vacations at a summer cottage in the Haliburton lakes region of Ontario.

1942
Joins the Junior Field Naturalist's Club at the Royal Ontario Museum. Becomes skilled in bird-watching and ornithology.

1943–48
Is active during high school in the Biology Club of the University of Toronto.

1947–49
Spends summers working at a government wildlife research camp in Algonquin Park in northern Ontario.

1950
Travels by bus to Vancouver Island to paint and sketch.

1950–54
Attends the University of Toronto in a four-year honors course in geography. Goes to Newfoundland, Ungava Bay, and Hudson Bay with geological field parties during summer.

1954
After graduating from the university, takes a painting and sketching tour of Europe and Scandinavia.

1954–63
Experiments with a range of painting styles from Impressionism and the style of the Canadian Group of Seven, to Cubism, and finally to Abstract Expressionism.

1955
Receives a teaching certificate from the Ontario College of Education and begins a career as a high school teacher of geography and art in Thornhill, Ontario.

1957–58
With friends, undertakes a round-the-world trip by Land Rover to England, Africa, India, Sikkim, Burma, Thailand, Malaysia, and Australia.

1958
Resumes his teaching career in Burlington, Ontario.

1960
Marries Suzanne Bowerman, a sculpture student at the Ontario College of Art.

1962
Attends a major Andrew Wyeth exhibition at the Albright-Knox Gallery in Buffalo, New York, which convinces him to return to painting in a realistic style.

1963–65
Spends two years teaching in Nigeria under the sponsorship of Canada's External Aid Program. Paints African wildlife and begins exhibiting at the Fonville Gallery in Nairobi.

1965
Returns to Canada to resume teaching in Burlington, Ontario. Continues to paint African wildlife and begins painting Ontario landscapes and rural settings in a realistic style.

1967
Shows series of historical scene paintings of Halton County, Ontario, at the Alice Peck Gallery in Burlington.

1969
Exhibits in one-man show at the Pollock Gallery in Toronto.

1971
After a successful show at the Beckett Gallery in Hamilton, Ontario, concentrates on wildlife paintings.

1975
Begins to paint full-time after the success of a large show at the Tryon Gallery in London, England, one of the world's foremost galleries of wildlife art.
Marries Birgit Freybe after his first marriage ends in divorce.

1978
Shows at the Beckett Gallery, Hamilton, and the Art Gallery of Hamilton, Ontario.
Travels to the Falkland Islands and the Antarctic aboard the Lindblad *Explorer*.

1980
Shows at the Beckett Gallery and The Sportsman's Edge Gallery in New York City.
Is named "Artist of the Year" by *American Artist* magazine.
Visits Ecuador and the Galapagos Islands.

1981
Images of the Wild, a major Bateman show organized by the National Museum of Natural Sciences, opens in Ottawa, Canada, and travels to museums in Quebec City, Winnipeg, Vancouver, and Toronto over the next two years.
Northern Reflections—Loon Family, a painting commissioned by the Governor-General of Canada, is the official wedding gift of the people of Canada to Prince Charles.
The Art of Robert Bateman is published, a book featuring over eighty color reproductions of Bateman paintings.
Visits New Zealand, Australia's Great Barrier Reef, and Melanesia.

1982
Explores the Queen Charlotte Islands.
With three of his children, visits the game parks of East Africa.

1983
The *Images of the Wild* exhibit opens at the California Academy of

Sciences in San Francisco.

Visits Alaska for the first time.

1984

Bateman is named an Officer of the Order of Canada.

Robert Bateman: Artist and Naturalist, a one-hour television documentary, is shown on the Canadian Broadcasting network.

1985

The Tryon Gallery in London exhibits a major Bateman show.

The World of Robert Bateman, a second book devoted to the artist and his work, is published by Madison Press Books.

Designs Canada's first federal conservation stamp. Proceeds from the sale of the stamp, which must be purchased at the time a hunting permit is issued, go to Wildlife Habitat Canada.

1986

"A Day in the Life of Robert Bateman" is produced by Charles Kurault for CBS News.

Receives an honorary doctorate of fine letters from Lakehead University in Thunder Bay, Ontario, his sixth honorary degree.

Bateman family moves from Ontario to Salt Spring Island in British Columbia, north of the San Juan Islands near Victoria.

1987

"Portraits of Nature: Paintings by Robert Bateman," an exhibition of 110 paintings, opens January 17 at the Smithsonian's National Museum of Natural History and continues through May 17.

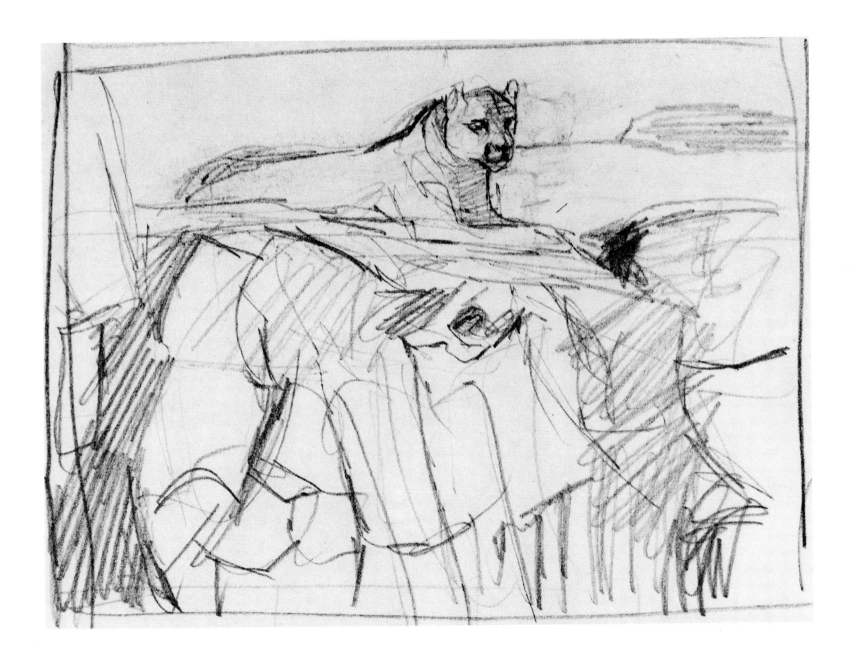

Checklist of Illustrations

Titles are listed alphabetically; dimensions are in inches, with height preceding width. Paintings followed by a number in brackets are also reproduced in the color plates section.

Across the Sky—Snow Geese [8]
Acrylic, 36 x 48, 1983
Private Collection

Afternoon Glow—Snowy Owl
Acrylic, 36 x 48, 1977
Private Collection

Along the Ridge—Grizzly Bears [back cover]
Acrylic, 24 x 36, 1984
R. L. Cram and M. L. Keough, U.S.A.

Antarctic Elements
Oil, 24 x 29½, 1979
Walter Scott, Jr., U.S.A.

Arctic Evening—White Wolf [11]
Acrylic, 24 x 18, 1978
Private Collection

Atlantic Puffins [16]
Acrylic, 18 x 24, 1977
Private Collection

Autumn Overture—Bull Moose [18]
Oil, 30 x 48, 1980
Mr. and Mrs. Murray E. Hogarth, Canada

Awesome Land—American Elk [5]
Acrylic, 24 x 43, 1980
Private Collection

Bluffing Bull—African Elephant
Acrylic, 24 x 32, 1979
Lloyd A. Wright, U.S.A.

Bull Moose
Acrylic, 30 x 40, 1978
James C. Midcap, U.S.A.

Cheetah Siesta [1]
Acrylic, 36 x 48, 1975
Private Collection

Coyote in Winter Sage [12]
Acrylic, 48 x 72, 1979
Private Collection

Downy Woodpecker on Goldenrod Gall
Acrylic, 13½ x 21, 1974
Beckett Gallery Limited, Canada

Early Spring—Bluebird
Acrylic, 20 x 36, 1982
Private Collection

Edge of the Wood—White-Tailed Deer
Acrylic, 23½ x 36, 1976
Mr. and Mrs. John G. Sheppard, Canada

Evening Grosbeaks [9]
Acrylic, 21 x 16, 1980
Private Collection

Evening Light—White Gyrfalcon [front cover]
Acrylic, 36 x 48, 1981
Private Collection

Flying High—Golden Eagle [7]
Acrylic, 42 x 30, 1979
A. J. Wool, U.S.A.

Ghost of the North—Great Gray Owl
Acrylic, 36 x 48, 1982
Leigh Yawkey Woodson Art Museum, U.S.A.

Giant Panda [32]
Acrylic, 36 x 48, 1985
Prudential Insurance Company of America, Canada

Gray Squirrel [19]
Acrylic, 16 x 24, 1981
Douglas Urch, Canada

Great Blue Heron [14]
Acrylic, 30 x 40, 1978
Private Collection

High Country—Stone Sheep
Acrylic, 36 x 48, 1977
Peter R. and Barbara J. Marsh, U.S.A.

Kingfisher in Winter
Acrylic, 48 x 42, 1980
The American Artist Collection, U.S.A.

Majesty on the Wing [6]
Acrylic, 36 x 60, 1978
Private Collection

Mallard Family [15]
Oil, 18 x 24, 1981
Private Collection

May Maple—Scarlet Tanager [24]
Acrylic, 9 x 16, 1984
Mr. and Mrs. R. Pafford, Canada

Misty Coast
Acrylic, 41 x 54, 1974
Mr. and Mrs. H. Bjorn Hareid, Canada

Northern Reflections—Loon Family [26]
Oil, 24 x 36, 1981
Their Royal Highnesses The Prince and
Princess of Wales

*On the Garden Wall—Chaffinch and
Nasturtiums* [27]
Acrylic, 12 x 8, 1985
Private Collection

Pioneer Memories—Magpie Pair
Acrylic, 24 x 36, 1981
Private Collection

Polar Bear Profile
Acrylic, 24 x 36, 1976
Mrs. Arthur J. Schaible, U.S.A.

Pride of Lions, Samburu
Acrylic, 36 x 48, 1975
Mr. and Mrs. Lionel Schipper, Canada

Queen Anne's Lace and American Goldfinch [25]
Acrylic, 12 x 16, 1982
Private Collection

Ready for Flight—Peregrine Falcon [31]
Acrylic, 18 x 36, 1983
Dr. David W. van der Bent, Canada

Red Fox—On the Prowl [20]
Acrylic, 30 x 48, 1984
Daniel Lawrie and David Ryan, Canada

Ruby-Throat and Columbine [23]
Acrylic, 12 x 16, 1983
Rocky Mountain Art Gallery, Limited, Canada

Snow Leopard [4]
Acrylic, 36 x 48, 1985
Private Collection

Spirits of the Forest—Totems and Hermit Thrush
Acrylic, 18 x 24, 1982
Private Collection

Spring Cardinal [22]
Acrylic, 14 x 21, 1980
Charlotte Kenney, Canada

Stream Bank—June [17]
Acrylic, 18 x 29, 1968
Madison Press Books, Canada

Sudden Blizzard—Red-Tailed Hawk [29]
Acrylic, 36 x 60, 1985
Art Gallery of Hamilton, Canada

Surf and Sanderlings
Oil, 24 x 36, 1979
Private Collection

Tiger at Dawn [3]
Acrylic, 30 x 48, 1984
Private Collection

Whistling Swan, Lake Erie
Acrylic, 36 x 48, 1976
Private Collection

White-Footed Mouse in Wintergreen [21]
Acrylic, 10 x 12½, 1969
Private Collection

White-Throated Sparrow and Pussywillow [30]
Acrylic, 9 x 16, 1984
Private Collection

Wildebeests at Sunset [13]
Acrylic, 40 x 30, 1975
Daniel M. Galbreath, U.S.A.

Winter Mist—Great Horned Owl
Acrylic, 48 x 29, 1979
Mr. and Mrs. Lionel Schipper, Canada

The Wise One—Old Cow Elephant [2]
Acrylic, 69¼ x 93¼, 1986
Private Collection

Woodland Drummer—Ruffed Grouse [10]
Acrylic, 12 x 24, 1980
Mr. and Mrs. Douglas H. Ptolemy, Canada

Yellow-Rumped Warbler [28]
Acrylic, 16 x 24, 1976
Beckett Gallery, Limited, Canada

Young Elf Owl—Old Saguaro
Acrylic, 8 x 12, 1982
Mr. and Mrs. Joel D. Teigland, U.S.A.

List of Lenders
to the Exhibition

"Portraits of Nature: Paintings by Robert Bateman,"
National Museum of Natural History, Smithsonian Institution,
17 January through 17 May, 1987

Paul Albrechtsen, Canada
The American Artist Collection, U.S.A.
Art Gallery of Hamilton, Canada
Thomas E. Bass, U.S.A.
Mr. and Mrs. J. R. Bateman, Canada
Beckett Gallery Limited, Canada
John J. Carey, Canada
Mr. and Mrs. Don Carlson, Canada
R. L. Cram and M. L. Keough, U.S.A.
Mrs. Vicky Evans, Canada
Mr. and Mrs. Ulrich Freybe, Canada
Daniel M. Galbreath, U.S.A.
Glenbow Museum, Canada
Mr. and Mrs. J. D. Hammond, Canada
Mr. and Mrs. H. Bjorn Hareid, Canada
Dr. and Mrs. Joseph J. Hickey, U.S.A.
Mr. and Mrs. Murray E. Hogarth, Canada
Joscelyn and Donald Hurst, Canada
Charlotte Kenney, Canada
Tilmon Kreiling, Jr., U.S.A.
William Everett Larose, Canada
Daniel Lawrie and David Ryan, Canada
Leigh Yawkey Woodson Art Museum, U.S.A.
Madison Press Books, Canada
Wayne L. Magee, Canada
Peter R. and Barbara J. Marsh, U.S.A.

Mr. and Mrs. Thomas McMillan, U.S.A.
James C. Midcap, U.S.A.
Mill Pond Press, U.S.A.
His Serene Highness The Prince of Monaco
Mr. and Mrs. Robert Murby, Canada
Mrs. Thomas O. Oliver, Canada
Mr. and Mrs. R. Pafford, Canada
The Prudential Insurance Company of America, Canada
Mr. and Mrs. Douglas H. Ptolemy, Canada
Rocky Mountain Art Gallery Limited, Canada
Royal Trust, Canada
Mrs. Arthur J. Schaible
Mr. and Mrs. Lionel Schipper, Canada
Walter Scott, Jr., U.S.A.
Dr. and Mrs. E. J. Shamess, Canada
Mr. and Mrs. John G. Sheppard, Canada
Mrs. G. L. Symmes, Canada
Dr. and Mrs. Joel D. Teigland, U.S.A.
Douglas Urch, Canada
Dr. David W. van der Bent, Canada
Their Royal Highnesses The Prince and Princess of Wales
A. J. Wool, U.S.A.
Lloyd A. Wright, U.S.A.
Mr. and Mrs. C. Young, Canada

Private Collections

Library of Congress Cataloging-in-Publication Data

Shetler, Stanwyn G.
 Portraits of nature.

 "Published on the occasion of the exhibition
"Portraits of nature: paintings by Robert Bateman,"
National Museum of Natural History, Smithsonian
Institution, January 17–May 17, 1987."
 Bibliography: p.
 1. Bateman, Robert, 1930– —Exhibitions.
2. Animals in art—Exhibitions. 3. Wildlife
conservation. 4. Wildlife management. I. Bateman,
Robert, 1930– . II. National Museum of
Natural History (U.S.) III. Title.
 ND249.B348A4 1987 759.11 86-22102
 ISBN 0-87474-839-9